Contemporary Theory of Conservation

Salvador Muñoz Viñas

ELSEVIER
BUTTERWORTH
HEINEMANN

AMSTERDAM BOSTON HEIDELBERG LONDON NEW YORK OXFORD
PARIS SAN DIEGO SAN FRANCISCO SINGAPORE SYDNEY TOKYO

Elsevier Butterworth-Heinemann
Linacre House, Jordan Hill, Oxford OX 2 8DP
30 Corporate Drive, Burlington, MA 01803
First published 2005

British Library Cataloguing in Publication Data
A catalogue record for this book is available from the British Library

Library of Congress Cataloguing in Publication Data
A catalogue record for this book is available from the Library of Congress

ISBN 0 7506 6224 7

For information on all Elsevier Butterworth-Heinemann
publications visit our website at http://books.elsevier.com

Typeset by Charon Tec Pvt. Ltd, Chennai, India
Printed and bound in Great Britain

Contents

Acknowledgements __

Contact with other conservators and researchers has indeed been important in shaping *Contemporary Theory of Conservation*. Among these, my colleagues at the Conservation Department in the Universidad Politécnica de Valencia deserve recognition, as they have helped me to dare to think. For this same reason, Eugene F. Farrell and the kind people at Harvard's Center for Conservation and Technical Studies (presently the Straus Center for Conservation) also had an influence upon this work.

I would also like to thank Mónica Espí, Emilia Viñas and Diodoro Muñoz for helping me to find the time to work on this book. This was a very great help indeed and I will always be grateful for their patience and generosity.

The support from Suzanne Ruehle and Natalia Gómez did have a very noticeable influence on the book. Suzanne and Natalia corrected the draft text and made many valuable suggestions – most of which were willingly accepted by the author. Their competent and dedicated work has improved this book in many ways.

Thank you all
Salvador Muñoz Viñas
Valencia

ix

Preface _____

... One should make sure at the very outset that there is a truly philosophic basis so that 'conservators' shall not only be good practitioners, but scholars as well, knowing not only what they do, but why they do it, and prepared to discuss fundamental questions effectively with their opposite numbers in aesthetics, art history and so forth. (George Stout, 1945)

This essay deals with contemporary theory of conservation. Perhaps the boldest thesis in the text is the very idea that a contemporary theory of conservation actually exists. No one doubts that there are a number of schemes, ideas and opinions – of theories or fragments of theories that differ to a greater or lesser degree from previous ones: they can be found or detected in written texts of many kinds (congress abstracts and preprints, periodicals, web pages, charters, etc.), in conversations and in the practice of conservation itself. However, these ideas could hardly be considered as a single, organized body of thinking. This book is an attempt to weave many of these ideas into a coherent theory, and to reveal patterns that might remain hidden due to their variety.

Stating that a contemporary theory exists implies that one or more non-contemporary theories exist as well. We might call them 'classical theories', but below this polite term there lies a less neutral assumption: it is obvious that non-contemporary theories are a thing of the past.

It therefore seems important to precisely define what we are talking about. By 'contemporary' we mean those ideas about conservation

that have been developed since the 1980s. It might be argued that this is an arbitrary date, and that several earlier examples of 'contemporary' conservation thinking do exist. However, these are exceptions, and so the 1980s must still be considered to be quite representative. In this decade, the second and third versions of the Burra charter were published, as well as the first consequential texts criticizing the principle of reversibility. Also, the notion of post-modernism became commonplace, with its emphasis on many ideas that have had a recognizable impact on conservation theory.

The notion of 'theory' is interesting, too. 'Theory' is usually defined by contrasting it with 'practice'. However, this idea cannot be applied here. When a conservation teacher explains, for instance, the effect of a solvent's surface tension on its dissolving capabilities when applied to a paint layer, he or she is dealing with a theoretical topic within the conservation field; however, no one would consider it to be 'conservation theory'. 'Conservation theory' is most often related to 'conservation ethics', although these notions are not synonyms. This is a convention which, even though it is very widespread, is still a convention. This book will adhere to it, since it is communicatively very efficient, but the expression 'contemporary philosophy of conservation' would not be inappropriate at all. Consequently, conservation ethics, as commonly understood, will be dealt with here, but, in order to reach this topic, others must be treated beforehand: first, the activity itself is defined, and the reasons why it is performed are investigated. Then, the values that lie behind conservation are examined – they interact to produce different 'ethical' codes of practice. In other words (which are more complex and unnecessarily pedantic), the teleological and axiological aspects of conservation are described.

This will all be done in a benevolent manner. First and foremost, this text is intended to be understood by the reader. It will perhaps convince some of them, but this is not its main goal. If understood,

it will reveal a coherent pattern behind a plethora of valuable, apparently unrelated thoughts; it will help the interested reader know them and know how to interpret them. To achieve this goal, the text is the result of a compromise between comprehensiveness and readability. In the next few pages, the reader should be more involved and intrigued than baffled and impressed. This is an invitation to the reader to enter into the discourse of contemporary theory of conservation.

What is conservation? _____

The first chapter in this book attempts to define conservation in the most precise way possible, for it is important in any discussion to know what exactly is being discussed. It should also be useful in clarifying some common misconceptions regarding the notions of conservation, restoration and preventive conservation. The precise use of these expressions is a requirement for any elaboration on conservation theory to be consistent; therefore, some rules of notation are presented to clarify what is meant at each moment.

A brief history of conservation

Conservation as we know it today is a complex activity. Since the nineteenth century, it has broadened in scope, strengthened in importance and, simply speaking, come of age. It has not always been this way; just a few decades ago, it was much simpler, and some decades before that, it did not even exist – it did not exist as we know it: as a particular activity, requiring special, well-trained skills, which are different from those of the artist, the carpenter or the sculptor.

Certainly, the statues of Phidias were cleaned and repaired as needed; new pieces in the large glass windows of the Cologne

cathedral were replaced when the old ones were broken; and old paintings all around the world were routinely varnished when the colour became too dull. However, the fact that these activities are now performed by conservators hardly allows us to think of them as conservation – and thus to believe that conservation, as understood today, has always existed. It would be far more historically accurate to call them 'servicing', 'cleaning', 'maintenance' or 'repairing'.

Conservation began when it became clear that the views, approaches and skills required to treat a painting were different from those required to treat the walls of a common peasant house; or when it was apparent that cleaning a Neolithic axe required a different attitude and knowledge from that needed to clean a household lamp. Conservation was born out of this realization, which became widespread sometime between the nineteenth and the twentieth century.

This attitude, however, can be traced to previous times, when certain individuals showed a special appreciation for the objects that we presently understand as 'heritage', and thus recommended their maintenance with the least possible interference. However, these cases were exceptions and should not be identified with our contemporary view of conservation.

Arguably, the most important of these exceptions is that of Pietro Edwards. In the eighteenth century, Edwards was commissioned by the authorities of Venice to supervise the refurbishing of Venetian artworks. As a result, he wrote the *Capitolato*, a set of norms to prevent the excesses committed by the restorers of Venetian paintings. It corresponds to some ideas which are very close to those that exist today. For example, he mandated the removal of old inpaintings, the use of 'non-corrosive' products, and stated that no new inpainting should extend beyond the lacuna it was intended to cover. These ideas, obvious as they may seem today, were a novelty in 1777 when the *Capitolato* was written.

Edwards can be viewed either as a pioneer or as an exception. The *Capitolato* had no immediate consequences and remained an isolated case for some time. Meanwhile, minds were changing in many ways. The consolidation of the notion of art within Western societies, which led to its special appreciation, was one of them. In the second half of the eighteenth century, Winckelmann wrote his seminal text on art history; fine arts academies became common around Europe; and Baumgarten formally created the philosophical field of aesthetics. All of this meant that art, and thus its objects, gained a special status within society – a status that is still valid today.

In the nineteenth century, the ideas of the enlightenment gained momentum and wide recognition: science became the primary way to reveal and avail truths, and public access to culture and art became an acceptable idea; romanticism consecrated the idea of the artist as a special individual and exalted the beauty of local ruins; nationalism exalted the value of national monuments as symbols of identity. As a result, artworks – and artists – acquired a special recognition, and science became the acceptable way to analyse reality.

This trend was especially intense in England, where the Pre-Raphaelite and the Arts and Crafts movements had a strong cultural impact among artists, art lovers and the cultivated public in general. John Ruskin was an English draughtsman and art writer, who had a strong influence over public opinion. In 1849, he published the well-known book *The Seven Lamps of Architecture*, which was followed by *The Stones of Venice*. In these books, his strong appreciation for the virtues and values of ancient buildings was wholeheartedly defended. In fact, his love for the past was so passionate and exclusive that it was also accompanied by a certain disregard for the present. For him, nothing present should disturb the original remnants from the past, especially if these remnants were Gothic buildings. For Ruskin, among these disturbing agents were the people trying to rebuild damaged buildings.

Across the channel, this Gothic-revival trend was also very strong. In France, where many splendid Gothic buildings remained, their reconstruction was considered to be a sort of national duty: La Madeleine de Vézelay, Notre Dame of Paris or the cathedral of Amiens had been repaired before Ruskin published *The Seven Lamps of Architecture*. The architect in charge of these and other similar works was Eugène Viollet-le-Duc, who was an enthusiast of Gothic art, and a very learned one as well. As an architect, he felt fully authorized to *fill-in-the-blanks* of damaged buildings. For him, the building could (and indeed *should*) be restored to as good a state as possible. This meant to its 'pristine' condition, a condition that might never have actually existed, as long as it was coherent with the true nature of the building. In 1866, the eighth volume of his *Dictionnaire raissoné de l'Architecture française du XI^e au XV^e siecle* was published. In it, he summarized his notion of *Restauration* in a very well-known phrase:

> [Restauration:] Le mot et la chose sont modernes. Restaurer un édifice, ce n'est pas l'entretenir, le réparer, ou le refaire, c'est le rétablir dans un état complet qui peut n'avoir jamais existé à un moment donné. (Viollet-le-Duc, 1866)

> [[Restoration:] Both the word and the thing are modern. To restore an edifice means neither to maintain it, nor to repair it, nor to rebuild it; it means to re-establish it in a completed state, which may in fact never have actually existed at any given time.] (*Author's note*: non-English quotes have been translated by S. Muñoz Viñas unless otherwise stated)

Ruskin and Viollet-le-Duc are considered by many authors to be the first true conservation theorists. In the case of Ruskin, this is quite a paradox, because he emphatically believed that restoration was 'a lie'. However, they have become icons of a sort, symbolizing two extreme attitudes about conservation, from the most restrictive to the most permissive. Later theorists have oscillated between these extremes, with some added principles thrown in. This is the reason why Ruskin and Viollet-le-Duc are so often

remembered and quoted: their ability to clearly represent two very distinct attitudes when contemplating a conservation object.

These extremes are very well defined. For Ruskin, the signs of history are one of the most valuable features of the object. They are a part of the object itself, and without them, the object would be a different thing, thus losing an important element of its true nature. On the other hand, for Viollet-le-Duc, the most perfect state of a conservation object is its original state. Wear and tear deforms the object, and it is the conservator's duty to free the object from the ravages of time. Actually, he took this idea so far as to defend that the original state of the object was not the state it had when it was *produced*, but the state it had when it was *conceived*: not really the original state of the material object, but the original idea the artist had, or should have had, for that object.

Ruskin and Viollet-le-Duc's positions can hardly be reconciled. Conserving both an object's original state and the signs that history has left on it is not an easy task, and this is the dilemma that later theorists tried to solve. Science, the preferred method of truth determination, entered the scene quite early. It did so in a *soft* manner, if judged by present standards: the earliest manifestations of scientific conservation were scientific because the decisions were made with the aid of *soft*, historical sciences, such as archaeology, paleography or history itself. The Italian architect Camillo Boito was a bold defender of the idea of the monument-as-document, or to be more precise, of the monument-as-historical-document. He tried to be 'philologically' faithful to that document, without adding to or cancelling its actual contents. This led him to establish some principles that continue to be widely accepted today; for example, the need for original and restored parts to be clearly discernible, which allows for honest restorations of the object. Later, other principles, such as reversibility or minimum intervention came into the picture to minimize the impact conservation processes actually have on conservation objects.

Boito was only one of the many theorists who tried to find a balance between the extremes proposed by Ruskin and Viollet-le-Duc, but there were others, such as Gustavo Giovannoni or Luca Beltrami. The fact is that no single theory managed to clearly triumph over the others, which led to great divergences in the way heritage was treated by the many people involved in its conservation. To alleviate this situation, several institutions made interesting attempts at normalization. A prominent consequence of these efforts was the promulgation of 'charters', normative documents that were the result of an agreement between professional conservators and specialists. The first consequential charter was the Athens Charter, published in 1931. After this, charters were promulgated with increasing frequency and became a common way of expressing ideas on conservation. However, there is a most relevant addition to the corpus of conservation theories that did not come from a group of specialists, but from the work of an individual: Cesare Brandi.

Cesare Brandi was neither a practising conservator, nor an architect, but an art historian. He directed the Istituto Centrale del Restauro between 1939 and 1961, and in that period he became acquainted with some of the problems faced by conservators in many different fields. Brandi published his *Teoria del restauro* in 1963, an unnecessarily obscure text in which he defended the relevance of a factor that was often neglected in scientific conservation: the artistic value of the object. According to this view, aesthetic values are of foremost importance, and they must necessarily be taken into account when making conservation decisions. The 1972 *Carta del restauro* reflected most of Brandi's ideas, which were further developed by Renato Bonelli and other authors.

In the latter part of the twentieth century, these 'aestheticist' views coexisted with another significant contribution to conservation theory: what could be called 'new scientific conservation'. This new scientific conservation was more of an attitude towards conservation techniques rather than a proper conservation theory;

in fact, it lacks a solid theoretical body that precedes or justifies it. 'Hard', material sciences (chemistry and physics) play a key role in this kind of scientific conservation. However, nowadays it is a very widely accepted approach to conservation, and, as such, it deserves to be studied.

Though different conservation ideologies may well coexist in the same country or region, some rough, blurred patterns can be perceived: new scientific conservation has taken a slight precedence in Anglo-Saxon countries, while in Mediterranean and Latin-American countries, artistic-value-based approaches are somewhat favoured.

In any case, critical or alternative thoughts have developed since the 1980s. These thoughts are disperse and are often produced in fragmentary form. They can be detected in many different forms: as isolated articles, as communications, as by-products within larger works, on the Internet, in personal communications, in charters, in conservation reports, etc. Nevertheless, these fragments do respond to a trend, and, if adequately gathered together, they produce a larger, more coherent and far more interesting picture. This picture is developed throughout this book. It is the contemporary conservation theory mentioned in the title: it is contemporary not only because it is different from 'classical' theories (all those that preceded it, and to which it is in some ways opposed), but also because it is quickly becoming a preferred conceptual tool for decision-making used by an increasing number of people in the conservation world.

Issues in the definition of conservation

Too many tasks

'Conservation' is a well-known notion. Most people use it correctly and opportunely, in the right context. However, using it

appropriately in a conversation or text does not necessarily imply its thorough understanding, in the same manner that knowing how to swim does not imply a thorough understanding of the Archimedes principle. In order to gain a deeper understanding of an activity, be it swimming or conservation, a different reflection than that required for performing it is usually required. This is particularly true in conservation, where language often leads to confusion. As Daniel McGilvray has written:

> There are literally dozens of terms that are used rather inter-changeably to describe various activities and projects. This has led to a great deal of confusion (...) as to the meanings, whether apparent or hidden, we express or imply by our use of terms. (McGilvray, 1988)

After just a 'quick perusal' of an issue of *Preservation News*, McGilvray found no less than 32 notions used to describe a variety of conservation-related actions with regard to historical properties, each one possessing its particular set of unique hues and under-tones: preservation, restoration, rehabilitation, revival, protection, renewal, conversion, transformation, reuse, rebirth, revitalization, repair, remodelling, redevelopment, rescue, reconstruction, refurbishing and so forth. McGilvray is speaking about building conservation only, but things get even worse when speaking about the broader field of 'heritage' conservation, where the use of terms is even less uniform. The many possible meanings that can be attached to the basic notion of conservation are an important obstacle to any reflection regarding this topic, thus requiring some preliminary definitions of, at least, the basic category of conservation and some of its most important derivatives.

Too many objects

In the second half of the twentieth century, conservation experienced a notable growth in developed societies, and it is now a

socially recognized activity, which is taken for granted by most people. A corpus of specialized knowledge has been produced around it, and it has in fact gained university-level recognition in many countries. Conservation laboratories have been established in every major museum, and the results of conservation are frequently announced, anticipated and celebrated – or discussed – by many people. However, perhaps the most important sign of that expansion has been the exponential growth of its field of action. The category of *conservation objects* seems to have no limit: From paintings to rocking chairs, from buildings to garments, from statues to photographs, from motorcycles to corpses. From a theoretical point of view, this growth poses some problems, as it makes it even more difficult to find a rationale behind that category.

Too many professionals

As conservation is a complex activity, it may involve many different professionals from many different fields working towards the same goal. The conservation of an altarpiece, for example, can ideally require one or more historians, one or more photographers and probably a team of video or filmmakers, if the altarpiece has some public relevance. If it is not an extremely small one, a scaffold is also needed, which must be built according to some special specifications. In addition, working on a scaffold involves safety issues, for which there are specialists who must be consulted: firemen who must supervise the scaffolds, electricians who have to guarantee electrical networks, etc. The people in charge of the altarpiece have to be consulted regarding the available working time, and other circumstances: if it is located in an area of public access, provisions must be made to allow the public to safely visit the area. In this case, announcements have to be made; signs have to be put up, and press releases have to be delivered to the media. Of course, contracts must be discussed and agreed upon, which involves lawyers and

other clerical workers. Insurance agents also play a role, since in these cases an insurance contract is strongly advisable, or even mandatory. Private security agents have to be hired to prevent an important source of damage: human vandalism, or simple human curiosity. Scientists from different fields also play a role in this process. In addition to historians, biologists might be needed to identify wood-eating insects and various kinds of woods; radiologists to X-ray relevant parts to inform about the presence of metal pieces; chemists to help determine the nature of some of the many components of the altarpiece; physicists to take precise measures of colours; engineers to aid in designing a stable structure to avoid future structural damage of the altarpiece, etc. So many people and so many points of view require an enormous amount of co-ordination, which, in turn, requires administrative support at different levels. If the work is important, it will probably require additional bureaucratic processes, and heritage technicians from different administrations will have to supervise the whole project.

There are conservators, too, but the fact remains that conservation as usually understood is not just performed by conservators. The profession of conservation is not equivalent to the general activity of conservation: 'conservators' conservation' is not equivalent to conservation in a general sense. Conservation, in this broad sense, has diffuse boundaries, since it may involve many different fields with a direct impact on the conservation object. The profession of the conservator, on the other hand, is a much more precisely defined activity: it deals with some very specific technicalities, while non-conservators' conservation deals with other technicalities within many varied fields (law, tourism, politics, budget-allocation, social research, plumbing, vigilance systems, masonry, etc.) (Figure 1.1).

Two key features of the conservation profession are its closeness to the conservation object and its specificity. Conservators are

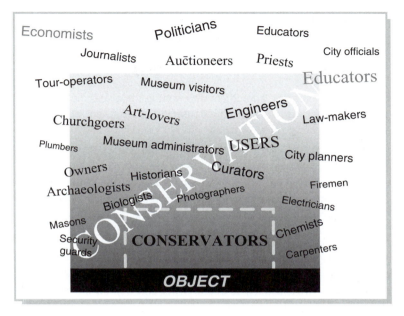

Figure 1.1 The conservator's domain within the larger, undefined conservation field

usually in very close contact with the object, in close physical proximity. Admittedly, conservators may occupy other positions that, while not being in direct contact with conservation objects, may have a strong impact on those objects: for example, a heritage management position or the management of a conservation centre. This is becoming more and more frequent and is undoubtedly positive, not only because it means that conservators are receiving a higher level of education (and this education is becoming more and more acknowledged among political, academic and social agents), but also because they often have a useful, more direct view of conservation issues than non-conservators. However, these managerial activities can only be considered to be actual conservation practice to the same extent that the management of a hospital can be considered to be actual medical practice.

The specificity of their knowledge is another key feature of conservation professionals. As Clavir has put it:

> The phrase "conservation professional" is sometimes used instead of "conservator" as it includes conservation scientists, conservation administrators, and others who work in the discipline but who are not necessarily performing conservation treatment of cultural property (...)
>
> The conservation of historic objects and works of art has developed into a distinct professional occupation. A conservator is different (...) from colleagues in allied museum fields. Conservation differs from other museum disciplines in such fundamentals as philosophy and qualifications, and, at the same time, conservators themselves share much in common, even internationally. As a relatively new occupation, conservation exhibits most of the traits of a profession and can certainly be said to be well into the process of professionalization. Conservation has its own codes of ethics (which are similar from country to country), its own training programs, a sense of duty to public service, and public acknowledgement of expertise. In many countries the field of conservation has articulated criteria for accepting individuals into the profession. These criteria include a common understanding of what constitutes knowledge, a common understanding of what constitutes an advancement of that knowledge, and the means for sharing that knowledge. (Clavir, 2002)

Simply put, conservators have a strongly specific knowledge, which is not applicable outside of their field. Professionals from other fields may play a role in conservation processes, but the fact that they are working within the conservation field does not convert them into actual conservation professionals. The field of the professional conservator may thus be represented as a domain inside the larger, more undefined field of conservation.

As shown in Figure 1.1, conservation in its general, broader sense has more undefined boundaries the farther it gets from the physical object. The conservators' field of operation has very precise boundaries and is very close to the object; other professionals,

such as lawyers, accountants, engineers, firemen, etc. populate the conservation area, although their fields of operation are not well defined; in fact, many of them are on the undefined, blurred boundaries of the conservation zone. The medical comparison might again be helpful in understanding this relationship: the role of professional conservators within the general conservation activity is similar to that of physicians, or even that of surgeons, in the general *health* activity – in which many different professionals (lawmakers, food engineers, catering industries, chemists in pharmaceutical labs, politicians, nuclear physicists, cooks, etc.) have strong impact, while not being doctors *per se*.

The dichotomy between conservation and the conservators' profession may lie at the heart of important misunderstandings, especially when a rigorous analysis is intended. For example, the American Institute for Conservation (AIC) defines 'conservation' as 'the profession devoted to the preservation of cultural property for the future' (AIC, 1996), thus ruling out all those involved in conservation except the conservators. At the same time, the Washington conservation Guild (WCG) defines conservation as 'the preservation and maintenance of culturally significant objects' (WCG, s.d.); for them, conservation is a general activity, in which many different people from different professions are involved at many levels. When speaking of 'conservation', the WCG and the AIC refer to quite different things.

Conservators' conservation

The intention of this book is to explain and revise the underpinnings of the kind of conservation that is mainly, *but not exclusively*, developed by conservators. It is interesting to note that the notion of conservation-as-an-*activity*-dealing-with-culturally-significant-objects includes the notion of conservation-as-a-*profession*-dealing-with-culturally-significant-objects, so that

theoretical principles that apply to the former will necessarily apply to the latter as well.

In order to provide a clear understanding of the text that follows, some definitions are examined, established and adopted. As has been pointed out, there are many notions that describe different conservation activities whose differences are sometimes very subtle (refurbishing, rehabilitation, renewal, rebuilding, restoration, etc.). Fortunately, as McGilvray has put it:

> We really have only three alternatives in dealing with an existing historic resource: we can *keep* it, we can *change* it or we can *destroy* it. (A fourth alternative, to return a historic resource, involves a decision to recreate something that was previously destroyed.). (McGilvray, 1988)

This book will concentrate on three of these basic options, the obvious exception being that of 'destruction'.

A note on the use of the terms

Even when it has been made clear whether 'conservation' refers to an activity or to a profession, another potential source of confusion exists when referring to 'conservation', since this term can be understood in both a broad and a narrow sense:

- 'Conservation' in a narrow sense: conservation as opposed to 'restoration'; the *keep* activity described by McGilvray.

- 'Conservation' in a broad sense: conservation as the sum of the activities included in sense 1 plus *restoration* and other possibly related activities.

The confusion is heightened because, in Latin languages such as Italian, Spanish or French, 'conservation' in the broad sense translates as 'restauro' (Italian), 'restauración' (Spanish) or 'restauration' (French), so that translations from these languages

to English, and vice versa, are often imprecise. Things get even worse because some authors and organizations use different expressions as synonyms of 'conservation' in the broad sense, such as 'preservation' or even 'restoration'.

In any reflection upon conservation, even more so in any *theoretical* reflection, the clear and consistent use of terms is a must. When common-language expressions do not allow for the required level of precision, some conventions are established to allow for a coherent discourse. For example, in the documents from the European Conservator-Restorers' Organization, the European Network for Conservation-Restoration Education, or the United Kingdom and Ireland's National Council for Conservation-Restoration the expression 'conservation-restoration' is used to refer to 'conservation' in the broad sense. AIC uses the term 'stabilization' to refer to conservation in the narrow sense. Throughout this essay, two simple rules have been followed:

- The term 'conservation' is used to refer only to conservation in the broad sense.

- The term 'preservation' is used to refer to conservation in the narrow sense.

Of course, when other authors have been quoted, these rules do not apply, as quoted texts have been maintained as originally written by their authors.

Preservation and restoration

Preservation

Beyond the heritage field, 'preservation' means to keep something as it is, without changing it in any way: retaining its shape, status, ownership, use, etc. This general meaning is maintained when speaking of heritage preservation, which could be provisionally

defined as 'the activity that avoids alterations of something over time'. This apparently neutral idea is not entirely innocent, because it mandates that any preservation activity must be successful to actually qualify as preservation. A treatment that does not avoid alterations will not qualify as preservation – which would rule out many, if not all, preservation processes carried out throughout history: preservation processes can, at best, slow down alterations, but in many cases, preservation has *accelerated* the alteration of the objects it has been performed upon: the use of cellulose nitrates and acetates in paper conservation, the use of polyethyleneglycols in archaeological conservation or the use of adhesive tapes on documents are some examples of stabilizing processes that not only did not achieve their goals, but unfortunately even had negative effects on the objects they were intended to conserve. However, they are still considered to be preservation – failed or bad preservation, admittedly, but still preservation.

Preservation is more perfectly defined not by its effects, but by its goals. Denis Guillemard, for instance, offers a concise example of this approach: 'La conservation se donne pour objectif de prolonger l'esperance de vie des biens culturels' (Guillemard, 1992) ['Preservation has the goal of extending the life expectancy of cultural heritage']. The AIC offers a similar definition of 'stabilization': 'Treatment procedures intended to maintain the integrity of cultural property and to minimize deterioration' (AIC, 1996). Goal-based definitions are preferable because they do not rule out failed preservation treatments, and they better coincide with the notion of preservation as it is commonly understood.

Restoration

'Restoration' is another commonly accepted notion in the conservation field. In a general sense, to restore something means to

return it to a former state. The 1801 edition of *The Shorter Oxford Dictionary* defines restoration as: 'The action or process of restoring something to an unimpaired or perfect condition'. This definition is typically fact based and presents the same problems described in the preceding section: if a restoration fails to return an object to an 'unimpaired', 'perfect' state, it will not qualify as restoration.

The problem with this criterion is that it rules out most actions that are commonly understood to be restorations, since very few of them actually manage to, or actually intend to leave the object in perfect condition. Just as was the case with the notion of preservation, goal-based definitions are more appropriate. The authors of the *Shorter Oxford Dictionary* seemed to reach this same conclusion, since in its 1824 edition 'restoration' was defined as 'the process of carrying out alterations or repairs with the idea of restoring a building to something like its original form' (Kosek, 1994). Although it only refers to buildings, this definition is far more efficient than that of the 1801 edition of the text, because as it is goal based, it does not exclude restorations that do not achieve the goal of returning the object to the state it had when it was originated.

This definition, however, emphasizes that the object is restored to its 'original' state, which is not always the case: not only can the notion of original be quite problematic (many objects have been elaborated by different authors over time), but the objective of many restorations is only to attempt to return the object to a better, less damaged state. It would be preferable to talk about a 'preceding' state, which may not be the state the object was in when it was originated. This is the idea behind definitions such as that of the Museums and Galleries Commission, for which restoration is 'all action taken to modify the existing materials and structure of cultural property to represent a known earlier state.' (MGC, 1994)

Throughout the twentieth century, goal-based definitions became more and more common, but fact-based definitions did not completely disappear. Fact-based definitions can be viewed as the result of an excess of optimism, while goal-based definitions are a quiet acknowledgement of the limits of current conservation techniques, and thus, as a more mature view of the field.

Preservation and restoration act together

No matter how precisely defined at a theoretical level, in actual practice, preservation and restoration are often two consequences of the same technical operation. Painted canvasses often lose strength over time, which increases the risk of tearing. To solve this problem, conservators usually reline the canvas, adhering a reinforcement material to its back. This is a preservation operation, as it helps to keep the painting as it is now by dramatically reducing the risk of tearing. However, the lining of a painting also takes it back to a state when the canvas was flat and terse on the frame, thus bringing it closer to the 'perfect', 'unimpaired' state mentioned in the 1801 edition of *The Shorter Oxford Dictionary*. Similarly, paper sheets often lose physical strength and resistance over time: the cellulose oxidizes and its average degree of polymerization decreases, causing the weakening of the sheets. In these cases, a typical preservation treatment consists in the washing of the sheets. This way, paper is re-hydrated and the number of hydrogen bonds between the cellulose chains is increased. Also, water-soluble degradation by-products, which also accelerate chemical reactions inside the sheet, are dissolved away in the wash. However, as these by-products can also cause the discolouration of the sheet, another noticeable consequence of this treatment is that the sheets often have a whiter appearance, which is very likely to be closer to the original. Furthermore, when the sheets are dried, techniques are applied to keep the paper from wrinkling, so that the sheets come out of the treatment as flat sheets. Thus, the washing of paper sheets, primarily a preservation

technique, also has unavoidable restorative side effects: technically, it is not possible to perform the elimination of degradation products in the paper without reducing its discolouration.

Restorative side effects of this kind are very common, but the overlap between preservation and restoration is even greater because preservation very often relies upon the restoration of some qualities of the conserved object. For instance, injecting an adhesive into a crumbling *intonaco* helps to preserve it because it restores its cohesive strength. Impregnating a weakened wooden chair with a consolidant, or laminating a poster, are also useful preservation processes because these objects are given back the strength they lost at some point in their history. Had these features of the objects not been restored, no preservative effect would have been produced. In this sense, preservation and restoration are comparable to a pair of Siamese twins who cannot be separated; each one relies on the other to continue living. This inherent mutual dependence is another important reason for preservation and restoration to be regarded as parts of the same activity.

Preservation and restoration are different

Even if preservation and restoration act together and have extremely close technical ties, these two notions still seem to be distinct concepts, each possessing its own nuances and connotations. Both trained and untrained speakers or readers, who use them fluently in everyday life (and usually in non-interchangeable ways), can distinguish them quite easily. This fact demonstrates that these two notions are not just different, but also useful; and that a criterion exists that allows people to distinguish them.

However precise, this criterion is not evident. In fact, it is not present in goal-based, academic definitions (such as those examined above), which do not explain the intricacies that lie behind the normal use of these notions. Preservation often works because

some qualities of the object are restored (strength, elasticity, chemical stability, etc.); thus, from a theoretical point of view, many preservation treatments should be understood as forms of restoration – but they are not. For example, the reinforcement of a wall, the substitution of a stronger metallic frame in a painting, the de-acidification of an acidified eighteenth-century military coat, are all operations that actually *restore* some qualities of the treated object, but they are still considered to be preservation by most people. Even if it is argued that the first goal of these operations is to keep the object as it is, any conscious conservator knows that they do not leave the object as it is, but actually improve some of its features, restoring them to a state that is closer to the original one.

The goal of the activity is not the crucial criterion behind common-use notions of preservation and restoration. Rather, the crucial criterion behind common-use notions of preservation and restoration is the *noticeability* of the action. What the speaker unconsciously considers before using one of these notions is not whether the action was done in order to restore something or not, but whether it has produced (or is expected to produce) *noticeable* changes in something. In this sense, 'noticeable' means 'noticeable by regular observers under normal conditions of observation or use': simply put, 'restored' objects do not look like they looked before, while 'preserved' objects do.

This criterion is not absolute, as some less relevant features of a preserved object may noticeably change for technical reasons. However, it is very valuable, as it provides a solid yardstick to measure one concept against the other. Preservation could thus be defined as the action intended to keep the perceivable features of an object in their present state for as long as possible – a goal which is usually achieved by modifying some of the object's non-perceivable features. In contrast, restoration can be defined as the action that attempts to modify an object's perceivable features.

Curiously, this idea underlies the 1824 edition of the *Shorter Oxford Dictionary* definition, because it recalls that 'form' is what is restored – not the inner structures, nor the original materials or functions. Form is a highly perceivable feature of buildings (the objects this definition refers to), and the fact is that preservation attempts to change the non-perceivable features of an object, while restoration attempts to change the noticeable features of that same object. It could be said that preservation often attempts to restore the unnoticeable: restoring the strength of a marble piece, for instance, would be understood to be preservation, while restoring the varnish of a piece of furniture would be understood to be restoration. Of course, sometimes preservation can be noticeable: the reinforcements in the Colosseum of Rome are perceived by visitors; and a new, metallic frame behind a seventeenth-century painting can easily be distinguished from the original wooden one. However, the perceivability of these modifications affects the less relevant parts of an object and is unwanted: it is the result of technical circumstances and is avoided whenever possible.

Preventive and informational preservation

Preventive preservation

Preservation can be performed in such a way that neither perceivable nor unperceivable features of the object are altered in any way. This kind of preservation is often called 'preventive conservation.

Though frequently used, the notion of 'preventive preservation' is quite ambiguous. In many cases, it has been defined as the branch of conservation that attempts to avoid damage before it ever happens at all. This idea is quite clear, and because of this, also widespread. However, it is not free from problems, because most preservation activities, whatever their nature, do attempt to prevent

future damage. When a conservator has to perform any preservation treatment upon an object, the future stability of that object is necessarily cared for. For instance, the consolidation of a corbel may cure its weakness, and it also prevents its, otherwise unavoidable, crumbling apart; and the elimination of insects in an infested wooden sculpture by fumigation not only cures the present problem, but it also prevents the damage that those insects would surely have inflicted upon the artwork. In other words, most, if not all, preservation activities have preventive effects, or even, aims: there is no such thing as 'non-preventive preservation'.

However, as is the case with 'preservation' and 'restoration', most speakers know how to distinguish between preventive preservation and the other forms of preservation. This again suggests that there is some rationale below the surface of the words. In this case, preventive preservation can readily be recognized because of its methods. Other forms of preservation imply a change in the object, while 'preventive' preservation implies a change in the object's environment. In the other forms of preservation treatments, the object is treated through 'direct' action (it can be brushed, coated, fumigated, de-acidified, lined, reinforced, put together, sandblasted, immersed, etc.) – this form of preservation has thus been called 'direct preservation' (Feilden, 1982; Guillemard, 1992), a term that will also be used in this essay. In 'preventive' (or 'indirect') preservation treatments, the object is not touched, but left in a different environment. This environmental change can take many forms: a new case, a new location, a new frame, a new light source, a new protective glass, a new relative-humidity control system, an exhibition room with reduced public access, a space-age oxygen-free chamber, etc. In all cases, it is the object's circumstances that change and not the object. Admittedly, the object itself may change as a result of these measures: a curled parchment, for instance, may become flatter in an appropriate environment, as it might become flatter after an appropriate direct preservation or restoration treatment.

However, it is the means, and not the effects, that makes the difference. Preventive preservation uses techniques that concentrate on the surroundings of the object and not on the object itself, while direct preservation acts by changing some features of the object itself, usually restoring some of its less perceivable features (internal coherence, pH, tensile strength, etc.). Preventive preservation could thus be appropriately called 'environmental preservation'. In this text, the term 'environmental' preservation is used to describe this activity.

There is yet another criterion that may help to establish a clearcut difference between direct preservation and environmental preservation: the duration of the action. Direct preservation is performed within a limited time frame; environmental preservation is performed over a theoretically unlimited time frame. The process of (direct) preservation of a mediaeval metal helmet, for instance, is usually performed by conservators within a given period of time: the helmet is handed over to the conservator at a given time, the treatments are performed, and the conservator returns the conserved object some time later. The preservation process ends at that moment. Environmental preservation, however, is a continued, theoretically endless process. Furthermore, even if the process is designed, implemented and monitored by a conservator, most of the time no conservator is actually required for the actual preservation of the object to take place.

Informational preservation

Among the many conservation-related terms in common use nowadays, none describes an emerging category in the field of preservation that is based upon the production of records, which can then be used by the observer to experience the object virtually. For example, the digitization of the documents in an archive permits historians to study them without even touching the original

manuscripts, which are safely kept in their repositories; and the use of a replica of the sixteenth-century *Bacchino* in Florence's Boboli gardens allows it to be safely stored away, while many visitors continue the tourist ritual of slapping their hands on the statute's belly. This form of preservation is currently strongly linked to photography and new digital technologies, but it also includes more traditional processes, such as the substitution of valuable original sculptures or even the manual copy of valuable documents. All of these techniques allow many observers to access some of the most important contents of the original object without any risk to it. These techniques could be properly called 'informational preservation', since they preserve part of the information contained in the object (the text, the shape and the look), but not the object itself.

Informational preservation techniques certainly have positive effects for the preservation of the objects. The duplication of objects allows the observer to access and enjoy some features of the object, without the need for the object to be there, thereby reducing the risks to the objects by reducing their exposure to potential sources of damage. As a consequence, the duplication of objects has an impact on their preservation, which has led some conservators to acquire a working knowledge of digitization or photography.

However, informational preservation must be approached with caution, as it does not necessarily mean an improvement in the actual preservation of the object, for two main reasons. First, producing replicas of the objects does not guarantee that the original objects will be safely kept: this, in turn, requires actual environmental preservation techniques. Second, in some cases the replicas, which are produced with newer techniques and materials, can last longer than the originals: as the most interesting information is already safely recorded, original objects can in fact become more dispensable for some people.

Informational preservation gained momentum in the last two decades of the twentieth century and is likely to continue to gain relevance. However, the fact that it only preserves a part of the information contained in the object should not be ignored: informational preservation only helps in the preservation of the object itself in the indirect ways described above. It is also interesting to note that the knowledge required for performing informational preservation is usually different from that of the conservator. It is closer to that of photographers, modellers, carpenters or even computer specialists. In this sense, informational preservation could be viewed more as a conservation-related activity (such as effective fire protection, public education or security measures in museums), than as a branch of the conservation profession (such as direct preservation, restoration and, very often, environmental preservation).

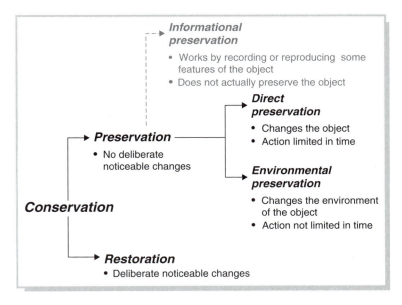

Figure 1.2 A classification of activities within the conservation field

The objects of conservation _____

Defining conservation and its related activities is useful, but it is not enough to understand the activity. The objects of conservation (the things upon which conservation activities are performed) play a key role for conservation to be what it is. From artworks to cultural heritage, from archaeological objects to antiquities, conservation has dealt with objects of very different kinds since its inception in the eighteenth century. In this chapter, the category of conservation objects, as currently understood, is examined and discussed, showing the rationale behind the crucial category of conservation objects, that is, revealing what makes a common object become a conservation object.

What shall be conserved?

The Mustang paradox

Conservation and some related activities have been defined, discussed and redefined in Chapter 1. While these definitions reveal some of the intricacies related to conservation practice, they still need further refinement. Giorgio Bonsanti explained why in an effective and concise manner:

> Se una sedia si rompe, viene riparata. Se la sedia è del Brustolon, viene restaurata. (Bonsanti, 1997)

27

[If a chair gets broken, it is repaired. If the chair was made by Brustolon, it is conserved.]

This constitutes a modest paradox: the same set of actions (gluing, varnishing, substituting damaged parts, eliminating insects, etc.) performed on two different objects may be considered as either carpentry or conservation. This proves that in order to precisely and effectively define conservation, the mere description of the activity or its aims is not enough: the object of that activity plays a crucial role in our understanding of these notions. For an action to qualify as conservation, it must be performed upon a certain kind of object.

This 'Brustolon paradox' has been taken a step further to become what has been called the 'Mustang paradox' (Muñoz Viñas, 2003). The Mustang is a World War II fighter airplane that played an important role in air combats all over Europe and the Pacific. Mustangs soon proved to be a formidable weapon, and, like any other weapon, they were carefully repaired when required: electric cables were replaced, screws were tightened, metal panels were flattened and reinstalled, insignia were painted and repainted, control systems were calibrated, and so on. Some years after the war, these planes became obsolete. Many of them were sold to private companies and individuals, who used them in many different ways. Some were modified and used as airplane racers; others were dismantled for their parts; others were adapted for use in movies; others were used as private planes; while still others were simply stored or forgotten in the darkest areas of remote hangars, never to be flown again. However, some decades later, an increasing number of Mustangs began to be reconditioned: electric cables were replaced, screws were tightened, metal panels were flattened and reinstalled, insignia were painted and repainted, control systems were calibrated – just as they were in the 1940s. However, now this activity was considered to be conservation: the Mustangs were not just being 'maintained' or 'repaired', but rather 'preserved' and

'restored'. The 'Mustang paradox' proves that the same activity can qualify either as conservation or as maintenance/repairing/servicing even if it is performed upon the very same object.

The evolution of conservation objects

Since its inception, conservation has not only reacted to theoretical and social needs by adapting its techniques and principles, but also by redefining its field of operation. The evolution of this aspect of conservation from the very restricted category of 'artworks' to the overly broad notion of 'heritage' is especially interesting, since it provides a glimpse of the tensions that can arise when theory and practice do not coincide.

The beginning of conservation, as we know it today, took place in the eighteenth century. The rules dictated by Pietro Edwards can be considered as the first consequential example of a behaviour that has since evolved into the complex social need we now call conservation. This conservation-conscious behaviour leads to treating certain objects differently from the rest, preventing their 'normal' use: conservation objects are not allowed to evolve in the same manner as common, non-conservation objects, nor can they be repaired, updated or trashed as are most non-conservation objects. The *Capitolato* is very interesting in this sense for what it says, but it may be even more interesting for what it does not say. It shows how to behave, but not the reasons for that behaviour, thus initiating a trend that has been largely followed since then. It refers to artworks, but not to other kinds of objects, perhaps suggesting that only artworks deserve the kind of special care we now call conservation.

Since the Renaissance, many objects from classical times have been appreciated with special reverence by cultivated

scholars – though not by the rest of their contemporaries, who would freely use pieces from abandoned old monuments to build their own housing. The 'chambers of wonders' in the mansions of educated noblemen not only included rare natural samples or delicate mechanical toys, but also old statues, jewels or pieces of pottery from countries such as Egypt, Greece or Rome. These latter collectibles were not 'wonders' or 'curiosities' but 'antiquities', a notion which, in turn, has been used to describe early conservation objects.

'Antiquities' and 'artworks' are notions that gained positive connotations in the nineteenth century, with the rise of the 'artist' as individual genius and the appearance of nationalisms (with their anxious search for the roots of each nation). Objects of this kind became particularly respected, and special care was devoted to them. Slowly, they ceased to be repaired, serviced or updated and began to be *restored*. On the other hand, the rise of science as the preferred method for discovering and establishing truths led to the appreciation of archaeological objects as evidence for historical sciences; as such, these objects had to be preserved in a manner that would not hide or deform the information that each one of them conveyed. This way of perceiving objects as evidence soon permeated other conservation fields and has remained a key notion since that time. The category of 'historical objects', which is a frequently used notion to describe conservation objects, partially reflects these views.

In the twentieth century, a wider category made its appearance: that of 'cultural heritage'. 'Cultural heritage' came to complement, and more often to replace, preceding notions, although it includes *intangible* heritage, such as traditional dances, languages, handicrafts or religious rituals. The general notion of 'heritage' is even broader, as it includes non-cultural heritage, such as forests, landscapes or animal species.

Problems of traditional categories

Many different terms are used by different people and entities to describe the objects of conservation: the terms 'heritage', 'cultural heritage', 'cultural property', 'historic objects' or archaeological objects', 'artworks', or 'antiquities' are common examples. This lack of agreement, as to how to describe the category of conservation objects, proves that no notion is fully satisfactory or clearly superior to the other ones. In fact, all of them present conceptual problems, and none is fully coincident with the objects that actual conservation deals with.

Art, archaeology and antiquities

The idea that conservation deals with artworks, for instance, has remained in use for many years, and to a certain extent it still pervades many reflections on this topic. Indeed, it is still present in the notion that the general public has of conservation: for many people, the idea that the word 'conservator' conjures up is that of a person in a white coat unnaturally bent over an easel painting, applying small brushstrokes with a thin brush, perhaps in the solitude of a dark studio, surrounded by magnifying glasses and a number of bottles of different sizes. This is not surprising, since the idea that artworks are the objects of conservation is certainly in the historical origin of the current notion of conservation. However, it presents two important problems: defining what is art and what is not art may be very difficult; and even if a precise description were reached, it would not describe the objects of conservation.

'Art' is a noun, but in normal use it often works as an adjective, as it almost automatically implies a value judgement. For instance, a bad painting may not be considered to be 'art' at all, and a nice basketball move may be considered to be a form of 'art'. In this

sense, the notion of art is not adequate to define conservation objects. A more precise notion of art could be used instead; for example, one that is based on classical artistic genres. Such a 'restricted' notion would include both classical and contemporary sculptures, buildings or paintings and it could perhaps be broadened to include photographs, furniture, prints or decorative objects; however, it should be taken into account that the broader the notion is, the more blurred its boundaries become. Even if the notion of art were extended so as to include *every* sculpture, painting, building, piece of furniture or print, the 'art' category would not cover the full variety of things that are presently conserved and/or restored. Nowadays, locomotives, pottery fragments and written documents are common objects of conservation, but they can hardly be considered to be art. If they were to be, the problem would be in trying to define what is *not* art.

Both conservation and art have experienced important changes in the last two centuries. As a consequence, while it may have proven useful in the beginning, the notion that conservation deals with artworks only (or even mainly) is outdated. A contemporary theory of conservation cannot limit itself to this idea, and this is a problem that underlies many efforts, even relatively recent ones, such as Cesare Brandi's *Teoria del restauro*.

The notion that conservation deals with archaeological objects is similarly flawed and is just as outdated. In fact, when, in the eighteenth century, Winckelmann published what is considered to be the first text of 'history of the arts' as such, he dealt mainly with classical Greek and Roman artworks, which might also be considered as archaeological objects. However, archaeological objects are also difficult to define. In a strict sense, an archaeological object is any evidence that helps us to know extinct civilizations and cultures: in this sense, the objects of conservation would be those that are useful for archaeologists, or, to be more precise, those that are useful for increasing archaeological knowledge.

While quite clear-cut, this notion is not synonymous with that of conservation objects: there are many examples of things that are conserved and/or restored which cannot be considered to be archaeological. A family heirloom (perhaps a rocking chair), or a painting by a living contemporary author, might be the object of a conservation operation, but it can hardly be considered as an archaeological object.

For many people, however, archaeology is more a historical method than a discipline; it is a method that is based on the analysis of material remnants from the past. Traditionally, archaeology has been closely linked to prehistory, where it plays a crucial role, and to the study of ancient civilizations. However, archaeology, as currently understood, is a broader discipline than it used to be. It now refers to recent civilizations as well as to remote ones. Archaeology studies the Aztec civilization, but it also studies the ravages of World War II; it studies daily life in classical Athens, and also the lives of workers in nineteenth-century Manchester. From this perspective, a rocking chair might well be considered as a 'recent' archaeological object.

However, the actual fact is that very few family rocking chairs are actually studied by archaeologists. They are still considered as conservation objects, which should prove that conservation does not deal with archaeological objects only.

It could be argued that an archaeological object is not just an object that has been used as historical evidence by archaeologists, but that it is also an object that *could* be used as historical evidence by archaeologists. However, every single object *could* become a piece of archaeological evidence in the future. Many common-life objects can become a valuable source of information in the future if most other sources happen to disappear – as is the case with many common pottery pieces that are painstakingly gathered, recorded and studied by archaeologists. Through careful

examination, sophisticated analysis techniques, and the collation of data, these pieces provide valuable information about many aspects of ancient human groups. Knowing how an object was produced can tell the archaeologist about the technologies that were available to that group; analysing the shape and size of the pot can reveal information about the way of life of a particular people; a comparative study of decorations and morphologies can suggest if, and with whom, economic exchanges were made; a technical analysis (carbon dating, thermoluminescence analysis, pollen analysis, etc.) can allow the dating of remnants, and thus, that of their originators. The collation of data further refines that knowledge, which can then be appropriately recorded for use by future researchers.

Nevertheless, the same might be said of most contemporary common-life objects. An ordinary beer can actually become extremely valuable evidence for a future archaeologist, given some (probably unfortunate) circumstances. Surely, no one expects these circumstances to happen, but then again no one in the ancient groups whose everyday objects are so greatly appreciated today by archaeologists expected their groups to disappear. Even if other, more impressive remnants survived, a beer can would probably be more informative about our present way of life than, for example, a Calder sculpture. However, if the notion of archaeological is interpreted in this *potential* sense (if any object that *could* be useful for archaeologists is considered as an archaeological object), it becomes far too broad to describe conservation objects, as it can then be applied to every single man-made object.

The idea that it is 'antiquities' that are conserved and/or restored creates similar problems, as it is obvious that not every conservation object comes from the ancient past – from antiquity. It could be argued that conservation actually deals with 'antiques', that is, with aged objects 'from an earlier period', as the *Collins Dictionary* suggests. However, it is not clear how much earlier that period

must be. A computer could be considered an antique at just 20-year old – while the Guggenheim Museum in New York, which was built in the 1950s, is far from being an antique. *Antiqueness* cannot be defined simply by age.

Some people consider that an antique is something that has become obsolete, but this is not true in many cases. A Vermeer painting, for instance, is still able to produce strong aesthetical emotions to many Western-educated spectators, and it is more than three-centuries old. Also, a Gothic church may still be working as such 600 years later. They can be considered as antiques, but they are not obsolete. Furthermore, there are objects of conservation that are neither obsolete nor old, such as modern artworks: a print or a sculpture by a reputed modern artist is not an antique in any sense, but it is a conservation object.

Historic works

Similar problems affect the notion of *historic work*. What is a historic work? A natural answer would be: an object that is useful to historians, an object which helps in the elaboration of historical knowledge, historical pieces of evidence. However, if this is correct, the category of conservation objects is much broader than that of historic works. Many conservation objects have never been useful to historians, nor have they been studied from a historical point of view. For example, contemporary art, personal memorabilia, even historical documents that lie in dark rooms in the city council archives of forgotten countryside villages, silently waiting to be analysed or read by someone, are considered to be conservation objects, even though they have not yet proven useful to historians.

It could be argued that 'historic' objects are those which have proved, or *might* prove, to be useful to historians. If this is accepted,

then it will have to be admitted that the category of 'historic' can be applied to every conceivable object, be it an art masterpiece, a child's pacifier, a videotape recorder or the beer can described in the preceding heading. Just as was the case with the category of archaeological objects, the notion of 'historic' object in this *potential* sense is far too broad to describe conservation objects.

Things become even more complicated because, in the common sense of the expression, there are objects that are considered clearly 'historic' while almost completely lacking value as historical evidence. The statue of Nelson in Trafalgar Square, for instance, is a historic object, but it does not provide information about Nelson himself, other than that he was an important figure for the British people – and even this information could be obtained without the statue itself. Again, a technical analysis could provide information about the casting techniques or alloy composition at the time the sculpture was produced (a piece of information that could also be obtained from many other non-historical objects, such as technical records or nineteenth-century treatises on metallurgy). True, the analysis could be used to confirm that the column was made from the iron of French cannons captured by the British hero. However, it has to be reckoned that every single object is able to provide information about itself that no other source can, so that its ability to function as historical-evidence-about-itself is not a particular feature of conservation objects.

Riegl's 'monuments'

Certainly, defining conservation as a whole is no easy task. Many classical theorists have elaborated a definition for a given kind of conservation object, and have simply ignored the other ones. As other conservation specialties gained social and cultural relevance, the problems inherent to past, narrow notions of conservation became apparent, as theorists proved unable to cope with the overwhelming variety of conservation objects and their related problems.

There is, however, one exception that deserves special attention and acknowledgement: that of Alois Riegl. In 'Der moderne Denkmalkultus' – originally published in 1903, this prominent Austrian art historian endeavoured to achieve a full understanding of conservation – of conservation as a whole, without limiting himself to a single field of specialization. Recognition is also deserved both for the outstanding quality of his reasoning and for the fact that many of the ideas proposed by the author continue to be valid or, at least, relevant today.

In this tiny masterpiece, Riegl examines the reasons why historic and artistic objects are valued. From this analysis, he suggests how their conservation should be carried out. To describe conservation objects, he used the term 'monument'. This term perhaps conjures up images of large buildings and complex public statues, but for Riegl, a 'monument' is any object with artistic and/or historic value. For him, even a paper sheet could be considered as a monument, as long as it revealed the passage of time (Riegl, 1982).

Riegl's notion of 'monument' is not free from some of the problems of the criteria for characterizing conservation objects described above, as Riegl's 'monuments' include practically every conceivable object. He was, however, fully aware of these problems. He suggested that 'monuments' are actually considered as such because we, 'modern subjects' attribute values to them – an idea that would suffice to set Riegl apart from the rest of the theorists. In fact, Riegl remained a somewhat isolated exception, as his thinking was probably too advanced for his times.

Heritage

The notion of 'heritage' became a widespread way to describe conservation objects in the last quarter of the twentieth century. However, it is quite difficult to describe what it exactly means. The 1986 edition of the *Collins English Dictionary* defines heritage

as 'anything that has been transmitted from the past or handed down by tradition', and also as 'the evidence of the past'. At first glance, these notions are perfectly acceptable. A more careful scrutiny reveals that every single object 'has been transmitted from the past' and can be considered to be an 'evidence of the past': every object becomes evidence of the past the second after its inception – and no object can have come from the future. Therefore, this idea does not help in discriminating conservation objects from the rest. More interesting still is the idea that heritage is 'handed down by tradition', because many things that are actual conservation objects are not handed down by tradition; for example, the documents in a national archive are not kept because of tradition, just as it is not a tradition to keep a particular letter from a person who someone wants to remember. These actions have become common and are repeated by many people in many places, but the fact that they are repeated does not convert them into a 'tradition', as this term is commonly understood. If this were the case, nearly every daily action should be considered to be a 'tradition': from crossing a street when the light is green to buying bread and milk. However, the milk handed down to a person in the traditional act of purchasing it does not automatically convert the milk, or even the bottle, into a piece of heritage. In this sense, the notion of tradition is far too broad.

Conservation objects have been identified with 'cultural heritage' in order to alleviate this problem. The adjective 'cultural' adds a nuance that reduces the scope of the noun 'heritage', or should do so. 'Culture' and its derivative, 'cultural', have at least two meanings that may be applied in this context: in a narrow sense, 'culture' can refer to the knowledge and tastes of cultured people; in this sense, 'culture' may be identified with Eco's 'hi-cult' or Bueno's 'cultura circunscrita'. It is the culture that is produced and valued in academic circles that is regarded as proper and valuable by cultivated people – the inhabitants of Wolfe's 'Culturburg' (Eco, 1964; Wolfe, 1975; Bueno, 1996).

In the 'hi-cult' sense of the word, not every taste, art or know-ledge qualifies as true 'culture'. Knowing the gory details of a series of murders published by tabloids would not be considered as true culture in this 'hi-cult' sense; however, knowing the evolution of the War of the Roses would be considered as such. In a similar manner, knowing the scores of a soccer team over the last 5 years (and perhaps the private lives of some of its most glamorous players) is not considered to be true culture, while knowing some poems by a long-dead poet (and perhaps some of the intricacies of the poet's private life) is culture in this sense.

In a different, broader sense, 'culture' is the sum of the beliefs, values, knowledge and uses of a social group. This sense, which may be called 'anthropological', includes every manifestation of everyday life in any social group. In an anthropological sense, culture does not imply any value judgement. There are no such things as good, bad, high, low, noble or ignoble cultures; instead, everything qualifies as 'cultural' if it clues the observer into what the beliefs and knowledge that rule a group's social behaviour are. For example, a middle-class wedding reception is no less a cultural phenomenon than a lecture on subatomic physics or a classical dance performance.

Not surprisingly, the hi-cult notion is not broad enough to cover conservation objects. For example, the hi-cult umbrella does not cover personal memorabilia, which is a category of conservation objects that rarely appears in classical conservation theories. On the other hand, the anthropological notion suffers from problems similar to those posed by the archaeological notion of conservation objects: nearly every artificial or collected object responds to cultural needs, and is thus 'cultural'. Speaking about 'cultural heritage' in an anthropological sense is to speak of everything produced or valued by a given culture. This is far too broad a category to describe the comparatively small category of conservation objects.

There is another problem that afflicts the notion of heritage. Heritage is not necessarily limited to material objects. It can include intangible heritage, and, in fact, some of the most important pieces of heritage are intangible. This kind of heritage includes, for instance, a tool that is of major importance for any group: language. Language is obviously a unique feature of humankind, and its crucial relevance in nearly every aspect of human behaviour is beyond discussion. It has permitted humankind to possess an efficient means of transmission of knowledge from generation to generation and allows for civilized argument, discussion, and poetry and, perhaps, even for thinking. However, language is also interesting if considered from other points of view that are closer to the conservation field. For instance, its detailed analysis can play a crucial role in different historical sciences by providing compelling information about the relations between ancient people and migrations – thus converting it into an important piece of historical evidence. Traditional rituals are also intangible heritage, as are beliefs, rules of behaviour and even religions. Technical knowledge and skills are also a part of this heritage; this is a phenomenon that may even get official acknowledgement, as in Japan, where some people possessing some of these skills are considered to be 'Living Treasures'. Something similar occurs in Western countries; in fact, the UNESCO World Heritage list includes some examples of intangible heritage. Some cities are well known for their intangible heritage instead of for their monuments or for other kinds of tangible heritage: the Mardi Gras in New Orleans, the Palio in Siena, the San Fermín in Pamplona, or the Carnival in Rio de Janeiro are good examples of this.

This kind of heritage can be conserved and restored by many different means. Languages in danger of extinction can be taught in schools as part of the curriculum, and providing financial incentives can encourage their use. Practitioners of ancient skills and trades that are disappearing can be subsidized in order to be able to keep doing their jobs in the old ways and teach them to others. Old

rituals can be registered and recorded, and they can be researched and then re-enacted, perhaps with economic and administrative support: permissions can be granted for the use of streets; scholarships can be awarded to researchers; politicians can support re-enactments by allocating resources; and the media can help them to be better known by more people, perhaps converting them into sources of pride for the locals and into tourist attractions for foreigners, which could, in turn, help their future continuity.

These measures and other similar ones help to avoid the definitive disappearance of intangible heritage, or to recover it from oblivion. In other words, intangible heritage is preservable and restorable. These processes, however, are not the task of conservators, but of a large range of different professionals: politicians, anthropologists, philologists, researchers, filmmakers, actors, teachers, etc. Conservators help by directly acting on tools, old pieces of furniture, old garments and similar objects: conservators work on tangible objects, although they will, in turn, be used for intangible purposes.

Being aware of this problem, some authors have proposed the notion of 'cultural property' to describe conservation objects, with 'property' being a term with a more material nuance that would rule out intangible goods (Müller, 1998). In this sense, 'property' more adequately describes conservation objects. However, since the adjective 'cultural' brings along all of the conceptual problems examined above, the resulting notion (that of 'cultural property') is still of little use in understanding what conservation objects have in common.

The nihilist turn

As the Brustolon and Mustang paradoxes demonstrate, conservation is defined by the objects it is performed upon, but it is

difficult to find a common factor in the objects of conservation as it is currently practised. It is performed upon artworks, but also on non-artworks; it is performed on antiques, but also on contemporary objects; archaeological pieces are only a part of conservation objects, as is historical evidence. To alleviate the logical and ideological problem derived from a definition of conservation objects that is too limited, new and broader notions have been adopted ('cultural heritage' and 'cultural property') which, in turn, are too imprecise and include many non-conservation objects. However, the objects of conservation may or may not be 'cultural' – except in the anthropological sense, in which nearly every conceivable object produced or collected by any social group is included.

Finding a common logical factor behind the category of conservation objects is not easy. Some authors, such as the participants in the 1992 Dahlem conference found it 'virtually impossible to define' (Leigh *et al.*, 1994). In a similar vein, Bonsanti, the creator of the Brustolon paradox, offered a definition which seems to acknowledge this same problem, as it is based more on the common use of the notion than on logical criteria:

> Il restauro allora è tale, non in quanto si applichi alla categoria delle opere d'arte, ma allorché le operazioni relative alla sua attuazione corrispondano fin dall'origine a quell'attitudine complessa, che quasi definirei un modo d'essere, fatta di quelle componenti tecniche, metodologiche, scientifiche, professionali, sospese fra tradizione e innovazione, che noi del mondo del restauro ben conosciamo e ricosnosciamo come nostre. (Bonsanti, 1997)

> [Conservation is such not because it is practised upon artworks, but because the operations involved in its development match that complex attitude – almost a way of being – which hangs halfway between innovation and tradition, and which is made up of technical, methodological, scientific and professional factors; an attitude that we, the people in the conservation world, know well and acknowledge as ours.]

The idea behind definitions of this kind is that conservation lacks a logical basis: conservation is what conservators recognize as such. Thus, it is defined as it is performed, and its use and repetition is what allows us to know and understand it.

The communicative turn

Both the answer of the Dahlem group and that of Bonsanti respond to a similar core idea: there is no clear logic behind the notion of conservation objects as it is understood in real life by most people. There is no real criterion that can explain or help to understand the conservation activity. The participants in the 1992 Dahlem conference defended this pessimistic view in a direct manner, by casting doubt upon the actual feasibility of establishing a working criterion; Bonsanti defined conservation by its actual practice and not by a logical principle preceding or availing that practice. This sort of logical 'nihilism' is not fully devoid of reason, as pure logic and reality rarely coincide in a perfect way. Looking for a logical, understandable criterion for human activities is a necessary – and sometimes rewarding – task, because it helps to understand human behaviour, much as scientists search for descriptive patterns to make the material world more intelligible. However, these searches are rarely ever finished. In this sense, pessimism about the feasibility of finding or creating a perfect logic that allows for the precise, neat characterization of conservation – and of its objects – is justifiable.

Nevertheless, scientific and philosophical progress does not exist because perfect knowledge is achieved; if it were achieved, no further progress would be possible. It exists because *improved* knowledge is achieved. While perhaps not perfect, there certainly is a more comprehensive, more perfect, improved answer as to

what makes an object become a conservation object. As some authors have suggested (Minissi, 1988; Cosgrove, 1994), this answer can be traced to the field of museology. In the 1980s, authors, such as Davallon (1986), Pearce (1989), Deloche (1985) or Desvallées *et al.* (1994) concurred in emphasizing the communicative nature of museums, and, thus, of its objects:

> La pieza tradicional del museo, un objeto, un hecho tridimensional, es solamente unos datos de la compleja información museística, de un mensaje. Nosotros no tenemos museos por los objetos que ellos contienen, sino por los conceptos o ideas que esos objetos puedan transmitir. (Šola, 1995; Spanish translation in Alonso Fernández, 1999)
>
> [The traditional museum piece, an object, a three-dimensional fact, is just a set of data in the complex framework of information generated by the museum. We do not have museums because of the objects they contain, but because of the notions and ideas that these objects can convey.]

In conservation, though, appealing to 'significance' as a feature of conservation objects can be traced back to the Venice Charter (ICOMOS, 1964), and, more consequentially, to the first version of the 'Burra Charter', which was developed and adopted in 1979 by the Australian branch of the International Council on Monuments and Sites (Australia ICOMOS). However, it was not until the 1990s that many authors acknowledged the basic relevance of communication for an object to be considered as a conservation object. This communicative phenomenon can be called 'symbolism' (Ballart, 1997), 'significance' (Australia ICOMOS, 1999; Washington Conservation Guild, s.d.), 'cultural connotation' (Vargas *et al.*, 1993), 'metaphor' (Myklebust, 1987), etc. Whatever it is called, the existence of communicative mechanisms as an essential characteristic of conservation objects became widely acknowledged in the last decade of the twentieth century (e.g. Cosgrove, 1994; Michalski, 1994; Müller, 1998; Avrami *et al.*, 2000). All of these authors, and many others

(e.g. Caple, 2000; Burnam, 2001; Pye, 2001; Clavir, 2002) came to agree that what every conservation object has in common is its symbolic nature: they are all symbols; they all communicate something.

What is a symbol?

In the broad sense, symbolism is a basic mechanism of communication that has been defined in many different ways. In the most common sense, a symbol is simply something that represents, or is thought to represent, something else; that is, three lines of a given shape represent a particular vowel sound ('A'); footprints in the snow represent an animal; or a red light means 'stop the car'.

Instead of using the word 'symbol', Charles Peirce, one of the fathers of Semiotics, preferred the word 'sign'. Thus, for Peirce, a 'symbol' was just one kind of *sign*: according to him, signs can be 'indexes', 'icons' or 'symbols', each one having a particularity. 'Indexes' work as communication because a causal relationship exists between the sign and the meaning (a column of smoke, for instance, means fire). 'Icons' work as communication because there is some kind of analogy between the sign and the meaning (a portrait, for instance, represents the person portrayed because formal analogies between both of them exist). 'Symbols', in this Peircean sense, are entirely arbitrary and work as communication only because the people interpreting them know the communication system, or code. A red octagon by a road means 'stop before continuing', and nodding the head means 'yes', while there is no causal, formal or logical reason for it to be this way. The communication is produced only because the interpreter knows that particular code, and these symbols would be meaningless, but they could have entirely different meanings for people with different symbolic backgrounds.

Peirce's classification is interesting in many ways. The same object may simultaneously work as a symbol and as an index or an icon, according to the level of significance or interpretation; for example, a Christian cross that is printed on a poster could be interpreted as a symbol of Christianity, as a burial place, or as a church. However, it is also an icon of Christ's Passion, since it presents formal analogies with the most important instrument of his martyrdom. Peirce's notions should not be identified with concrete objects, but rather with ways of conveying meanings: things are not 'symbols', or 'icons' or 'indexes'; rather, they convey meanings through symbolic, indexical or iconic processes. Objects can be named accordingly, but this is not an intrinsic feature of theirs and, in many cases, they can work in several communicative ways at the same time.

Webs of meaning

Symbols, in the broad sense, can be very strictly coded. Their meaning is usually well established and admits little deviation. A yellow triangular sign with a picture of a lightning bolt is bound to be interpreted in just one manner: 'Danger: live wires'. In this context, the lightning bolt represents the risk that electricity poses; it does not represent the existence of an electrical appliance shop or the idea of technical progress derived from electricity or the branch of sciences that studies electricity.

However, other symbols can work because of much subtler communicative mechanisms. Symbols, in the broader sense of the notion, not in the Peircean sense, have been aptly described as:

> ... any device with which an abstraction can be made. (...) The abstractions of the values that people imbue in other people and in things they own and use lie at the heart of symbolism. (...)

Almost every society has evolved a symbol system whereby, at first glance, strange objects and odd types of behaviour appear to the outside observer to have irrational meanings and seem to evoke odd, unwarranted cognitions and emotions. Upon examination each symbol system reflects a specific cultural logic, and every symbol functions to communicate information between members of the culture in much the same way as, but in a more subtle manner than, conventional language. (...) They are not a language of and by themselves; rather they are devices by which ideas too difficult, dangerous or inconvenient to articulate in common language are transmitted between people who have acculturated in common ways. It does not appear possible to compile discrete vocabularies of symbols, because they lack the precision and regularities present in natural language that are necessary for explicit definitions. (Gordon, 1998)

For something to be considered as a conservation object, it has to convey this type of 'abstract' meaning, though it may also have more precise meanings, as they also may be 'symbols' or even 'indexes' in the true Peircean sense, from which the diffuse, abstract meanings often derive. Michelangelo's David, for instance, conveys a series of ideas; perhaps the most immediate one is the idea of Michelangelo himself, which is a very precise concept. This meaning is based on a non-arbitrary, causal relationship: the statue was produced by Michelangelo, and he is the major cause of its very existence. In Peircean categories, the statue could be considered to be an *index* of Michelangelo. However, the David also conveys other notions, many of which are far more abstract. It conveys the notion of individual genius, and that of ingenuity and art. It also conveys the notion of sculpture as a major art, and that of Florence, or the Renaissance. For more illustrated people, it probably conveys the idea of rewarded effort, as Michelangelo is said to have taken the David as a kind of personal challenge: in the last part of the fifteenth century nobody in Florence (including some well-established artists) thought it possible to sculpt the piece of marble that the young Michelangelo managed to transform into what is arguably the most well-known sculpture in the world.

Of course, for certain people, the sculpture might convey other meanings: anger and frustration, for instance, if someone missed the statue after a much-expected trip to Florence because it was being cleaned, or because there was a general strike; of happiness, if the wish to visit this wonderful piece of marble was the cause of some particularly happy meeting; or of friendship, if the David in some way reminds the beholder of an important personal relationship.

Assuming the role of an imaginary observer, the meanings conveyed by the 'David' could then be structured in several levels, from the concrete to the abstract:

- Level 0: the David itself.
- Level 1: its creator, Michelangelo.
- Level 2: Florence; sculpture as one of the fine arts; the Italian Renaissance.
- Level 3: Art; individual genius; rewarded effort.

In fact, personal meanings are unconsciously added, so that this short, imaginary list is likely to be closer to the reality of a given individual as follows:

- Level 0: the David itself.
- Level 1: its creator, Michelangelo; that film with Charlton Heston (Michelangelo) arguing with Rex Harrison (the Pope).
- Level 2: Florence; the Hotel Brunelleschi; sculpture as one of the fine arts; Italian Renaissance; my art class with Ms Torrance.
- Level 3: Art; individual genius; rewarded effort; my own failed attempts at clay modelling.

Personal memories and meanings are often closely interwined in the complex 'webs of meanings' conveyed by hi-cult objects.

These personal meanings may be more or less important, but they are often inseparable from those shared by the rest of the society one belongs to. As Michalski (1994) has noted, 'we process perceptions and knowledge, both banal and profound when confronting artefacts', an idea that was very clearly illustrated in the following description of the thoughts of a person who is contemplating an Attic vase in a museum:

> Hmmmm, nice. I'm in a museum. Ahh, quiet in here, isn't it? (Smells) Bowl? Vase? Hungry. Says it's Greek. Attic – mum's looked like this. This is older. Really is lovely. So smooth and cool. Oops. 'Do not touch'. (Michalski, 1994)

Attached personal meanings of this kind, such as an Attic vase reminding an observer of a close relative, are pretty common when viewing many conservation objects. In many cases they do not contribute in a decisive manner to our considering an object to be a conservation object; however, in some cases they may be crucial in this sense. Of course, personal meanings are not crucial in the David being considered as a conservation object, because its social meaning is so powerful for so many people. However, personal meanings can be very important in the case of a 3×2 ft charcoal drawing of a clay replica of the David that was made 30 years ago by a beloved person, even if it has little or no artistic value. Objects produce what has been called 'webs of meaning', which are impossible to untangle in a precise way, since they vary from individual to individual because some objects convey different meanings for different people.

It is perhaps interesting to note that this book is a written text, only meanings for which words exist can be used as examples. However, words do not always allow for an appropriate description of feelings or ideas. The readers will have to imagine or look inside themselves to find examples of ideas or meanings that, while being definitely real, do not easily lend themselves to being expressed with words.

Too many symbols

Of course, many objects convey messages, and it could be argued that any object can indeed be symbolic in this sense. Semiologists have suggested that any object can function as a sign beyond primary, material functions. For example, Barthes described what he called the 'sign function' of many utilitarian artefacts, while Eco distinguished between primary, material functions and secondary, connotative functions (Barthes, 1971; Eco, 1997). A car's primary function, for example, is to carry people and things from here to there; but it also has a secondary function, which is to indicate the owner's social position – a function which many people are willing to pay for. In this sense, the mere feature of being symbolic, in whatever sense, is not enough to distinguish conservation objects from non-conservation objects because it can be applied to nearly every single object. Things are not that simple: the idea of conservation objects as symbols requires further precision.

Refining the communicative turn

Symbolic strength as a criterion

As a first, general rule, it may be noted that an object's ability to convey meanings is a requisite for it to be considered a conservation object. Many objects have symbolic ability, but it would be a mistake to assume that all objects are equally symbolic: some are very powerful, while others are very weak.

Generally speaking, the more powerful a symbol, the more likely it is to become a conservation object. However, this is not always true. For instance, a sign with a human skull and two-crossed tibias (a skull and crossbones) is an extremely powerful symbol representing danger; and a print out of a capital 'S' crossed by two vertical parallel straight lines (a dollar sign) is also a powerful

symbol, representing not just a national currency, but also material wealth in a general sense. Nevertheless, neither the sign with the skull nor the sketch of the 'S' will necessarily become conservation objects: the skull may well be imprinted on a bottle of poison for garden insects, and the 'S' may well be part of an advertisement in a newspaper; in both cases, these objects will almost certainly be thrown away as soon as they are used. The notion of symbol is so broad that it can still include many examples of non-conservation objects that do possess strong symbolism. Being powerfully symbolic does not necessarily convert an object into a conservation object.

Which meanings make up a conservation object?

An object may in fact have plenty of meanings, but not all of the meanings of an object contribute towards its becoming a conservation object. Among the many meanings that make up an object's web of meanings, only a few of them actually contribute to its being considered a conservation object. These are:

(a) hi-cult meanings

(b) group-identification meanings

(c) ideological meanings

(d) sentimental meanings.

Hi-cult meanings are those which are directly related to notions or disciplines prevalent in high culture, as defined above: those meanings which are regarded as such by, or useful for, those disciplines of science and art considered as elevated by most members within a society.

Among hi-cult icons, those related with art and ethno-history are usually the most valued ones. In this sense, 'ethno-history' describes any discipline dealing with cultures that are distant from ours in time and/or space. It thus includes history and some closely

related disciplines that study the past, such as archaeology and palaeography, but also includes ethnography and anthropology, which study alien cultures from past *and* present times. It also includes some specific histories, such as the history of the arts, the history of sciences or the history of languages. Any meaning that is helpful (or is likely to be helpful) to these disciplines contributes to the consideration of an object as a conservation object. Therefore, almost any painting, drawing, print or sculpture will qualify as such, as they are within the traditional artistic genres that art history deals with. It is interesting to note that they may or may not be 'historic', as contemporary artworks are also considered hi-cults objects. Similarly, there are many historic objects that may not be artistic at all, such as cannons or steam engines.

Group-identification meanings work in the same manner. A group-identification meaning is one that is related to characteristics that create group identities. Here, the term 'group' may include many different kinds of groups, from the extremely large (Westerners, Africans and Chinese) to the extremely small (the inhabitants of a tiny village in Austria, the McIntosh clan and the Imsov family). Regardless of the size of the group, there are objects that are only meaningful to its members. For these people, the conservation of many of these objects is entirely justified. Outsiders, on the other hand, will see their eventual care as an oddity: this difference will identify them as outsiders, while strengthening the links between the members of the group:

> Heritage reverts to tribal rules that make each past an exclusive, secret possession. Created to generate and protect group interests, it benefits us only if withheld from others. Sharing or even showing a legacy to outsiders vitiates its virtue and power; like Pawnee Indian 'sacred bundles', its value inheres in being opaque to outsiders. (Lowenthal, 1996)

If these objects finally become conservation objects for their identifying value, it will be because they have some meaning for

the people within the group, while outsiders instead will contemplate it as a tolerable quirk that affects the members of that particular group. Religious objects are good examples of this, but there are other instances, such as monuments or artefacts that are related to historical events or heroes (which may be periodically celebrated by the locals by gathering around the object or by parading it through the streets) or Hollywood stars' memorabilia (which is usually sought after, and cared for, by the fans of that star).

Conservation objects can also have powerful *ideological meanings*, in the moral, religious or political senses. Any object with the ability to convey meanings of this kind in a more or less direct way will likely be considered a conservation object. Saint Peter's Cathedral in Rome is a symbol of a given religion, just as the Dome of the Rock in the Al-Aqsa Mosque in Jerusalem can symbolize a different religion. On the other hand, the Auschwitz concentration camp works towards this same objective – though in a different way, by showing what should not be: by symbolizing moral abomination in such a clear way that the resulting message is as direct, or probably much more direct, than a 'positive' monument celebrating human rights.

Sentimental meanings are extremely variable. In the sense described here, sentimental meanings are produced out of personal experiences: the meanings that appeal to individual feelings and memories, as opposed to those meanings that are mainly 'taught' through collective means (schools, media, exposure to traditions and customs, etc.). For example, a ticket from a massive rock-music concert signed by a pop-star may have certain meanings for different people, but it is likely to have some personal, stronger meanings for the person who fought to get the star's attention, and who had it signed after an extremely long wait. The ticket can become a conservation object for its widespread meaning as a collector's item, but also because of the strong feelings attached to it

in that person's mind. Similarly, an otherwise worthless pencil sketch by a 5-year-old child could become a conservation object just because it was drawn by a beloved person.

These categories are not mutually exclusive. The same object can belong to several of them simultaneously, which is, in fact, quite a common occurrence. These categories are not watertight compartments in real life or from a scholar's point of view: they should not be seen as a sort of taxonomy, but rather as a set of factors contributing towards an object being considered as a conservation object which just happen to occur together within a same object. This is particularly true of the first three categories of meanings, those of hi-cult, group-identification and ideological meanings, which are closely intertwined. Hi-cult meanings, for instance, very often serve to identify groups. Some authors, such as Taylor or Bueno, have even suggested that hi-cult, or art, for that matter, can serve as a form of class discrimination; that is, to identify intra-social groups, since hi-cult and art are closely connected with social power. Owning a piece of art of recognized quality serves to distinguish the owner as having a certain level of economical power, just as knowing and recognizing 'good' art serves to prove that the observer possesses good taste and education. Thus, it distinguishes the owner or the observer as belonging to a privileged, intra-social group; hi-cult values are widely accepted by society, but their production and use are most often limited to the small group of people they also serve to identify (Taylor, 1978; Bueno, 1996). Therefore, it is not easy to find an example where hi-cult meanings are produced without the occurrence of group-identification or ideological meanings. For example, Angkor Wat is a great work of art and also a Cambodian source of pride and a vague reminder of Eastern religions. Likewise, the Blue Mosque is a Turkish icon and an elegant artwork, but it also conveys the notion of Islamism – even more so than Angkor Wat conveys the notions of Hinduism or Buddhism. In practice, all three meanings occur more or less simultaneously

within the same object, with some of them prevailing over, but not excluding, the rest.

Sentimental meanings are slightly different in this sense. An object may become a conservation object for its sentimental value only. For example, the private owner of a damaged child's miniature rocking chair from the 1940s might have it restored just because it evokes his or her childhood. Meanings of this kind do not necessarily relate to religious, political or moral ideologies, nor do they have to do with group-identification or high education knowledge; they seldom occur combined with the other kinds of meaning. Because of this, the categories described above could be summarized as follows:

(a) Social meanings
 (a.1) Hi-cult meanings
 (a.2) Group-identification meanings
 (a.3) Ideological meanings
(b) Sentimental meanings

Mechanisms of symbolization

The synecdoche is a figure of speech that consists of referring to something by naming just a part of it. When someone says 'there are 300 head on the ranch', the speaker usually means that the ranch has 300 animals of some kind, usually cows, bulls or horses. The idea that 300 decapitated heads have been stored somewhere on the ranch is not conveyed to the audience, because it is automatically understood that a mechanism of synecdoche has been used by the speaker, and hence an adequate, equally automatic mechanism of decoding is used.

The metonymy is a closely related figure of speech. It is based on grounds that are similar to synecdoches, except that, in this case,

a thing is referred to by naming some of its related properties. 'The pen is mightier than the sword' is a well-known example of metonymy: 'pen' is used to mean 'written thoughts', because they are usually written with this tool; 'sword' is used to refer to physical violence and strength, which is what swords are used for.

In an essay on the role of museums, Donato (1986) suggested that the very notion of museum lies upon repeated 'metonymies' that produce representational illusions upon the observer. This is an interesting idea that can be safely brought into the conservation field, as many of the meanings that characterize conservation objects are produced in a similar way. A bell that is supposed to have been rung at a given moment during the war of independence of the US may become a symbol of that war, and then a symbol of freedom and national pride. The airplane that dropped the first atomic bomb could become the symbol for the entire historical episode, and indeed that of the disasters of atomic warfare. The first Soviet tank to enter Prague during World War II was placed on a plinth and converted into a monument to symbolize the Soviet liberation of the city, which, in turn, soon became the symbol of Soviet oppression for many Czechs. A letter by someone can represent that person or that friendship, just as a piano played by Chopin might become the symbol of Chopin himself, and perhaps of piano virtuosity or Romanticism.

It must be stressed that among the many meanings that a given object can have, only a few play a crucial role in their becoming conservation objects. These are produced through metonymic–synecdochic ways of symbolization, but this is not necessarily true for other meanings conveyed by the object. In a fourteenth-century Flemish painting, a round, golden circle around the heads of the characters means that they are saints. This meaning is conveyed for arbitrary reasons, and it cannot be negated that it is a well-established communicative mechanism. However, it does not contribute towards the understanding of that object as

a conservation object: that meaning could also be conveyed by a bad photocopy of a bad photograph of that painting, and that photocopy would usually not be considered as a conservation object. What turns that painting into a conservation object is its ability to convey the idea of art, painting, history, Flemish genius, high culture, etc. (an ability which the photocopy itself lacks almost entirely), and not its ability to express the idea that someone has reached sanctity.

Changing meanings

It is very interesting to note that many conservation objects have experienced a change in meanings from their original ones. The pyramid of Kheops no longer serves as a burial place to safely conceal the corpse of the pharaoh, nor is it a display of the power of the Egyptian emperor. Similarly, Hyeronimus Bosch's 'Garden of Delights' serves no moral purpose, and the Book of Kells is not used to read the gospels. As a result of the observers' change of attitude and education, they have lost some of their meanings and acquired new ones, which have in turn led us to consider them worthy of conservation. Typically, these new meanings fit into the categories described above.

In most conservation objects, the symbolic, communicative function takes precedence over other original, material functions it could have had. Bakelite phones, for instance, were technically obsolete by the 1970s, but a couple of decades later they became collectibles – and conservation objects. The reason for this appreciation is not the dependability of their dialling mechanism, or the quality of their sound; it is rather the strong message of distinction, personality, refinement, sophistication, etc., that they convey. These phones are useful for some people because of the attached messages: their meanings take precedence over their primary, material function.

This same phenomenon is very obvious in many objects, from old cars to classical ruins, from a Gutemberg Bible to the Tower of London: none of them fulfils their original function. A Ford Model-T is not comfortable, nor is it fast; there are plenty of cheaper, far better and infinitely safer cars around, as there are far better places for performing theatre, music or sports than the Roman Amphitheatre of Verona. And of course, a Gutemberg Bible is heavy and awkward, and no prisoner is locked up in the Tower of London. While these objects still perform some material functions (the Ford Model-T can transport people, the Verona Arena can accommodate people for live performances, the Gutemberg Bible can still be read, and the Tower of London houses British treasures), they are conserved not because of their ability to fulfil these functions, but because of the messages they convey. Were it for their material or technical usefulness, they would have been replaced or demolished a long time ago, as they are not efficient by any present standards. However, their newly acquired, non-original symbolic functions have taken precedence and have turned them into worthy conservation objects.

Two exceptions: Riegl's 'deliberate monuments' and recent artworks

There is, however, a notable exception to this rule. Sometimes, an object has been produced to convey meanings that still remain valid. This happens to some objects that fall within the category Riegl named as 'deliberate monuments'. Riegl defined deliberate monuments as 'a human creation, erected for the specific purpose of keeping single human deeds or events (or a combination thereof) alive in the minds of future generations' (Riegl, 1982). This category of objects would include the Mount Rushmore statues and Jimi Hendrix' rather inconspicuous tomb in the Père Lachaise cemetery in Paris. The way these objects are observed is still similar to the way they were intended to be observed. These 'monuments' were made to remember a beloved person or

to exalt the values of the American political system and values through some of its most prominent practitioners; their meanings have thus remained essentially similar to the original ones, but they are still considered to be conservation objects.

Artworks created *after* the inception of the contemporary notion of art can also keep their original, aesthetic function. This is particularly true of works produced since the beginning of the twentieth century, when the notion of the artist as an isolated individual became as widespread as the notion of art as a result of self-expression and genius. Van Gogh's 'Room at Arles', for example, has acquired new meanings since it was created, but its artistic meaning – its ability to produce aesthetic sensations – is still important for a number of people. Thus, the rule regarding the change of original meanings in conservation objects must be acknowledged to be an imperfect one, as there are two possible exceptions (Riegl's 'deliberate monuments' and recent artworks) that are worthy of note.

Ethno-historical evidence

Most well-known hi-cult objects work mainly as symbols. Although they are supposed to be historically or artistically valuable, their value for history, and even their ability to produce aesthetic effects upon the observer is often very limited. Adorno described museums as 'the family sepulchres of works of art', containing 'objects to which the observer no longer has a vital relationship and which are in the process of dying'; while Félix de Azúa has described art museums as 'meros depósitos documentales' ('mere document repositories') (Adorno, 1967; Azúa, 1995).

Of course, this is not always the case. Even Azúa acknowledges the possibility that 'alguna mirada aislada, entre la masa de turistas que repasan la historia, pueda iluminar de pronto una obra de arte' ['an isolated gaze, among the masses of tourists watching history,

may suddenly shed light upon a work of art'], and, as Arthur C. Danto has pointed out, for some people with a special sensitivity, museums are not always 'filled with dead art, but with living artistic options' (Azúa, 1995; Danto, 1998). However, it should be acknowledged that these people are as exceptional as the 'isolated gaze' described by Azúa. For most visitors, few of the works kept in classical museums, if any, produce little more than a feeling of completing a cultural ritual. Admittedly, this feeling is gratifying and has many personal nuances, but it is not properly an aesthetic effect, as this notion is commonly understood. Visitors to the Uffizi Gallery, for instance, are allowed to view Botticelli's *Allegory of Spring* in conditions which are, to say the least, not ideal for aesthetic enjoyment, but many dedicated visitors keep flocking from all around the world to see it. The *Allegory of Spring* works more as a symbol than as a real work of art, and there is nothing wrong with that – unless it is assumed that it should be otherwise.

Many artistic masterpieces have this same effect, from Las Meninas to the Taj Mahal. In most cases, they could be considered to be principally symbols of a much respected and admired history of art. This, in turn, is an important part of history, which is also a noble part of high culture, a culture that helps to enhance group identification. The idea of art as a universal category reinforces the idea of humanity, the idea of Western art reinforces the idea of Western culture, the idea of European culture reinforces the idea of Europe as an entity with its own values, and so forth. Knowing, respecting and then visiting these symbols is a 'ritual of citizenship' (the expression has been taken from Duncan, 1994).

These objects are also said to possess 'historical value', but this is another inappropriate expression to refer to their symbolic value. In fact, the more well known an object is, the more likely it is to have been thoroughly examined, analysed and studied. It is undeniable that these objects might still contain as yet undiscovered historic information, but it is also true that most of it has already

been extracted. It could well be said that they actually are almost-depleted historical resources. The Mona Lisa (and every other object, for that matter) can conceal this hidden historic information somewhere in its material components, which perhaps will be accessible with sophisticated techniques that are not yet known. However, its main value no longer resides in being a document for researchers, but in being a symbol for art lovers around the world.

There are, however, objects that, while having strong 'historic' value, seem to be weak symbols: the remnants found in one of the many archaeological sites unknown to the public, or the seventeenth-century documents in an obscure church in a small village are good examples. They have little symbolic value for most people, but are still conservation objects. These objects could be described as 'ethno-historic pieces of evidence'.

Ethno-historic pieces of evidence are those objects that have provided, or are expected to provide, ethnographical and historic sciences with raw data for researchers to interpret. This category can include a number of very different materials, such as nineteenth-century industrial machinery, mediaeval helmets, magazines and newspapers from different times, ancient pottery fragments, audio recordings or seventeenth-century religious garments. What they all have in common is that they are useful for historians, scientists and other researchers. Many of these objects are unknown to common people: they do not work as symbols, as do famous paintings or buildings. Rather, they are hidden from public view, under layers of earth, in the sea bottom or in dark corners of forgotten archives. They work mainly as historical evidence, waiting for qualified experts to analyse them.

Ethno-historical pieces of evidence are conservation objects, thus shaping a new category of objects that are conserved because of what they mean to experts. Their meanings do not fall into any of the categories described above, as they provide academic or scientific information.

It is interesting to note that not every piece of academic or scientific evidence makes for a conservation object. With very few exceptions, this effect is only produced if the evidence is useful to the *ethno-historic* sciences; that is, for anthropology, ethnography and history – and its many offspring: history of art, history of sciences, archaeology, palaeography, prehistory, etc.). However, pieces of evidence used in hard, material sciences (e.g. mineralogical slides, water samples or chemical extracts) are not conservation objects. They are discarded as soon as they become scientifically useless. They are only conserved when they convey some of the symbolic, non-evidential meanings described above. For instance, if the microscopic slides prepared by neurobiologist Ramón y Cajal or Harvard's glass flower collection are still conserved in museums, it is mainly because of their historical, exemplary, hi-cult-related meanings, and not because of their scientific usefulness: Ramón y Cajal's slides have been photographed and reproduced many times, and even though their quality is still outstanding, they could easily be replaced with more modern ones; and while Harvard's glass flowers are truly amazing works that are well worth seeing, the scientific information they may provide might well be obtained by more efficient methods without all the problems attached to the preservation and restoration of these extremely delicate, wonderful pieces.

Summing up

It could thus be concluded that conservation objects are considered as such not because they are cultural, artistic, historic or old. They are considered as such because they work as symbols or as evidence for ethno-historic disciplines.

The symbolism of conservation objects fulfils three conditions. Conservation objects are:

(a) Symbols that have strong symbolic power, which usually take precedence over material functions.

(b) Symbols that have private or sentimental meanings; hi-cult, group-identification or ideological meanings (which are often different from their intended, original meanings); or have evidential value for ethno-historical disciplines.

(c) Symbols that work through synecdochic or metonymic mechanisms.

The likelihood of an object being considered as a conservation object, and thus as an object to be preserved or restored instead of repaired, serviced or refurbished, has been elegantly represented by Michalski in a three-dimensional space, which could be called 'the conservation space' (Michalski, 1994). In this space, each axis represents one of the three main types of meaning (private, social and scientific) that make up a conservation object; the further an object is from the axis origin, the more likely it is to be considered as a conservation object (Figure 2.1).

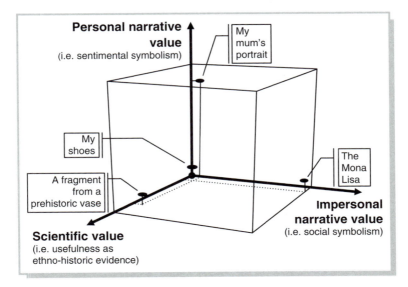

Figure 2.1 A classification of activities within the conservation field

However, this three-dimensional space is not a measurement tool: this model allows for a better understanding of the factors that make up conservation objects, but it does not mean that each of these factors can be easily or objectively quantified, nor that a precise limit exists separating conservation objects from non-conservation objects. The logic behind the category of conservation objects can be revealed through this representation, but part of its efficiency would be lost if it were thought that the 'conservability' of an object could be precisely evaluated.

Truth, objectivity and scientific conservation

For many people working in conservation at the beginning of the twenty-first century, some classical principles, and especially those of scientific conservation, are essential to the activity itself. Some of them are known to everybody, but there are others (perhaps the most fundamental ones) that may not be that evident. To a certain extent, they constitute an infrastructure that, while pervading the whole activity, can go unnoticed. In this chapter, some of the underlying assumptions that constitute those theories will be described and analysed, in an attempt both to prove that they really exist, and to better understand them.

The pursuit of truth in classical theories of conservation

As Muñoz Viñas (2003) has put it, classical theories contemplate conservation as a *'truth-enforcement'* operation. Although they do not agree upon exactly where that truth resides, since its very inception, the main purpose of conservation is to maintain or reveal an object's *true nature* or *integrity* (see, for instance, UKIC, 1983; Fernandez-Bolaños, 1988; Caple, 2000; Clavir, 2002). Similarly, as Orvell has stated, 'conservation and preservation (let alone

restoration) have no meaning or purpose without a concept of the real, the original, the authentic' (Orvell, 1989).

According to Clavir (2002), classical conservation emphasizes three kinds of integrity: physical, aesthetic and historical. Physical integrity refers to the material components of the object, which cannot be altered without violating it. Aesthetic integrity describes the ability of the object to produce aesthetic sensations upon the observer; if this ability is modified or impaired, the aesthetical integrity of the object is thus altered. Historical integrity describes the evidence that history has imprinted upon the object – its own, particular history. In a somewhat different vein, Muñoz Viñas has suggested that for classical theories, the 'integrity' of an object may lie upon four main factors: (1) its material components, (2) its perceivable features, (3) the producer's intent and (4) its original function (Muñoz Viñas, 2003). Most classical theorists defend a given combination of 'integrities' as being 'truer' than other possible ones, by stressing the relevance of a particular integrity or truth factor, while just occasionally mentioning the others. However, in any case, all of these theorists have retained the basic notion that conservation should always be a truth-based activity.

In conservation, however, these views often conflict. Choices have to be made, because implementing each and every one of them at the same time is not possible. Ruskin, Morris and the people of the Society for the Protection of Ancient Buildings did value material components and historical integrity. Changing the buildings, even in the name of restoration, was considered:

> ... the most total destruction which a building can suffer: a destruction out of which no remnants can be gathered; a destruction accompanied with false description of the thing destroyed. (Ruskin, 1989)

As such, they strongly opposed any kind of restoration, favouring preservation, and accepting decay as an added value. For Viollet-Le-Duc, on the other hand, it was the producer's intent

and the aesthetic qualities of the object what actually determined an object's true nature – even if the object never actually existed in this *pristine*, ideal state. In order to fulfil the producer's real intentions, and to confer on the object the stylistic integrity it should have had, the material and historical integrities of the object were entirely dispensable. Even though the works were based upon solid academic studies, many of his restoration works (Notre Dame of Paris; the cathedrals of Amiens, Chartres and Reims; the château of Pierrefonds; the church of Sainte-Marie-Madeleine in Vezelay; etc.) are now seen as almost Disney-like re-creations.

In the latter nineteenth century, Boito's *restauro scientifico* gained wide acceptance. This new theory retained truth as a guiding principle but stressed that truth was objectively determinable, and thus it was to be achieved by objective methods. In this way, personal appreciations would not step in the way of conservation and discussions would be avoided – or at least, drastically reduced. Of course, the best, and perhaps the only way to establish objective truths was the way of science.

Aestheticist theories

Around the mid-twentieth century, two somewhat new conservation theories gained momentum and popularity: the aestheticist theory of conservation and the *new* scientific conservation theory. Both the theories are essentially classical, as both of them seek to preserve and recover the integrity of the object of conservation. Aestheticist theories are centred around the notion of aesthetic integrity, which is a basic asset of any artwork that conservation should strive to preserve and which restoration should recover whenever possible, while at the same time preserving the imprints history has left upon the artwork. These are conflicting aspirations: respecting history while at the same time recovering the artistic integrity of the object is an almost impossible task.

This basic contradiction was described by Philippot as 'the heart of the problem of restoration' (Philippot, 1996).

To solve this dichotomy, aestheticist conservation theorists such as Brandi or Baldini have emphasized the need for the conservator's additions to be easily distinguishable from the original remnants; by doing this, the conservator can restore the object's aesthetical integrity while avoiding the creation of a 'historical forgery'. To be a legitimate, truth-respecting operation:

> Il restauro (…) non dovrà presumere né il tempo come reversibile né l'abolizione della storia. L'azione di restauro inoltre, e per la medesima esigenza che impone il rispetto della complessa storicità che comete all'opera d'arte, non dovrà porsi come segreta e quasi fuori del tempo, ma dare modo di essere puntualizzata come evento storico quale essa è, per il fatto di essere azione umana, e di inserirsi nel processo di trasmissione dell'opera d'arte al futuro. (Brandi, 1977)

> [[Restoration] cannot presume that time is reversible or that history can be abolished. Furthermore, the act of restoration, in order to respect the complex historical nature of the work of art, cannot develop secretively or in a manner unrelated to time. It must allow itself to be emphasized as a true historical event – for it is a human action – and to be made part of the process by which the work of art is transmitted to the future.] (Translation from Stanley Price, Kirby Talley and Melucco Vaccaro, 1996)

Classical aestheticist theories do attempt to bridge the gap between historical truth and artistry. In fact, as Brandi has stated, the only 'legitimate' conservation treatment is that which is performed 'colla più vasta gamma de sussidi scientifici' ['with the help of the widest range of scientific techniques'] (Brandi, 1977). Furthermore, artistry is treated like an almost objective feature of the object:

> … occorre allor che l'azione dell'uomo (…) non sia in nessun caso modificante bensì esaltante e chiarificante dell'esistente; che sia un intervento critico non nel senso del gusto nè personale ma estratto come regola dalla stessa realtà dell'oggetto. (Baldini, 1978)

[... the action of man (...) should not alter in any way the work of art, but instead emphasize and clarify it. This should be a critical intervention that derives from the reality of the object and is unaffected by taste of personal inclinations.] (Translation from Stanley Price, Kirby Talley and Melucco Vaccaro, 1996)

This attraction for objectivism is very characteristic of all twentieth-century classical truth-seeking conservation theories. Objectivism is, in fact, closely related to the notion of truth, since objective truths are considered the most valuable ones. By pursuing truth *and* objectivism, aestheticist theories, to a great extent, suffer from the theoretical problems that are outlined in the following chapter. However, classical aestheticist theories also have a specific problem that greatly limits their actual usefulness in the conservation world: they only apply to a single category of conservation objects, that of artworks. Scientific conservation views do not have that limitation.

Scientific conservation

Boito or Beltrami had defended the role of *soft* sciences in conservation decision-making, but in the first half of the twentieth century, the new 'scientific conservation' came into play. It was characterized by its emphasis on the use of *hard* science in conservation. Though there are earlier examples of hard scientists occasionally working to solve conservation problems (Davy, Chaptal, Augusti, Doerner, Bonnardot, Faraday, Herbst, Rathgen, etc.), the scientific approach to conservation became widely recognized between 1930 and 1950. In 1930, the *Conférence internationale pour l'étude des méthodes scientifiques appliquées à l'examen et à la conservation des oeuvres d'art* was held in Rome. In 1950, the International Institute for the Conservation of Museum Objects (presently known as the International Institute for Conservation of Historic and Artistic Works, a strong advocate

of hard scientific conservation) was incorporated. Between these two key events, many scientific laboratories were created in relevant museums and conservation centres around the world, such as those of the Istituto Centrale del Restauro, the Doerner-Institut, the Fogg Museum, the Louvre or the London National Gallery.

This scientific approach to conservation gained momentum, and in the second half of the twentieth century, it obtained some recognition as the best approach to conservation problems – the only valid one, actually, since non-scientific approaches were disregarded as obsolete at best, or as a product of ignorance in many other cases. Conservation became a university discipline, professional bodies were created, national and international associations emerged and publications flourished. The role of science in conservation became apparent through the use of scientific techniques but also, and more conspicuously, through its symbols: microscopes proliferated in the workshops – which now became 'laboratories' – conservators in white coats became a common sight, and test tubes and reactive chemicals invaded the laboratory shelves.

However, the influence of science was not just cosmetic, as it also cast its own goals upon the whole activity. As early as 1947, conservation came to be contemplated as:

> Any action taken to the end of determining the nature or properties of materials in any kinds of cultural heritage or in their housing, handling, or treatment, any action taken to the end of understanding and controlling agencies of deterioration, and any action taken to the end of bettering the condition of such holdings. (Staniforth, 2000)

Thus, conservation came to include not only actual conservation but also 'any action' that leads to *knowing* the properties of materials and to *understanding* deterioration processes. Since producing knowledge and improving the understanding of physical phenomena have always been noble goals of science, this view warranted scientists a relevant place in the conservation scene.

The notion of conservation-as-research has pervaded scientific conservation, and thus conservation at large, for a long time. In the 1984 code of ethics promulgated by the International Council of Museums (ICOM), for instance, it is stated that:

> An intervention on an historic or artistic object must follow the sequence common to all scientific methodology: investigation of source, analysis, interpretation and synthesis. Only then can the completed treatment preserve the physical integrity of the object, and make its significance accessible. Most importantly, this approach enhances our ability to decipher the object's scientific message and thereby contribute new knowledge. (ICOM, 1984)

This evolution has had a strong impact on conservation, which has been beneficial in both technical and social ways. The advent of hard science in the conservation field has been one of the most important single factors in the development and shaping of the conservation profession. However, it is striking that no relevant theoretical effort has been made to justify the validity of this approach. This is in marked contrast with the theoretical elaborations made by 'soft' scientific conservators in the late nineteenth and early twentieth century. Curiously enough, 'soft' scientific conservation theorists were neither soft scientists nor conservators; they were architects.

An observation on the role of architects in conservation theory

For many reasons, architects have led the conservation world in matters of principles and philosophy. For many centuries, architects have enjoyed high social status, which in the nineteenth century allowed them to have formal academic training and access to cultural resources far beyond the reach of other professionals. In that century, architects created strong national and international professional bodies and were willing to promote theoretical and technical debates on many aspects of the profession. Camillo Boito

himself was the President of the Milanese Architects' Guild and a Professor at the College of Engineering and Architecture of Milan.

Boito elaborated his theory of the 'restauro scientifico' 50 years before scientific conservation effectively reached the non-architectural conservation world. This gap between architecture conservation and the other conservation fields is very revealing. It suggests that architectural conservation is somehow distinct from the rest of the conservation fields, and, indeed it is distinct in several important aspects:

- Social recognition: architecture is a well established and highly valued profession, while conservation has not enjoyed social acceptance until recently.

- Academic recognition: Architecture has always been one of the major arts. This long tradition has warranted it a place in higher institutions of knowledge.

- Formal training: Until the mid-twentieth century, conservation was learnt through apprenticeship, while architecture has been taught at universities for a long time. This has provided a recognized system of qualification, which has served to avail the architects' ability and preparation, and to confer on them an authority which conservators lacked until recently.

- Pre-existence of a large body of knowledge: For a number of reasons, architecture has produced an important body of knowledge, which has passed the test of time. The body of knowledge existing in other conservation fields is not comparable to that of architecture in extent or in nature.

- Nature of knowledge: The conservation architect does not need the ability to readily detect and interpret the extremely subtle symptoms that only experienced conservators can perceive, nor the manual dexterity required to perform a successful conservation project. While other

conservators 'perform surgery', architects design abstracts conservation projects that are then implemented by other people (masons, carpenters, painters, etc.).

- Building conservation involves many people: Architects have to act as team directors, as the actual conservation process requires the work of many other professionals. In other conservation fields, the conservators are often the ones who carry out most of the conservation process.

Buildings are different from other conservation objects for a number of reasons, which can further explain the peculiarities of architectural conservation:

- Buildings are more visible and socially relevant than easel paintings, prints or archaeological objects. They often constitute powerful local symbols of identity.

- In most cases, the conservation of a building is much more expensive than that of any other object. As such, it is only logical for the degree of scrutiny to be greater than in other cases.

- Architecture objects are experienced by users in a much more direct way than other conservation objects. In many cases, conserved architecture objects are experienced by users (inhabitants, visitors and workers) not through mere contemplation, but through direct and extended contact. Buildings are usually not only seen, but also touched, walked through, stepped on, smelled, felt, *experienced* through different senses and in many more ways than other conservation objects are.

- Conserved buildings fulfil many material functions: Buildings are usually expected to house people, to be a workspace, to function as showrooms, etc. The conservation process must not only conserve the building, but it must also guarantee that it is useful for people with varying needs and expectations.

- Conserved buildings are subject to strict norms: In most
 societies, architecture is ruled by a plethora of technical
 norms and standards which have been designed to ensure its
 safety and efficiency. Architects have to abide by these stan-
 dards, which often collide with pure conservation interests,
 and which further complicate their work. In other conser-
 vation fields, these rules are much more relaxed, and/or have
 been designed with conservation purposes in mind.

In spite of these differences, building conservation principles
are not substantially different from the principles of the rest of the
conservation fields. The core ideas remain valid and may be used
in both the cases. Boito, Beltrami, Dezzi Bardeschi, Ruskin,
Bonelli, etc. have written about building conservation, but building
conservation is still conservation. The first consequential theore-
tical elaborations by specialists in other conservation fields
appeared in the twentieth century (100 years after Ruskin and
Viollet-le-Duc). These elaborations have greatly benefited from
the reflections of architects upon topics that are common to all
conservation fields, but they also include different views and con-
cerns. Contemporary theory of conservation, therefore, has a wider
scope, since it has been developed not only by (and for) architects,
but also by (and for) conservators from many different fields.

What is 'scientific conservation'?

Around the mid-twentieth century, the notion of scientific con-
servation seeped from the architectural field into the conservation
fields that deal with non-architectural heritage, such as paintings,
sculptures, archaeological objects or documents. Nowadays, scien-
tific conservation is a notion that is not frequently mentioned in
architectural conservation, where it is perhaps taken for granted.
Instead, it is a popular notion among the rest of the conservation
fields.

This modern scientific conservation is not identical to Boito's *restauro scientifico*, as modern scientific conservation is applied to a wider kind of heritage and makes a more extensive use of hard, material sciences. In the following pages, the term 'scientific conservation' refers to this modern, post-1950s notion of scientific conservation. It will be analysed in some detail, for two reasons: first and foremost, because it exemplifies many of the principles common to all classical theories, and thus many of the reflections made upon it can be safely applied to other classical theories; second, because it is the prevailing theory that, to some extent, contemporary conservation theory has reacted against.

Scientific conservation is not a well-defined notion, and its practice may adopt a variety of forms. In this respect, a preliminary distinction between scientific conservation and conservation science is necessary. Obvious as it may appear, it is not always clear that conservation science is a branch of science which is practised by scientists, while scientific conservation is a branch of conservation which is practised by conservators. This confusion arises for two principal reasons. The first reason is that neither conservation nor science is a clearly defined activity. The second is that, in practice, these notions are often mixed and intertwined, so that it is often hard to ascertain exactly whether an assertion is directed towards scientific conservation, conservation science, pure science or the role of science in conservation.

Much has been written regarding the indefinite nature of conservation, but much more has been written regarding the indefinite nature of science. Apparently, science is a well-established notion, and everyone knows whether something is 'scientific' or not. However, this is just an illusion. Most people's perception of something being scientific (its 'scientificity') rests upon trust, belief and a set of *clichés*, such as an *atrezzo* of white coats, glass jars and tubes, complex apparatus with buttons, cables and lights,

strange graphs with tiny incomprehensible labels, etc. Clavir has summarized these beliefs as follows:

1. There is a real world 'out there' that operates according to natural laws that can be examined and understood (empiricism).
2. A causative agent produces a repeatable effect (determinism).

(...)

4. Solutions must be confirmed before being accepted: control groups, repeated experiments and other methods are used to eliminate the possibility of results being caused by other factors.
5. Assumptions must be acknowledged and tested.
6. Vague statements are not acceptable. However, absolute precision is tempered by an acceptance of levels ranging above or below an average point.
7. The world should be explained according to scientific knowledge (i.e. one should rely on other scientists rather than relying on religious/spiritual ideas or what people say they know but cannot prove scientifically).
8. One should respect broad areas of knowledge that are already scientifically established (paradigms).

(...)

12. It is important to respect quantification and mathematical expression, including statistical probability, as the language of science (Clavir, 2002).

In fact, if carefully examined, the quality of 'scientificity' is far from clear. Notions that relate scientific knowledge to knowledge that is derived from experience (or even from *repeatable* experiences) are out of the question, since this would include the knowledge of non-scientific artisans, which is acquired through sheer, repeated experience. The idea that science is characterized by the fact that it demonstrates scientific truths through scientific means is not correct either, not only because the defined term is included in the definition, but also because, as Popper showed as early as 1934, the very idea that science *demonstrates* things is

not correct: scientific truths are not those which are demonstrated to be true, but rather those which cannot be demonstrated to be wrong (Popper, 1992). To make a long, complex story short, it should be recognized that 'science is what men call science' (Wagensberg, 1998) much as 'physics is what is included in *Das Physiks Handbuch*' (Bueno, 1996).

Things are also confusing when it comes to defining not just 'scientific conservation' but 'conservation science'. Three different approaches are discussed here, covering a wide range of notions. The first of them is the most open notion of conservation science, which encompasses a wide range of scientific research, both with and without direct impact on conservation practice. This view is perhaps best understood sifting through the contents of many prestigious conservation magazines – such as *Studies in Conservation, Restaurator* or *The Conservator* – or through the proceedings or acts of many conservation meetings and congresses. These publications, and other similar ones, contain research articles that are not often relevant to practicing conservators, while most of them are relevant to conservation scientists. They could be considered *endoscience*: science for scientists. This is not necessarily a criticism: there is nothing wrong with them, but they have to be approached bearing in mind that they are based upon a wide, open notion of what conservation science is.

Other people have a more restricted view of this subject. According to this view, the characterising feature of conservation science is the inclusion of real works within the experimental procedures. Curiously enough, the actual relevance of conservation science to conservation practice is not a defining factor:

> To put a boundary on the subject of conservation research, we require that it involve some art object or material. If several adhesives are studied 'in the pot' by measuring variables such as viscosity, density, shelf life and fume toxicity, then the subject is adhesive chemistry. Even if such work is done by a conservation scientist and

is relevant to conservation practice, it is not conservation science as defined here. If one applies the same adhesives to some art material and then measures properties, such as strength and discolouration, then the study falls within conservation science. (Hansen and Reedy, 1992)

The third view is different from both the first and second views, as it makes relevance to conservation the key feature of conservation science. This is the view shared by most practicing conservators, but also by conservation scientists such as Torraca (1991, 1999), De Guichen (1991) or Tennent (1997):

... the prime function of a conservation scientist [is] to provide knowledge or technical information which enables more effective preservation and conservation of cultural heritage, be it fixed or moveable cultural property. (...) My opinion is that only when conclusions are drawn from that examination which directly help the practice of conservation can it truly be called conservation science. (Tennent, 1997)

The (missing) theoretical body of scientific conservation

As has been mentioned above, no consequential theoretical elaboration has been made upon scientific conservation, aside from the ones made in the late nineteenth and early twentieth century. There are plenty of declarations of adherence, but their principles and grounds have rarely been discussed. Sánchez Hernampérez has made an interesting analysis on the evolution of conservation theory; to conclude that the theoretical debate actually ended when scientific conservation came into play:

... a partir de Boito, las aportaciones teóricas en conservación han sido meramente testimoniales. (...)

El debate teórico empieza a languidecer a partir de los primeros años del siglo XX y en la actualidad parece reducido a la nada, siendo sustituido por investigaciones técnicas: metodología de la

reintegración, estabilidad de los materiales originales, idoneidad de los tratamientos y reversibilidad, siendo incluso notorios los intentos por derivar el debate teórico al meramente material. En las publicaciones periódicas dedicadas a la conservación los aspectos filosóficos de la conservación han pasado a un plano muy discreto salvo los intentos de fijar códigos deontológicos acordes en su mayor parte con lo expuesto por Boito. (Sánchez Hernampérez, s.d.)

[... since Boito, theoretical reflections in conservation have been merely testimonial.

(...)

The theoretical debate began to subside in the first years of the twentieth century; today, technical research seems to have substituted it: techniques for loss compensation, original materials stability, suitability of treatments and reversibility; even attempts to substitute a merely material debate for a theoretical one have become very noticeable. In periodicals on conservation, philosophical questions have moved to a very secondary position, except for the attempts to establish codes of ethics, in most cases according to Boito's views.]

Boito was the first to emphasize that the *target state* of a conservation process should not be dictated by personal tastes (as with Ruskin's appreciation of the romantic ruin) or by personal hypotheses over how a monument should have been (as with Viollet-le-Duc), but rather by objective, scientifically grounded facts.

Boito's notions became quite widespread and were somewhat distorted in the twentieth century. As science became what Feyerabend described as a 'universal religion' enjoying 'an almost superstitious veneration' (Kirby Talley Jr, 1997), no need to justify its use in any field seemed to be necessary, and thus, no theoretical reflection preceded or justified its use in conservation.

Another likely reason for this striking absence lies in science's aspiration to *objectivity*. The objectivity of scientific conservation (its revolving around objects and facts, and not around ideas) may have led to the belief that no philosophical theory is required

for it to function. Scientific conservation deals with materials, not ideas, and in doing so, it employs its tools to apprehend the material world as hard sciences do.

Scientific conservation, though being the most notable manifestation of objectivity in conservation, is not well defined, and lacks a coherent theoretical, epistemological body. Any critical or analytical reflection will suffer from this imprecision; when it is not entirely clear what is at the centre of the discussion, any idea or reflection may be disregarded by negating not the idea or the argument itself, but by negating its subject or some of its features. In different academic forums, 'scientific conservation' can therefore be an encompassing conservation ideology or even a 'new paradigm', or a sort of enhanced traditional conservation, or anything in between. Most often, however, this confusion is unintended and unconscious: the notion of 'scientific conservation' of a conservation scientist and that of a non-conservation scientist may differ greatly, not to mention those of an art historian or even a layperson.

This is especially interesting given the fact that scientific conservation is a prevalent model of conservation in most *Westernized* countries. It has been argued that science is even essential to conservation: an intrinsic feature, a requisite for conservation to exist as such. In this case, 'scientific conservation' would be a redundancy, since there is no such thing as 'non-scientific conservation'. Coremans, for instance, has talked about 'aesthetic surgery' to describe the kind of restoration that flourished after the Renaissance, and which was mainly devoted to repairing and completing broken and missing parts:

> ... aesthetic surgery (...) gave a work of art a pleasant appearance, even if such surgery greatly accelerated its deterioration. Thus, at this stage the restorer restored, but did not yet conserve. (Coremans, 1969)

Pure restoration, thus, preceded conservation: out of the craft of restoration came conservation. This happened when restoration was pervaded by two related principles:

> How and why did conservation emerge from restoration? Why did it come to define its field according to two values that are in marked contrast (...) to the values of restoration (...)? These two values are: (1) a belief in the fundamental need to preserve the integrity of the physical object (as well as its aesthetic and other qualities) and (2) a belief in scientific inquiry as the basis for the proper preservation and treatment of collections. (Clavir, 2002)

The principles of scientific conservation

Scientific conservation actually emanates from an elliptic but over-whelmingly powerful set of principles: it is guided by the unspoken *material theory of* conservation which is, in turn, based upon the need to preserve the object's material 'truth', and the belief in scientifically grounded knowledge. The first assumption (the need to preserve the object's material truth) can be divided into two different principles: first, it emphasizes that scientific conservation has a fundamental need to preserve the integrity of the object, and, therefore, that it is a *truth-enforcement operation*; second, it stresses that for scientific conservation, the integrity of the object fundamentally lies in its *physical* features and constituents. From the second assumption (the belief in scientific enquiry), there follows the idea that for a conservation technique to be fully acceptable, it should have been developed, approved, selected, performed and monitored according to scientific principles and methods, and specifically those emanated from hard, material sciences.

The first principle, the need to pursue truth, is common to all classical theories of conservation, and, as such, it has been discussed above. The other principles, however, require further explanation.

Material fetichism

On 6 September 1736, a fire destroyed part of a church in Carcaixent, Spain. The fire destroyed several parts of the building, such as the choir and the organ, as well as many ornaments and pieces of furniture. A small marble statue of the Virgin and the Child, which had been borrowed from a nearby convent to conduct some special prayers, was also destroyed. The image was said to have been found buried by a farmer in 1250, and it was the object of great devotion. The day after the fire, some fragments of the Virgin's statue were identified among the ashes and rubble, much to the joy of the people of the village. Some of these fragments appeared to be from the heads of the Virgin and the Child, and a special commission was created to confirm their identification. On 5th October, the mayor commissioned a new statue. A contemporary document describes the process of its production:

> En el día 31 de octubre del mismo año 1736, víspera de Todos Santos, el dicho señor Cura, acompañado de su Alcalde, dos regidores, el Escribano y el Síndico del Convento de Aguas Vivas con algunas velas encendidas, trajo los fragmentos en una cajita a casa de la viuda de Pedro Talens, los cuales se pusieron en un hornico que había prevenido en la cocina; y puesta su cubierta, se cubrió todo de lodo para molerlos (…); quedando de vela toda la noche sin salir de la cocina el Sindico del Convento de Aguas Vivas y Fr. José Gisbert del mismo Convento (…).
>
> En el día siguiente se empezaron a moler los fragmentos y darse principio a la fábrica de la Sagrada Imagen de Nuestra Señora de Aguas Vivas por dichos artífices: el Hermano Jesuita Paradís y Andrés Robres; el Hermano componiendo las aguas para arrojar los polvos de los fragmentos, y el escultor Robres fabricando la Santa Imagen, en la cual vació el pecho y puso dentro de él la cabecita del Niño que pareció no molerla, y la cabeza de la Virgen que tampoco quedó molida, se colocó en la parte que corresponde a las rodillas de la Imagen, y los polvos raidos, negros y quemados se incorporaron a la peana de la Virgen (…).

[On October 31, 1736, just before All Saints' Day, the aforementioned Priest, along with the Mayor, two city officials, the Notary and the Aguas Vivas Convent Administrator, holding lit candles, brought the fragments in a box to the home of Pedro Talens' widow, and put them into a little furnace that had been prepared in the kitchen; and with the lid on, all the fragments were covered with mud in order to crush them (...); the Aguas Vivas convent administrator and Brother José Gisbert, from that same convent, stayed awake all night, without leaving the kitchen (...).

The next day, the fragments were crushed and the new figure of Our Lady of Aguas Vivas was begun by the aforementioned artisans: Jesuit brother Paradís and Andrés Robres; the brother prepared the water in which to drop in the dust from the fragments, and the sculptor Robres made the figure, and hollowed out its chest to put the small head of the Child, which he did not crush, inside. The head of the Virgin, which he had not crushed either, was put in the part of statue representing the knees, and the burnt, worn-out dust was put in the base of the figure (...)]

This newly made gypsum image has survived to this day, though a wooden base has been added. In 2003, some studies were carried out in order to assess its conservation state. Computerized axial tomography showed that the 1736 document was entirely true, and that in order to preserve the special power of the original statue, remnants of the precedent, Gothic image were incorporated into the new image. Furthermore, the original base was actually preserved inside the new, wooden base, which was hollow (Guerola, 2003).

This story might seem curious to twenty-first century readers. The notion that the original material may have some special power, even if that material is actually not perceivable by spectators in any way, might provoke a slight, benevolent smile, even if we are aware that it took place 300 years ago. However, this attitude is not that different from the attitude that pervades some contemporary notions that are still rooted in many people. As a matter of fact, many people are ready to travel long distances and wait in long

lines in the sun or rain just to *see* some *authentic* objects – even if the difference with a replica is impossible for them to distinguish. Tusquets has gone a bit further, arguing that in many cases a replica may offer a more complete experience than the authentic one. After considering several cases, such as the *moulages* in the École des Beaux Arts in Paris, the reproduction of the Altamira cave, the *Museo de Calcos* in Buenos Aires, or Leo von Klenze's copy of the Parthenon, the *Walhalla*, Tusquets asks:

> ... ¿no apreciaría más el talento de Leonardo contemplando tranquilamente una buenísima reproducción de la Gioconda, del tamaño real, sin cristal, acabada con un ligero barniz, como lo estuvo el original, que en el Louvre, a empellones, atisbando la pintura original tras varias capas de vidrios antibala que reflejan el grupo [de turistas] que no cesan de disparar sus flashes, aunque esté prohibido?. (Tusquets, 1998)

> [... wouldn't I better appreciate Leonardo's genius by leisurely contemplating a very good life-size copy of the Gioconda, with no protective glass, which is lightly varnished, as the original was, than being in the Louvre, pushed back and forth, hardly discerning the original behind several layers of bullet-proof glass that vividly reflect the group [of tourists] who unceasingly shoot their flashes even though it is forbidden?]

Certainly that is true; but the fact is that most people still prefer to view the original object than a copy, regardless of its quality. It is not aesthetic enjoyment what is expected, but a different experience. The fact is that for many people, the *authentic* material has a numinous quality (perhaps the 'aura' described by Walter Benjamin) that renders it very powerful in comparison with replicas or virtual experiences – an attitude which is not very far from that seen in the case of the Carcaixent Virgin: both this statue in the eighteenth century and many artworks in the twenty-first century are regarded as *relics*:

> Why, if what we value from a work of art is the aesthetic pleasure to be gained from it, is a successfully deceptive fake inferior to the real thing? What most of us suspect, that aesthetic appreciation is

not the only motor of the art market, becomes evident when a work
of art is revealed as a fake. When a 'Monet' turns out not to be, it
may not change its appearance, but it loses its value as a relic.
(Jones, 1992)

This special, often irrational appreciation for the *material*
components of an object is what confers it with a strong, unique
value. Just as the eighteenth-century makers of the new sculpture
in Carcaixent tried to keep as many original fragments, many
people still make painful efforts for this same purpose today.
A dramatic example of this took place in Assisi, Italy, on
26 September 1997.

At 2:33 a.m. on that day, an earthquake shook some regions of
the Italian peninsula. Among many other consequences, it dam-
aged the well-known Cimabue's mural paintings in the vault of
the San Francesco basilica, producing some alarming cracks, and
making fragments of the decoration fall apart and break into tiny
pieces on the floor. Sergio Fusetti, who had worked for years in
the conservation of the basilica, arrived at the building at around
3:00 a.m. By 6:00 a.m., he had gathered some 600 of the small
pieces that resulted from the fragments of plaster decoration
falling down and splitting into many smaller pieces. Later, other
experts arrived to examine the damage. Then, some 20 minutes
before noon, a small but noticeable rumble shook the basilica.
Some fragments from the paintings in the ceiling fell down,
which, as Fusetti recalls, looked like gold dust because of the
intense sunlight entering the basilica through the fully open
doors. And almost immediately, at 11:43 a.m., a much stronger
tremor surprised everyone, causing a tragedy. Large parts of the
ceiling fell down, crushing four people to death. Fusetti himself
was lucky, as he survived with only some broken ribs.

Fusetti's previous efforts in collecting those 600 pieces was well
intended, but later, when the havoc caused by the earthquake
disappeared, it became clear that it would be insufficient. The

restoration team gathered more than 100 000 minute fragments from the ceiling, which had resulted from plaster and bricks hitting the floor after a 20-m fall. Trying to collect as many of these pieces as possible became a prime concern, and even computer and image analysis experts took part in ensuring that as many of those tiny pieces of the original painting as possible could be put back in place, more than 20 m above the spectators' heads. There, it is completely impossible to discern the fragments. Even before the earthquake 'merely a blur of colour' could be seen by the many pilgrims, churchgoers and art lovers who visited the basilica (Leech, 1999).

There are close similarities between the case of the Carcaixent statue and that of the Cimabue's Assisi paintings. In both the cases, a valuable object was suddenly destroyed, and, in both the cases, its material components were considered valuable or potent all by themselves. The fragments of the Carcaixent Virgin were invisible for churchgoers and visitors, as are many of the fragments of the Assisi paintings, but nevertheless some special efforts were made to preserve them. In both the cases, the result of those efforts is unnoticeable: the observer is assured that the fragments are there, and it is that *belief* what renders the effort worthwhile. The lesson here is that placing value upon the material components of an object is neither a modern nor a scientifically grounded attitude. Rather, the opposite is true: this *belief*, which Petzet aptly called 'material fetishism' (Stovel, 1996), is what provides support for modern scientific attitudes in conservation.

It is because of this material fetishism that, for most Western people, the conservation of the material components of an object is a worthwhile endeavour, even when it is physically unnoticeable. Physical stimuli provided by replicas or reproductions may be objectively similar to those provided by the original object, but they are not perceived as being as intense and complete as those provided by *real* objects, or, to be precise, by objects whose

material components are the original ones. This recognition plays an important role in the implicit scientific theory of conservation that emerged between 1930 and 1950, as it mandates that conservation should avoid, as much as possible, the elimination, alteration or concealment of original materials. This precludes the removal of original fragments and the hiding of original materials. On the other hand, this principle does encourage the removal of 'non-original' materials, such as yellowing varnishes on paintings or corrosion crusts on metal pieces.

Belief in scientific enquiry

The other principle of scientific conservation (the belief in scientific enquiry) is harder to explain, due to the fact that science has not been well defined and that it is a very widespread belief. Most people would be unable to offer a minimally coherent definition of what science is, but the fact is that a basic trust in what is commonly called science exists among most people in Western cultures. Hence, instead of trying to describe or discuss the principles of scientific knowledge (a task that would take far more effort and time than is worthwhile here), it may suffice to stress that science is nowadays a preferred way of gaining knowledge, and that it has almost completely displaced other ways, such as artistic or religious ones (Wagensberg, 1985).

There is, however, a very important feature of scientific knowledge that deserves special mention: objectivity. Scientific knowledge is not supposed to be related to the subject performing the enquiry, but rather to the object itself. It is not based upon subjective feelings or impressions, but upon hard facts, precise measurements and repeatable experiments developed under controlled conditions. This kind of knowledge is thought to be superior to subjective knowledge, because it is not subject dependent, and is, therefore, of nearly universal validity, as it is not contaminated by

the personal biases, preferences or beliefs of the observer – or of anyone discussing its findings.

Objectivity is thus a prime advantage of scientific knowledge, which explains its pre-eminence. Admittedly, the grounds for that pre-eminence have been contended by philosophers as different as Goodman (1965), Feyerabend (1975, 1979), or Lyotard (1979), but these reflections have not gone beyond the philosophers' domain, or, at best, the hi-cult domain. Indeed, they are far from pervading society at large, perhaps because the notion that science actually is, to use Chomsky's or Hachet's expressions, a 'necessary illusion' or a '*mensonge indispensable*' (Chomsky, 1989; Hachet, 1999). In 1932, the President of the British Association for the Advancement of Science thought that 'science is perhaps the clearest revelation of God in our Age' (Clavir, 2002); nowadays, little has changed, as science remains the clearest revelation of truth for many people.

The pragmatic argument

Just as in the case of material fetishism, the belief in scientific knowledge may be a matter of faith for many people. Then again, this faith may be based upon the achievements of science-based technologies, just as other faiths have been based on the miracles and wonders they could produce or upon the emotional relief they could confer believers with (Burke and Ornstein, 1995; Noble, 1997). Medical treatments, communications, transports and many other aspects of everyday life have experienced a significant improvement that is based upon scientific knowledge, and this constitutes a good reason why science, or perhaps *technoscience*, should be trusted. Likewise, scientific conservation also relies on this same important argument, which is of a different nature from those described by Clavir: it is not strictly epistemological or theoretical, but rather a *pragmatic* argument. Scientific conservation

is thought to be a better form of conservation simply because it produces results which are superior to those offered by non-scientific conservation; the results are more reversible, more efficient, longer lasting, truer, more objective and less controversial. Technical analysis allows for the detection of non-original parts; accelerated-aging tests predict the decay of original and conservation materials; chemistry allows the understanding of deterioration processes and helps in their prevention, etc. Science has developed a number of complex, valuable methods, techniques and tools, and their use has led conservation to new levels of excellence. As a consequence, new techniques have been developed, new standards have been set and objective, scientific knowledge has substituted subjective judgement.

These assumptions underlie the whole set of principles behind objective, scientific conservation and perhaps constitute another reason why so little effort has been made in elaborating a theoretical reflection upon it: facts, hard facts, speak of and by themselves, so that no other reflection appears to be necessary. As such, the pragmatic argument complements scientific conservation's 'material theory' described above, which could then be relabelled as a 'material and pragmatic theory of conservation'. In a certain sense, this is an oxymoron, since, strictly speaking, no 'pragmatic theory' can exist. However, this expression accentuates the idea that the superiority of scientific conservation is based not only on a solid theoretical reflection upon the qualities and purposes of conservation objects and methods, but also on its sheer, objective results.

Summing up

Scientific conservation is a form of conservation that gained wide acceptance in the latter part of the twentieth century. It is based upon the pre-eminence of objectivity, and as a consequence

it emphasizes scientific forms of knowledge at all stages of the conservation process.

Scientific conservation lacks a written, theoretical body that precedes or avails it. However, it is unavoidably based upon strong, implicit principles, which constitute what could be called a *material theory of conservation*. These principles can be summarized as follows:

1. Conservation should attempt to preserve or restore the *true nature* of objects. This is its most important principle, which is common to all classical theories of conservation.

2. An object's *true nature* relies mainly upon its material constituents (material fetishism).

3. The techniques and target state of the conservation process should be determined by scientific means. Conservation techniques should be developed, approved, selected, performed and monitored in accordance with scientific principles and methods, and particularly in accordance with those emanated from the hard, material sciences. Subjective impressions, tastes or preferences should be avoided; instead, decisions should be based upon objective facts and hard data.

4. Scientific conservation methods and techniques actually produce results that are objectively better than those provided by traditional, non-scientific techniques.

The decline of truth and objectivity ____

This chapter elaborates on the criticisms of classical conservation theories and on their most important occurrence at the beginning of the twenty-first century: that is, scientific conservation. These criticisms are based mainly upon the analysis of the notions of objectivity and truth in conservation and rely upon two core arguments: the first argument is based upon the problems found when the notion of authenticity and its role within the conservation ideological framework is carefully examined. The second argument stresses the relevance of subjective, personal tastes, biases and needs when it comes to conservation decision-making.

The tautological argument: authenticity and truth in conservation objects

For classical theories, conservation is a 'truth-enforcement' operation. It can be safely said that the goal of conservation is to reveal and preserve an object's true nature or true condition.

This notion is very widespread and is present in an overwhelming number of cases. It is very frequent to read or hear that a restoration 'has revealed an object's true condition'. In Spanish it is often said that a conservation process *nos ha devuelto* ('has given us back') the authentic object, while in Italian it is very common to

read that an object *è ritornato* ('has returned') to its original state. In any case, the idea underlying these and other similar expressions is that an object's true nature was unfortunately hidden or covered up by some obscuring factors, and that conservation solved the problem, thus revealing the truth: revealing the object's truth. For instance, removing a darkened varnish from a wooden statue is thought to *reveal* the statue's true appearance, while eliminating the extensive, low-quality nineteenth-century retouching of a Rembrandt painting helps it *recover* its authentic nature.

However straightforward these and other similar assertions may seem, they still convey a potent set of ideas – so potent that they are often taken for granted. The choice of terms, for instance, is not innocent at all, as they are strongly charged with connoted meanings that stress objectivity and truth: only true things can be *revealed*, as 'revelation' is the display of previously hidden truths. And the *nature* of objects obviously seems to be based on their *natural* features, something that pertains to the physical world, something that is external to subjects, and thus, something that is intrinsically, objectively real and authentic. Assuming that conservation can preserve or *reveal* an object's *true nature* means that the entire conservation process is bound by truth, and thus that truth is a guiding principle. In this sense, conservation can be viewed as a manifestation of the ethical imperative of not lying. For aestheticist theories, truth is closely related to the artistry of the object. For scientific conservation, on the other hand, this truth is neither an aesthetic truth nor an emotional truth, since truths of this kind cannot be scientifically verified; it is instead a material, objective truth.

More important, however, is the assumption that an object may have a true nature, or exist in a true state or condition, because it implies that an object can have a different, *non-true* nature or that it may actually exist in a *non-true* condition: if it is accepted that conservation can reveal the true state or condition of an object, it

is necessarily so because it is previously assumed that the object can exist in a different (a non-true, i.e. false) state or condition. In the name of truth, the features that obscure or conceal an object's true nature are sacrificed and eliminated through restoration. From the point of view of classical theories, the conservator has the duty – perhaps the *moral* duty – to enforce truth, and, in doing so, has the right to get rid of or alter some material features of that object: the material features that caused it to exist in an untrue state or condition, the features that made its untrue nature prevail. Removing the darkened layers of varnish in Tiziano's 'Bacchus and Ariadne', reducing 'El caballero de la mano en el pecho' to its original size, or cleaning the tomb of Giuliani de Medici are operations which are meant to reveal the true nature of these masterworks.

However, no matter how widespread these assumptions are, the logic behind them is severely flawed. *Objects cannot exist in a state of falsehood*, nor can they have a *false* nature. If they really exist, they are inherently *real*. The expected, imagined or pre-ferred state of an object is not real unless it coincides with the existing object. The real, existing object can be altered through conservation to make it coincide with, or come closer to, a dif-ferent, preferred state, but the object will be no more *real* than it was before.

In 1986, for example, a mentally disturbed man shot Leonardo's drawing of the Virgin and the Child in the National Gallery of London, causing a hole in the figure of the Virgin. The shot per-forated the glass that protected the drawing, and the drawing itself, causing a hole of approximately 12 cm in diameter. When the conservators examined the work, they found that the brittle paper had fragmented into many small pieces and that tiny splinters from the protective glass had become entangled all around the hole. The laborious restoration included the recovery of the many tiny pieces of paper, and the removal of all the splinters. The

pieces were then precisely relocated, and the cracks were skilfully covered with pigment. The result of this delicate restoration work is that the hole is now invisible to most visitors: it now looks pretty much as it did before the shooting. Most people, including the author of this essay, would think that this restoration was necessary, and that the result is brilliant. However, in which sense is it possible to think that the restoration has brought Leonardo's drawing back to its *true condition*? Is it now in a more authentic condition than it was after the shot? The answer must be 'no'. The successive conditions are all equally authentic, silent testimonies of its actual evolution. We cannot believe that it existed in a *false* condition when the hole was perfectly visible, for if a drawing is shot, it is bound to have a hole, an authentic hole, and this is how it will exist in the authentic, real world. From an objectivist point of view, its present, 'holeless' condition is probably less authentic than it was before the restoration, since drawings that are shot actually suffer authentic, perceivable damage.

Or, then again, maybe not: its present condition is actually as authentic as it was with the hole before its restoration, because restored drawings may show no damage at all, even if they have previously been shot at close range. The present condition is necessarily authentic, and furthermore, its present condition is the only actually authentic condition. Any other presumed, preferred or expected condition exists only in the minds of the subjects, in their imagination or in their memory. Non-authentic states cannot exist in the *real* world. Likewise, non-existing conditions are non-authentic by definition; therefore, speaking of an object which exists in a non-authentic condition is a kind of oxymoron. If something exists, be it a perforated cartoon, a darkened painting, a rusted mediaeval sword, a partially ruined church or any other object, it is real: it really exists. If something exists in a given condition (e.g. with an oxydized crust, with a layer of smoke particles all over its surface, or with a 12-cm perforation caused by a shotgun blast), that condition is necessarily, *tautologically* authentic.

Since its very inception, conservation processes have been modifying objects and these modifications have presumably been made for the sake of authenticity. However, as the tautological argument proves, this is not the case: the modifications that have been made to bring the objects to a preferred condition cannot make them any more authentic than they are at present (although, these modifications can improve the objects in other senses). The belief that the preferred condition of an object is its *authentic* condition, that some change performed upon a real object can actually make it *more real*, is an important flaw in classical theories of conservation.

As a consequence, the role that authenticity plays in objectivist theories of conservation is fictitious. Modifying an object cannot be done for the sake of authenticity, even if the subjects who decide this modification choose to abide by the findings made through scientific methods. In these cases, the role of science is secondary: it helps to know historical and technical facts, but it does not help in making the core decision of returning an object to a past (suspected, imagined or remembered) condition; preferring that condition is not objectively reasonable. Jerry Podany's reflection upon the restorations of the Lansdowne *Herakles* is a very interesting example of this.

The Lansdowne *Herakles* is a marble sculpture, which was probably copied by a Roman artist after an earlier Greek work. It represents a larger-than-life figure of the Greek hero, carrying a club and the skin of the Nemean lion. It was found near Tivoli, Italy, at the end of the eighteenth century, and was sold to Lord Lansdowne in 1792. As it was in bad condition, the sculpture was restored around this date, very likely by Carlo Albacini. The restoration was made following the tastes and standards prevalent in those times. Many newly made parts were added to the remnants of the original sculpture in order to bring it back to its presumably 'original' or true condition – in this case, the condition

it was in when it left the sculptor's workshop. The nose, the right forearm, several fingers, the ends of the club, the back of the lion's skin, part of the right thigh, the whole left calf and several other pieces were carefully sculpted and skilfully placed next to the ancient remnants in such a way that they were neither discernible nor distracting to the observer. The restored scultpture remained in the Lansdowne mansion until 1930, when it was brought to auction. In 1951, it was bought by John Paul Getty to become a part of the Getty Museum.

In the 1970s, it was reported that the iron and lead pins holding the restored pieces in place were corroded. Because of the increasing size of the corroded metal pieces, cracks and iron stains could already be seen in some joints which, if left alone, could end up with some relevant marble fragments actually splitting apart.

The conservation treatment of the scultpture started in 1976. The sculpture was carefully dismantled, and its various pieces were put aside for the replacement of the corroded pins. When it was time to re-assemble the fragments, the curator and the conservator made the decision to 'free' the Roman sculpture from the eighteenth-century additions. Only a few new pieces were added to the Roman fragments of the statue, for the sake of physical stability or for 'aesthetic reasons', as some new metal rods would otherwise be too noticeable. The tip of the nose or the ends of the club, for example, were not replaced, while the left calf or the centre zone of the left arm, including the elbow, were replaced with new pieces made of epoxy resin, polyurethane and fibreglass. The conservator's report explained the removal of the eighteenth-century pieces as follows:

> The new restoration of the statue was not only made for technical reasons, but also to show the original as much as possible free of alien additions. The emphasis is now on what is left of the original, with additions limited to those necessary to cover the technical joins. (Podany, 1994)

Thus, for the sake of truth, *authentic* imprints of real history (in this case, the substantial work of a neoclassical sculptor) were removed due to them being considered *alien* to the object. The rationale behind this decision was that some of them are *truth-bearing* features while others are *truth-concealing* features, deserving removal – a very typical approach in classical theories prevalent in the second half of the twentieth century. In this sense, the 1976 process was no less biased than the Albacini treatment, 200 years earlier: bold decisions were made, technical skills were applied and the results were satisfactory to most people.

This case is interesting, though it is far from being unique. Choices of this kind are made very frequently, and, in all cases, 'authentic' is confused for 'preferred' or 'expected'. The *Herakles* was expected to be the work of a classical sculptor, though it was actually the work of at least *two* sculptors. And though their work is equally authentic, it is our own belief, our own expectation that the sculpture should be the work of a single Roman sculptor, what makes us think of some of its parts (those attributable to Albacini) as false or non-authentic.

Likewise, the Sistine Chapel's *Final Judgement* is not any more authentic now than it was before its recent restoration, as 500-year old paintings do not look the way *The Final Judgement* looks now. The painting was mainly the work of Michelangelo Buonarotti, but it was also the work of Daniele da Volterra and other painters, who skilfully painted some draperies upon some of Michelangelo's nude figures in order to partially conceal their nudity, as it was offensive to post-renaissance sensibilities. In addition, layers of hide glue were added by unknown artisans throughout its history to 'refresh' its colours, and smoke particles from the candles illuminating the Sistine Chapel accumulated all over the painting. Both these factors combined to confer it with a particularly characteristic look. These additions were as authentic

as the rest of the painting, and, in fact, they were a relevant part of its history. However, the smoke, the glue and many draperies (some of them were left in place for technical reasons) were duly removed, dramatically changing the painting's appearance. And while there may be nothing wrong with these operations, there surely is something wrong in believing that it was done for the sake of truth: contrary to the expectations or preferences of many people, the painting was not just a Michelangelo painting, as it actually included the work of other artists, layers of varnish and a subtle layer of carbon black particles (the smoke) which were an integral part of that large, complex object which was, and still is, so appealing to many people. Admittedly, after its restoration this half-a-millennium-old object may look closer to how it looked before the draperies were painted, or before it was varnished, or before thousands of masses were celebrated in front of it. Indeed, it looks as many people would expect a restored Michelangelo-only painting to look; however, this does not make it any more real or false than it was before the restoration. The expectations of an as-new Michelangelo-only painting have little to do with reality: to say the least, it is a mistake to believe that making a 500-year old object look as if it is brand new can be done for the sake of truth. *The Final Judgement* is no more authentic than it was before the restoration, as is the case of the Lansdowne *Herakles* or any other restored object, for restoration does not make an object any truer than it was before, but just truer to our expectations.

From an objective point of view, the notions of authenticity and falsehood are meaningless even in the case of deliberate forgery (Eco, 1990). Forged objects are undisputable, tautologically authentic objects, even if they have been incorrectly identified by the subjects; the fact that they were purposely produced to be wrongly identified by the subjects does not deprive them of a basic feature: real existence. Again, the beliefs of the subjects may or may not agree with the real world, but the real world is,

well, real. Science may help in *knowing* the real world and past facts, but even if a painting presumedly dating from the sixteenth century happens to be primed with titanium white and is painted with cadmium pigments (which came into use in the twentieth century), it will still be a true painting: a contemporary painting more or less accurately imitating an earlier formal style with modern materials. It is the subject's belief (the subject's *expectation*) that this modern painting should date from the sixteenth century what may be demonstrated to be false, but not the painting itself. No less than beauty, falsehood is in the eye of the beholder.

Legibility

Perhaps anticipating the tautological argument against truth-enforcement conservation, some authors have brought the notion of 'legibility' into conservation ethics. In this context, legibility is the ability of an object to be correctly comprehended or 'read' by the observer. The pursuit of conservation, thus, would not be to impose truth, but rather to facilitate the reading of an object, to make it understandable (MPI, 1972; Guillemard, 1992; Keene, 1996; Bergeon, 1997; ECCO, 2002).

The notion of legibility might be viewed as a small step away from classical positions, as the notion of truth is related not to the physical features of the object, but to its ability to convey its meaning. Consequently, the communicative turn, so essential to contemporary views, is accepted to a certain degree. However, it still remains within the realm of classical theories as it holds that objects have a worthwhile meaning, a legibility, which damage hinders or hides. Correct as this may appear to be, it is not so.

Every object has a meaning: Stonehenge reminds the observer of old, past times, of a long lost culture, of unknown beliefs or of

mysterious rituals. The object's decay means that those beliefs and rituals became obsolete and were replaced by new ones at some point in the past. A statue portraying an eighteenth-century nobleman means power; but a burnt statue of that same nobleman may mean that there was a fire, perhaps because of an important historical event: a World War II bombing, a peasants' rebellion or a full-fledged revolution. A rusty machine, for example a Mule Jenny, means that it was in use some time ago, but that it was later disposed of, perhaps because new, more efficient machines were developed. A crust-covered metal armour means that it has not been used for years, and perhaps, that it had actually been buried. A painting covered with darkened varnish will be 'read' as an old painting, with little or no restoration at all, perhaps because it was hidden or because it was considered worthless – but then again, it could be a badly restored painting. When conservators decide to render an object 'legible', they are actually making a choice; they are deciding which legibility should prevail over the many possible ones. For example, if the Mule Jenny or the armour were left as new, they would have new meanings that are different from the ones described above. They now inform the observer about how those objects looked, or even worked, when they were made. However, the idea that it is an obsolete item will have to be 'read' not in the object itself, but in a different place – perhaps in a sign, or in a catalogue. Likewise, Stonehenge or the darkened painting, or any other conservation object, is not made 'comprehensible' or 'legible' if left as new; rather, they would acquire new meanings: they would be legible in different ways, no more or less authentic than the previous ones, but different and, hopefully, more opportune and preferable for most people. As Ames has suggested (1994), objects can be compared to palimpsests, in which texts (information, messages and meanings) are written in succession, each one hiding or modifying the previous ones. It is the conservator who chooses which meaning (which legibility) should prevail, often at the expense of permanently excluding other possibilities. It is the conservator who decides whether a

burnt painting should be evidence of the burning or, rather, of the artist's work and genius; whether a ruined lighthouse should be evidence of the obsolescence of the functions it fulfilled a long time ago or, rather, evidence of old building and lighting techniques; if a friable *intaglio* print should be evidence of cellulose deterioration or, rather, evidence of the skills of the engraver. In these choices, once again, objective arguments (arguments related to the object's physical properties and features) can have little or no relevance at all, as it is the observers who will determine whether or not the newly acquired meanings of a given object are appropriate or pertinent. If they do not find them to be pertinent these changes will most likely be regarded as 'damage'.

The notion of damage under scrutiny

Damage is a crucial notion in conservation: it is a prerequisite for conservation itself to even exist, since if no actual or potential damage existed no conservation act would ever be performed.

Nevertheless, it is not always clear that 'damage' is not the same as 'alteration'. As Ashley-Smith has put it (1995), the alteration of a conservation object may be of three different kinds:

1. Patina
2. Restoration
3. Deterioration

All of these terms describe an alteration of the object, the criteria behind them being both intention and value. Patina is, thus, the kind of alteration which is unwanted and adds to the object's value. Restoration also contributes to the object's value, but it is a deliberate alteration. On the other hand, only those alterations of the object which actually reduce its value are usually considered as 'deterioration' or 'damage'. This idea lends itself to a graphic representation (Figure 4.1).

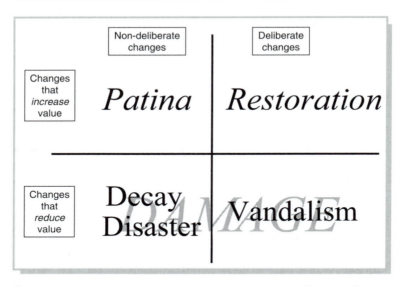

Figure 4.1 A graphic representation of Ashley-Smith's classification of a conservation object's possible alterations. 'Vandalism' has been added for the sake of completeness

It is very interesting to note that neither intention nor value are material, scientifically determinable factors, so that, ultimately, the all-important notion of damage is neither within the reach of science, nor is it a property of the object, but the result of a personal, subjective judgement.

Admittedly, sometimes it may be possible to objectively measure the set of alterations that are commonly understood as damage. For instance, it is possible to measure the discolouration of a historical textile as well as to evaluate the concentration of salts in an alabaster bass relief. It may even be possible to predict the evolution of certain features of an object with some degree of precision, such as the critical weakening of wood pulp paper or the yellowing of terpenoid resin varnishes. However, even when this is feasible, the degree of damage does not need to be proportional to the degree of alteration. Cellulose depolymerization may cause a newspaper sheet to break when being consulted, thus provoking

important damage. However, that same level of chemical alteration may not be as important a damage in the case of other kinds of papers with different technical characteristics (perhaps with larger fibres or more throughly sized). In fact, even the same degree of weakening may not be considered as important a damage if the newspaper belonged to a periodicals library, and it were bound to be handled by many people, as it would be in the case of a framed print. Furthermore, even if the same degree of chemical alteration caused the same degree of weakening in the very same paper sheet, the damage would be much less relevant if the sheet belonged to a library which had already conducted the microfilming or digitization of its collections. Likewise, the same layer of dirt that is almost imperceptible on a baroque painting in a chapel could be quite damaging to Malevich's 'White on White'; a coffee stain could, indeed, be much more damaging to a Goya print than to a written document, as the document would still be readable while the aesthetic qualities of the drawing might be dramatically reduced; and that coffee stain could be much more damaging if it were located in a conspicuous place of the Goya print than if it were in its margin.

This same reasoning can be taken just a step further, as sometimes apparent deterioration can actually be valuable:

> Not only is there the risk that the condition of the materials, established by laboratory procedures, may not relate in any way to the condition of the work of art established *de visu*, through aesthetic appreciation, there is even the possibility that an extreme state of deterioration of materials may coincide with a maximum display of the work's aesthetic potential.
>
> (...)
>
> Let us consider the Colosseum. Anyone is capable of seeing that its state of conservation is awful; yet no one would know how to tell us if and to what extent our understanding of the Colosseum as historical testimony and as a work of art is compromised by this desperate state of conservation. (Urbani, 1996)

This reflection proves that the notion of damage is the result of subjective perceptions, even if these perceptions are very widespread. Ruins and many other 'damaged' objects may become meaningful because of their alteration. For example, a stain on a coat or some mud on a historical uniform might not only be considered as a form of damage, but also become so valuable as to be painfully conserved (the stain could be from blood of a dead hero, and the mud could be a strong reminder of the extreme conditions of life in World War I trenches, as is the case with Nelson's coat or the soldier's uniforms kept in the Australian War Memorial) (Pearce, 1990; Eastop and Brooks, 1996; Jaeschke, 1996). As Manieri Elia has written:

> ...la ruina (...) puede poner en situación paradójica la cientificidad de la conservación, ya que su sentido, más allá del valor histórico de documento material (...), consiste precisamente en su encanto como ruina. (Manieri Elia, 2001)

> [... ruins (...) may expose the scientific nature of conservation as a paradox, as their meaning, beyond their value as a material document (...), lies in their charm as ruins.]

This paradox is produced when 'damage' is thought to be synonymous with 'alteration', that is, when damage is thought to be an objective notion. However, there is no paradox when it is acknowledged that damage heavily depends on *subjective* value judgements. In fact, many debates upon conservation (from the 'cleaning controversy' to the polemic over the Sistine Chapel) revolve around whether or not a given alteration should be considered as 'damage' or as 'patina'. Unfortunately, in many cases, hard scientific methods are brought into the debate, which, while having a tantalizing effect, are not really helpful when deciding about this basic question. By not realizing that damage is, preeminently, a value judgement, objectivist theories of conservation take both science and conservation to a position where they are forced to solve problems which they are not prepared to solve.

The argument of unsuitability: subjective and intangible needs in conservation

The first argument against classical views on conservation relies upon the subjectivity of judgements based on the authenticity or falsehood of an object's condition or nature. The second argument stresses the unsuitability of objective knowledge in conservation, reminding us that conservation responds to human (subjective) priorities, tastes and needs. This argument relies heavily on the fundamental ability of conservation objects to communicate meanings, which has been described in Chapter 2.

Communication is both a non-material phenomenon and a subjective phenomenon. Hard sciences are unable to cope with it, and, furthermore, objective conservation approaches are bound to fail in addressing this all-important factor. A strikingly naïve example was offered by Helmut Ruhemann recalling an experience in Central America:

> In 1956 I went to Guatemala on behalf of UNESCO for three months, to train three artist-craftsmen in picture restoration. The many religious paintings in the charming baroque churches badly needed attention, though few were of high value. Hardly any had ever been restores or cleaned, but when it came to removing the darkened varnishes from some of the sacred pictures I hesitated. It occurred to me that the population, the majority of whom are *Indios*, descendants of the Maya in fact, might be appalled if they suddenly saw their Saints, whom they had always known with skin as brown as their own, emerge as white Europeans. (Ruhemann, 1968)

In this case, there are conflicting views – conflicting meanings actually. On the one hand, there is the expert from abroad, who sticks to scientific, objective standards and who considers that darkened varnishes obscure the authentic condition of the object: it can be objectively demonstrated that the past look of the object was a very different one, and for the sake of 'authenticity', the

object should be returned to that condition. On the other hand, there are the *indios*, the legal and moral owners and custodians of the object; for them, the object is important because of its meanings, and for the object to mean 'properly', it is important that the darkened varnishes be maintained.

As the tautological argument proves, relating the authenticity of an object to its original condition (or to any other past or presumed condition) is an entirely subjective choice. Even if it were not, the appropriateness – the suitability – of applying an objective approach to objects which are appreciated (and thus conserved and restored) for their subjective values is highly questionable. Should scientific, objective criteria prevail? Why, and at what cost? The well-known *'cleaning controversy'* is another example of this problem and is especially interesting because of the quality and novelty of the discussions that ensued and the publicity of the arguments.

This controversy took place in the mid-twentieth century and revolved around the cleaning of ancient paintings in the National Gallery of London. While such cleaning was performed with scientifically approved techniques, it still produced far too harsh results which were not acceptable for many observers. An open debate ensued regarding cleaning methods, art techniques and the authentic state of the paintings. The debate soon became an expert's *querelle* between hard and soft scientists, particularly between chemists and art historians. The chemists argued that the cleaning of darkened protective varnishes had been scientifically devised and monitored to avoid the removal of paint layers, while art historians responded that, according to their own historical research, coloured resin-based varnishes were purposely applied by painters themselves and could have been affected by the same solvents used to remove darkened protective varnishes (Brandi, 1977; Walden, 1985; Conti, 1988; Daley, 1994). However, beyond the scientific quality of the research performed by both sides, and

even assuming that the scientific cleaning of a painting could always be safely performed, the very suitability of the objectivist approach could be questioned. For many people, the value of those paintings does not rely on the documental value they could have for experts, but on the aesthetic and symbolic values that the paintings may have for them. Objectivist approaches simply ignore these values, as they cannot cope with them at all.

Objective approaches have been thus questioned both by classical aestheticist theorists and by contemporary theorists alike. The grounds are different in each case: classical aestheticist theorists emphasize the relevance of aesthetical values and the role of soft sciences in conservation decision-making (e.g. Carbonara, 1976; Brandi, 1977; Baldini, 1978; Walden, 1985; Bonelli, 1995; Kirby Talley Jr, 1997; Philippot, 1998), while contemporary theorists stress symbolism and communicative functions. Both criticisms thus form a pair of tweezers, acting in opposing directions, but collaborating towards the same purpose. They act in opposing directions because classical aestheticist theories still consider truth (aesthetic and historical truth) as a primary goal, which belongs to the expert's realm. Contemporary theory, on the contrary, stresses subjective decisions and values. Muñoz Viñas (2003) has described and exemplified the '*acts of taste*' that conservation (whatever its scientific level) necessarily relies upon:

La Restauración es una actividad basada en el *gusto* de cada momento o de cada persona. El gusto influye sobre los criterios de Restauración empleados en cada caso de tres maneras distintas:

- Contribuyendo a la priorización de la Restauración de unos objetos sobre tros.
- Haciendo prevalecer un *estado de verdad* sobre otros.
- Recreando ese estado de una forma u otra.

La catedral de Valencia, por ejemplo, fue construida en su mayor parte en estilo gótico mediterráneo y objeto de una profunda y espléndida reforma en estilo neoclásico. En los años 70 del siglo

XX se decidió su Restauración (un primer acto de gusto, porque esa decisión implicaba la no-Restauración de otros edificios y objetos). La restauración planteó un dilema: se podía conservar el interior neoclásico, o intentar recuperar el gótico original. En la historia de Valencia, sin embargo, el siglo XV representó un momento de esplendor, y en la década de 1970 el gótico era considerado como una especie de 'estilo nacional' que simbolizaba un brillante pasado, por lo que finalmente se optó por eliminar el interior neoclásico. Los revoques, los dorados, las pinturas, los pilares, fueron picados (esta decisión fue un segundo acto de gusto) hasta alcanzar el núcleo de piedra gótico, un núcleo cuyo estado era poco *presentable* y que tuvo que ser adaptado a su nueva condición, confiriéndole unos acabados particulares que fueron elegidos entre varios posibles para producir un resultado final concreto (un tercer acto de gusto).

[Conservation is an activity which is based upon the *tastes* prevalent at a particular time or in a particular person. Taste has an influence on the conservation criteria used in each treatment in three different ways:

- In prioritizing the conservation of some objects.
- In making a "true condition" of the object prevail over other possible ones.
- In re-creating that condition in a given way.

For instance, most of the cathedral of Valencia, Spain, was built in a Mediterranean Gothic style; subsequently it was the subject of a splendid neoclassical refurbishment. In the 1970s, its conservation was decided (the first act of taste, because this decision implied the non-conservation of other buildings and objects). The conservation raised a dilemma: whether to conserve the neoclassical interior or to attempt the recovery of the original Gothic style. In the history of Valencia, however, the fifteenth century is considered to be an era of splendor, and in the 1970s, the Gothic style was considered to be a sort of 'national style' symbolizing a brilliant past. As a consequence, it was finally decided that the neoclassical interior would be eliminated (this decision was a second act of taste). Plaster layers, gilt decorations, paintings and pillars were chipped away until the Gothic stone nucleus was reached, a nucleus which was not in very good condition, and which had to be adapted to its new state, conferring it with some particular finishes,

chosen among the various possible ones, to produce a given final
result (a third act of taste).]

These *acts of taste* are unavoidably performed in each conserva-
tion treatment, with environmental preservation being the only
partial exception, as in this case only the first act of taste actually
does take place. Whenever an object is conserved or restored, it
might be asked whether or not there are other objects in worse
physical condition and why they should be allowed to decay or
even be trashed. And once the conservation of that object is
decided, the question as to why not just conserve it in its present,
real condition could be raised again. For example, when a painting
is conserved and restored, it can be stretched, cleaned or even com-
pleted to bring it into a new state which is supposed to resemble the
state it was in at some point of its history. This is done not because
this condition is objectively more authentic, but because the paint-
ing will, thus, better fit the tastes of the conservator, the owner, the
custodian or any other interested person. If the work has to be com-
pleted, the conservator will have to decide how to complete it: by
doing so in an invisible way; by using pointillism, *tratteggio* or
rigattino; by leaving a recessed surface in the added fragments; by
drawing a line around added parts; by using the same flat colour
for all added parts; by using several flat colours, according to the
surroundings; by inserting a computer-printed paper or plastic
piece upon the missing parts, etc. All these options, and many
other ones, are there for the conservator to choose, and none of
them is objectively better: its choice constitutes a third act of taste.

David Lowenthal's work is pertinent at this point because he has
aptly and passionately defended the role of subjectivism with
regard to heritage. Many authors have stressed the biases and the
lack of objectivity necessarily inherent in any interpretation of
past facts, from many different points of view (e.g. Walden, 1985;
Dezzi Bardeschi, 1991; Bomford, 1994; Kosek, 1994; Leitner
and Paine, 1994; Stopp, 1994; Mansfield, 2000; Pizza, 2000).

Lowenthal's work is based upon the account of a plethora of examples, showing not only how the past is fabricated today, but also how it has been 'fabricated' for centuries. In 'Fabricating Heritage' (1998), where he has extracted and summarized much of his previous work, he proposes one of those examples:

> Milan in 1162 had just fallen to Frederick Barbarossa. As a reward for his help in the conquest, archbishop-elect Rainald of Cologne pillages Milan's relics. Rainald's most notable coup is the remains of the Magi, legendarily brought from Constantinople with Constantine's consent by St Eustorgio in an ox-cart in 314. Now they are on the move again. Though waylaid en route by minions of Pope Alexander III, the three coffins with their sacred booty reach Cologne unharmed. In Nicolas of Verdun's splendid golden shrine (c. 1200) they become Cologne's main patrons.

> The Three Kings by the thirteenth century were a royal cult, emperors coming to venerate the Magi after being crowned in Aachen. Otto IV of Brunswick had himself portrayed on the reliquary as the Fourth King. Belatedly the Milanese lamented the theft. The sixteenth-century Archbishop St Carlo Borromeo campaigned for their return; in 1909 a few Magi fragments were actually sent from Cologne to Milan.

> But they were *not* sent *back*; they had never been in Milan. The whole story – Constantine, Eustorgio, removal to Cologne – had been fabricated by Rainald. Every mention of the Magi in Milan traces to the archbishop's own account. No wonder the Milanese were tardy in recognizing the theft; only in the late thirteenth century did Rainald's tale reach them. Then Milan mourned the loss of relics it had never had.

The moral here is twofold. First, the facts were created; second, they were created for good reasons and were effective:

> Rainald's purpose was clear: to promote the power of the emperor and the glory of Cologne. Relics of the Savior were the most precious the Franks got from Italy and the Holy Land. As symbols of Christ's lordship and of divine kingship, the Magi trumped vestiges of Church Fathers and Roman martyrs. But they needed a pedigree; a legacy of veneration was vital to their efficacy in Cologne. Hence

Constantine, the ox-cart, stewardship in Milan, their incorruptible state en route. And it worked. It worked even in Milan, where Visconti patronage of the lamented Magi helped scuttle both republicanism and Torriani family rivals accused of exposing the Magis' hiding place to Frederick Barbarossa.

This fabrication was worthy in various ways. It confirmed the Empire's sacred roots. It updated and enlarged a useful biblical legend – little before was known of the Magi, not even how many they were. It became an exemplar of other sacred translations – fragments of bone and dust that were easy to fake, easy to steal, easy to move and easy to reassign to new saints as needed. It begot great value from wishful fantasy. It destroyed nothing, not even faith when the fake was found out.

For Lowenthal:

We must reckon with the artifice no less than the truth of our her-itage. Nothing ever made has been left untouched, nothing ever known remains immutable; yet these facts should not distress but emancipate us. It is far better to realize the past has always been altered than to pretend it has always been the same. Advocates of preservation who adjure us to save things unchanged fight a losing battle, since even to appreciate the past is to transform it. Every relic is a testament not only to its initiator but its inheritors, not only to the spirit of the past but to the perspectives of the present. (Lowenthal, 1985)

Presently, fabrication of the past is not produced in as bold and deliberate a way as that of Rainald's. The fabrication pro-ceeds through subtler, less obvious manners, and in many cases conservation is involved in it: 'To be a living force the past must be ever remade. (…) Heritage must feel durable, yet pliable. It is more vital to reshape than just to preserve' (Lowenthal, 1996). Lowenthal has summarized the ways in which 'heritage' alters the past to adapt to present needs:

It *upgrades*, making the past better than it was (or worse, to attract sympathy). It *updates*, anachronistically reading back from the

present qualities we want to see in past icons and heroes or "restoring" paintings in line with modern preferences for a Michelangelo to look like a Matisse. It *jumbles* the past in a synchronic undifferentiated Dumpster, so that the Gauls come close to de Gaulle, Elizabeth I joins Elizabeth II, witchcraft and pseudomemories of satanic abuse tread the same American stage. It *selectively forgets* the evil or indecorous or incomprehensible in acts of oblivion and bowdlerizing. It *contrives genealogies* to satisfy mystiques of lineage, as with mediaeval kings who traced themselves to Troy and revolutionaries who bolstered claims with classical prototypes. It *claims precedence* as a bona fide of possession, superiority or virtue, as with primogeniture, Piltdown Man, and today's First Nation peoples. (These modes of contrivance have much in common with cinema, through which many if not most people derive compelling notions of the past). (Lowenthal, 1998)

Most of the contemporary *fabrication* of heritage is done in an unintended and often unacknowledged way. Conservation plays a role here as, regardless of its 'scientificity', it contributes to Lowenthal's fabrication techniques. The *selective forgetting* of some objects is done each time some objects are selected for conservation treatment, while many others are not, actually condemning these to oblivion. *Upgrading* is also quite common: it happens each time a lift or a fire-protection system is added to a restored building, a canvas is mounted on a self-tensioning frame (which effectively keeps the canvas terse regardless of climate variations), a hand-made paper document is flattened, or whenever any conservation decision is taken in which some features are added to an object that never existed prior to the intervention. The *contrivance of genealogies* happens in a subtler way, and it happens whenever conservation processes attempt to take the object to a state which coincides with any of the preconceived ideas we have about how it should be: a Michelangelo ceiling should look like Michelangelo's paintings should look (perhaps not like a Matisse), and a building should coincide with a recognizable style, or it faces the risk of not being considered valuable (Longstreth, 1995). *Claiming for precedence* takes an interesting form in heritage conservation.

Its consequence is the frequent destruction of some features of an object so that older ones may be displayed, as was the case with the cathedral of Valencia or the Lansdowne *Herakles*.

These *fabrication* processes, and even more so the *acts of taste*, are subjective by definition. For some classical theorists, this may seem disadvantageous, but it is not: it is a prerequisite for conservation to be acceptable. Attempts at purely objective conservation are otherwise likely to be rejected by the subjects for whom conservation is performed, because objective criteria are not necessarily pertinent or superior. Even if the technical problems of objective approaches in conservation could be overcome, the subjective nature and functions of conservation objects could render these criteria unsuitable for the task.

A brief excursion into the real world ___

It is undeniable that both hard and soft sciences have contributed to the improvement of conservation. Generally speaking, conservation techniques are now safer, more efficient and better understood than they were a few decades ago, and many of these improvements have come from scientific research. Many conservators consistently employ or are familiar with conceptual and physical tools and techniques that were originally intended for scientific use, such as stereomicroscopes, lignin detectors, UV lights or Tea's solubility model. For many people, the improvements that science has brought into conservation are the best proof of the validity of scientific conservation. This chapter examines this argument, and in doing so, it necessarily swings away from theory into reality, from the philosophy of conservation into the sociology of conservation.

Conservation and science

Science can be related to conservation in a great variety of ways, ranging from pure science to pure conservation. Even if the notion of science is restricted to hard sciences, it still plays a great variety of roles within conservation:

- It helps to assess a given object's condition. For example, by analysing a set of samples from a marble column, the amount of oxalate salts or other damaging compounds can

115

be precisely known; Fourier transform infrared (FTIR) spectroscopy can reveal the nature (and to a certain extent, the degree) of chemical alteration within a paper sheet; the use of a georadar can inform of fractures and cracks within the wooden structure of an altarpiece.

- It helps to know a given object's history. For example, identifying a given pigment within a paint layer can provide the analyst with some 'ante-quam' and 'post-quam' dates which may be helpful when determining the age of the painting or some of its parts; carbon dating can help in determining the age of an archaeological object; trace analysis of a stone sculpture can let us know its provenance.

- It warrants a given conservation technique or material. For example, research done on cellulose ethers has proved that sodium carboxy-methyl-cellulose is a very stable compound, which can be safely used as an adhesive, but it can also be used in poultices and cleaning gels; analysis of varnish samples can help to determine how the varnish could be safely removed; knowing the concentration of sulphur dioxide in an environment can help to devise appropriate preventive strategies.

This list of categories is not exhaustive but is still quite representative. The only exception worth noting is what could be called 'conservation endoscience', which is the kind of conservation science that includes research that is addressed to conservation scientists rather than to conservators. This is a large category, indeed. It includes the development and adaptation of analytical methods for the identification of material components in conservation objects (a line of research whose sheer abundance can be viewed as a problem (Child, 1994) or as a 'disturbing trend' in Tennent's words (Tennent, 1997)); the study of the mechanisms of the physical and chemical changes in a given compound; the development of theoretical models of behaviour of different materials and other research which increases our knowledge base,

but has no actual impact on conservation (although this research *might* hypothetically have an impact upon actual conservation through further research).

Although some types of conservation science are not relevant to conservation practice, the criticism that conservation science is not useful to conservators does not have universal value and is plagued with exceptions. For many people, however, these exceptions are much fewer than those plaguing the pragmatical argument itself. This question has been analysed by different authors who have stressed the lack of pragmatical relevance of conservation science (e.g. Sánchez Hernampérez, s.d.; De Guichen, 1991; Hansen and Reedy, 1994; Tennent, 1994; Keck, 1995; Torraca, 1999). Their reasons for this lack of relevance can be classified into three broad categories: the first one is the lack of communication between conservators and scientists; the second one is the inability of science to cope with actual conservation problems and the third reason is the lack of technological knowledge.

Lack of communication

Around the mid-twentieth century, the alliance between science and conservation seemed extremely promising. The scientific analysis of material compounds in conservation objects, the study of decay processes and the assessment of conservation techniques seemed to be very productive ways to improve conservation practice. Scientists soon became a common presence in most leading conservation centres. This presence was expected to foster an exchange of knowledge between conservators and scientists, which was to be fruitful and mutually beneficial.

Almost 50 years later, and with some brilliant exceptions, things seem to have gone awry. As Yasunori Matsuda conceded, 'conservation scientists are unable to provide a support system for restorers' (Matsuda, 1997). The difficulties in communication

between conservators and scientists seem to be an important reason for this, so important, in fact, that in the latter part of the twentieth century, the British Museum organized an international meeting to deal with this matter. It was aptly titled 'Can scientists and conservators work together?'.

Answers to this question may vary, but many conservators do not think that direct contact with conservation scientists is of much help, while some even think of it as an annoyance. As Gianluigi Colalucci, who conducted the restoration of the Sistine Chapel, has written:

> Los restauradores casi siempre (...) consideran [a los comités científicos] un incordio. Quienes los constituyen, generalmente quieren servirse de ellos como una sombrilla con la que protegerse de la lluvia de críticas, mientras que los componentes del comité tienen siempre la intención de dar órdenes y de establecer los métodos de intervención (...). La mayoría de las veces estos comités son un problema en sí mismos y para los demás, porque quien los requirió se arrepiente de la decisión; los componentes del comité se sienten frustrados y se enfadan cuando sus consejos no se siguen, y los restauradores sufren y miran el reloj porque esperan que se vayan pronto para trabajar tranquilos. (Colalucci, 2003a)

> [Most often, conservators consider [scientific committees] to be an annoyance. Those who appoint the committees usually want to use them as an umbrella against a hail of criticisms, while those taking part in them always want to be in control and decide which conservation methods should be employed (...). Most of the time, these committees are a problem in themselves and a problem for others as well; the person who appointed the committee regrets the decision; its members feel angry and frustrated when their directives are not followed; and conservators go through them painfully and look anxiously at the clock waiting for the committee to leave so that they can work undisturbed.]

The imposition of scientific values, methods and criteria over those of the conservators is often felt as a kind of 'colonial' imposition: in this comparison, scientists are seen as newcomers

who have the will (the good will) to impose a knowledge that they honestly feel as superior to the nearly superstitious knowledge of the original inhabitants of the field. The notion of science as 'imperialist' has, in fact, been used by different authors (De Guichen, 1991; MacLean, 1995; McCrady, 1997; Clavir, 2002); and, as usually happens in imperialist processes, 'natives are frequently hostile' (the expression is Torraca's, as quoted in De Guichen, 1991).

This and other reasons for the lack of communication between scientists and conservators have been analysed by different authors. Some scientists, such as Chartier, Hansen and Reedy, suggest that the problem is really on the conservators' side, as there exists:

> ... a need for greater awareness (and education) on the part of practicing conservators regarding the nature of laboratory research, how it is conducted, its limitations and practical benefits, and how research results can be meaningfully translated into improved conservation practice. (Hansen and Reedy, 1994)

Other people, however, think differently. Conservation scientist Giorgio Torraca believes that conservators have already moved 'into the frontier between culture and science' (Torraca, 1999). The lack of communication between conservators and scientists could be due to the fact that, many times, the scientist uses 'the most abstruse technical jargon' to keep other people from reading reports (Torraca, 1999) – a point of view shared by authors such as Kirby Talley:

> Unfortunately, many scientists do little or anything to make their field easily understood by conservators in all its complicated details, and the details are usually of paramount importance. Too many scientists in our profession have adopted the stance that if you really want to understand things then you had better study more science. (Kirby Talley Jr, 1997)

Whatever the reason, this situation seems hard to overcome. In many cases, the solution requires not better education or more

research, but personal skills and abilities on both sides, especially humility and open-mindedness, which can be considered as very valuable forms of wisdom. Apart from being hard to learn and teach, these skills are not reflected in diplomas or résumés and cannot be measured by objective means. Therefore, the choice of professionals with these talents very often becomes a matter of luck.

As a consequence of the lack of communication between conservators and conservation scientists, more and more endoscience is produced. The problem is worsened by yet another difficulty, which derives from the actual limits of science as practised today: the insufficiency of hard sciences to cope with all but the simplest technical conservation problems.

The insufficiency of hard sciences

Complexity

The development of scientific knowledge is a truly impressive human achievement. Its growth has been incredibly rapid: as a consequence of the work of a vast number of scientists at all levels and all around the world, thousands of articles, congresses communications, books, databases, etc., are produced at an astonishing rate. All of them contribute towards the enlargement or the perfection of humanity's knowledge in every conceivable scientific field, from medicine to astronomy, from biogenetics to electronics, from computer science to optics, etc. The growth of scientific knowledge is so impressive that it might even produce the illusion of perfection: it may lead us to believe that it can cope with almost everything, that there are no gaps, that it provides the almost total comprehension of the physical world. Of course, this impression is misleading. The fact is that the more perfect our knowledge, the more aware we are of the huge gaps in this same knowledge.

In many cases, these gaps are caused by the complexity of the real world. Scientists value simplicity highly, to the point of regarding a working hypothesis as false just because another simpler working hypothesis exists: as Occam would have it, *entia non sunt multiplicanda praeter necesitate*. Science works by isolation of factors and by dissection of phenomena (this is what the word *analysis* means). In fact, science works quite well when facing simple systems: the most familiar case is astronomy, where phenomena develop in an almost perfect vacuum and occur on a time scale that is so overwhelmingly large that 'asystematic', accidental phenomena (such as a giant meteor deflecting the orbit of a planet) are extremely rare. As a consequence, science can determine with exhaustive precision, the time when an eclipse of the sun will take place, the exact moment at which some planets will be arranged in a given way or exactly where the moon will be in an absurdly long period of time.

However, it is not possible for scientists to precisely know *whether* it will rain next week (not to mention *when* or *how much*) or when a light bulb will fuse. Rain and light bulbs are much closer to people than any planet or star, and the bulb has even been designed and manufactured by human beings according to strict specifications and with perfectly known materials. It is not a question of predicting events that will take place in 10 000 years, but of predicting events that will happen in few years or in few days. Why cannot science answer these questions?

The answer is simple: because of complexity. While planets and sidereal bodies exist in a nearly perfect labora-tory chamber (space), and are subject to almost pure physical forces with extremely rare interferences, rain is the result of many constantly changing factors (relative and absolute humidity, pressure, temperature distribution, winds, geography, etc.) that interact in many complex ways. Similarly, the life of a light bulb depends on the pureness of the tungsten filament, its constant thickness, the

vacuum level achieved within the bulb, the stability of the power supply, the quality of the manufacturing process, the quality of the materials and the construction of the appliance where it is mounted, etc. Science finds it difficult to deal with complex phenomena; to do so, it resorts to statistics, and in many cases, it does not produce certainties, but mere probabilities. Even so, in many cases, reality evolves in very unpredictable ways: as the chaos theory suggests, a small variation in obscure – or uncontrollable, unmeasurable or simply unknown – variables within a system can have important consequences upon the evolution of the entire system:

Tiny details are often neglected in studying many phenomena in nature, but these details prove to be quite important in the big picture of things. Introductory physics instructors (the brave ones anyway) often attempt to exemplify the equations of physics by performing classroom demonstrations. For instance, while covering projectile motion, an instructor might calculate on the blackboard exactly how far a ping-pong ball will travel after being shot out of a catapult at an angle of a certain degree with a certain initial velocity of definite amount. Any introductory textbook will assert that Newton's laws of classical mechanics may be used to calculate exactly where the ball will land. So then, attempting to liven up the classroom (as quite a few of the students have already zoned out by the time projective motion is covered in class), the teacher brings out an actual catapult, sets it to exactly the angle and initial velocity calculated on the blackboard, and shoots the ball across the room.

The instructor repeats the demonstration ten times and each time the ball lands in a slightly different location, no location corresponding to where Newton predicts the ball to land. But how can this be? Classical physics asserts that the ball should land in exactly the same spot every time. But of course it doesn't. One time it's a little to the left of the projected landing spot, while another time it's a little to the right. For a number of the runs the ball does not travel quite as far as the calculation predicted, while for some runs it travels a little further. What has happened?

Well, the reason for the differing results of the experiment has to do with the fact that the world is not perfect. The spring constant on the catapult was only 99.9% accurate and the blackboard problem assumed a 100% accuracy, thus, the actual initial velocity of the ping-pong ball was not quite as large as expected. Furthermore, the air conditioner was on in the back of the room, thus creating an air current that sent the ball on a slightly off-centre trajectory (and the air conditioner had switched on and off a number of times over the course of the ten shootings). The ping-pong ball itself had a mass that was slightly greater than the mass used in the calculation, as it was dirty and had acquired a very small layer of dust around its surface. In bulk, the demonstration was not conducted in a vacuum with perfect conditions, so the ball did not hit the ground exactly where it was 'supposed' to hit the ground. All these tiny factors, the spring in the catapult, the air conditioner, the dirty ball, though seemingly insignificant in themselves, when taken together contributed to the ball landing really nowhere near where it was predicted to land (and thus making the professor look quite foolish – no doubt reinforced by a flippant remark from one of the students sitting in the back row who shouted, 'It's a good thing we know these principles in theory, because we sure as hell can't demonstrate them'). (Donahue, s.d.).

These complex mechanisms leave many things out of the reach of science. As Jim Yorke has put it, 'we tend to think science has explained everything when it has explained how the moon goes around the earth. But this idea of a clock-like universe has nothing to do with the real world' (Donahue, s.d.).

Many practising, hands-on conservators have achieved similar conclusions regarding their field. All too often, materials do not behave in the way they should. As expressed by a professional conservator, 'there is often a great discrepancy between what a conservation scientist tells us will happen during a particular treatment and what actually occurs. Sometimes what we are told and what actually happens are polar opposites' (Hansen and Reedy, 1994). While much research has been done in the laboratories to characterize and understand the physical and chemical reactions

of conservation objects, reality stubbornly refuses to abide by theoretical formulas, much like the ball described by Donahue. Water-soluble inks in a manuscript, for instance, can remain in place even after immersing the whole artefact in water for several minutes, while other materials can be severely affected by contact with solvents which are supposed to have no effect upon them; some impregnation products will deeply penetrate – and consolidate – a stone statue with a given porosity, but will hardly penetrate another stone artefact with a similar porosity; two products with identical chemical composition can behave differently even if acquired from the same provider and so on. Many hands-on conservators (with or without scientific education) often experience problems of this kind. In these cases, it is up to them to solve the problem, frequently before a given deadline and within a given budget.

As the conservation scientist Mary Striegel has written, 'the scientist searches for truth. The conservator searches for solutions' (McCrady, 1997). Conservators are not required to solve scientific problems, but rather to solve conservation problems. For example, they do not need to study the chain scission route in cellulose degradation, or study the kinetics of a given chemical compound under accelerated-ageing conditions. Their duty is to keep the artefact as it is expected to be, or change it to an expected condition. Mistakes are a given in science, because it evolves through trial and error: by the production of new hypotheses that derogate preceding ones, by proving the mistakes of other scientists. However, they are hardly tolerable in conservation, especially if they happen to have short-term, perceivable consequences. Admittedly, the solution to certain scientific problems could help in finding solutions to certain conservation problems, just as some specific conservation technical solutions could help produce new scientific knowledge. However, while in some cases conservators might contribute to scientific knowledge and scientists might actually help solve a given conservation problem, these are often just by-products of each activity.

An infinite variety of objects

An important reason why actual conservation objects most often escape the realm of scientific predictability is that there are no two identical objects: every object is truly unique for at least two reasons:

1. Even with industrial techniques that emphasize quality control, exacting analysis of materials, and assembly line production, it is extremely difficult to produce two completely similar objects.
2. No object is ever exposed to identical conditions, and thus each one has a different evolution.

Computer microchips are a good example of the first reason. These amazing objects are produced in sterile environments, with extremely strict quality controls, and following exacting standards. And yet, they can behave in quite different ways: some work at a given clock speed, but others can work at double that speed – and still others will not work at all. This phenomenon is much more acute in the case of conservation objects, as most of them have been produced in a much less controlled manner. The oil-binding medium in a seventeenth-century oil painting, to name a relatively common example, can vary greatly depending on its very origin. Even seeds from plants of the same species (e.g. linseed) can yield slightly different products, with varying proportions of derivatives of fatty acids and other natural impurities from the seeds – as these may or may not have been thoroughly cleaned – or from the press itself. The resulting product might have been treated in different ways, with different refining techniques, and heating at different temperatures for different periods of time and with varying levels of oxygenation. The oil thus treated might have been stored in different containers made of different materials, and then kept for different periods of time in different places, with different temperatures, atmospheric pressures and relative humidities. The oil may have then been

combined with hand-made pigments, dyes, resins, dryers, solvents, other oils, etc., each of which has its own unexpected, uncontrollable impurities.

When the oil was applied to the canvas, a new set of variables came into play. The first layers were in direct contact with the canvas, which might contain different impurities, priming, textures, etc. The final layers were covered by another layer of paint, thus modifying its drying time and its future behaviour. Furthermore, there is no reason why the oil in a painting should be evenly spread all over its surface or why it should have the same thickness.

Then, there is the *history* of the object once it has been created, as every object is subject to different conditions, and thus evolves in different ways. There is no chance that two objects are exactly the same, but even if they were, there is no chance for them to be exposed to exactly the same conditions. The painting was covered likely with a varnish at some point in its history, and perhaps more than once. It was probably kept in some specific environmental conditions and could have been moved from one location to another several times: it could have been exposed to sunlight for 50 years, then stored in a dark, humid room for a century, only to be later taken to the house of a different owner living in an area with a different climate. It could also have been cleaned, perhaps by an untrained maid who might have used a broad range of products (from water to bleaching powders, from ammonia to saliva). It might even have been treated by a conservator who applied some chemicals to its surface, causing the lixiviation of some part of the oil paint layers.

Under these conditions, the oil in the painting can be compared to the ball in Donahue's example. The role that minimal changes play in the behaviour of a system, which is pivotal to the chaos theory, comes into play as well. Even though these materials are

described using the same broad term (*oil*, or perhaps *linseed oil*, or *poppy-seed oil* or *walnut oil*) it would be a mistake to assume that they are exactly the same thing or that they should behave in an identical way, just as it would be a mistake to expect the ball to consistently land in the same spot. While all oils fall under the same conceptual umbrella (*oil*), and we use the same word to describe them, reality remains stubbornly complex, proving that two oils of similar origin, and even present in the same painting, can still be different, and behave differently. True, all oils share important similarities, and they often behave in quite similar ways, but differences can and do exist. Science may predict, with some degree of precision, how a drying oil (like those used in paintings) will behave when exposed to a given solvent, but the conditions of the oil in a sample in the laboratory are not like those of an actual, unique painting. Conservators perform their own experiments through real practice on real works. Experienced conservators have conducted their own experiments in conditions that are close to reality, and they are able to make their own predictions, which, more often than not, are very accurate. However, it must be stressed that while the scientific method seeks to produce rules whose validity is as universal as possible, the conservator always has to deal with specific, individual cases. To bring back some classical dichotomies, it could be said that traditional science tends to be conceived by its practitioners in an ideal, Platonic way, while conservators need to be essentially Aristotelian because they have to deal with unique, complex artefacts. Using Windelband's notions, it can be said that conservation scientists' work is 'nomothetic', while the work of the conservator is necessarily 'idiotechnic' (nomothetic disciplines, such as natural sciences, search for general, reproducible rules while idiotechnic disciplines, such as history or archaeology, study particular cases (Windelband, 1894)).

Indeed, the conservator has to solve specific problems, which never fully adjust to chemical or physical rules: the conservator

cannot consider the object being worked upon as a matter of mere statistics, but as a unique work that poses problems that have to be solved regardless of whether it adheres to present scientific knowledge about its material components. As an American conservator has put it:

> Scientific research seems necessarily limited (…) while the problems conservators face are highly complex. We need researchers to identify clearly the limitations of their conclusions and to help us bridge the transition from lab experiment to actual treatment. (Hansen and Reedy, 1994)

A bridge is really needed; the transition from the conclusions obtained in the laboratory to the real conservation world can be contemplated as a leap of faith:

> … resulta evidente que para proporcionar resultados *científicos* sólo debemos aislar las variables y realizar muchas observaciones para de ahí dar un salto mortal y enunciar generalizaciones sobre objetos y situaciones reales. Sin embargo resulta muy difícil extrapolar resultados de laboratorio a los de la vida práctica, sobre todo teniendo en cuenta que los análisis se centran en sistemas cerrados en los que dominan una o dos variables. (Sánchez Hernampérez, s.d.)

> [… it is evident that, in order to get scientific results, we only have to isolate the variables, make plenty of observations and then take a leap of faith towards the general statements about the real objects and the real circumstances. However, it is very hard to extrapolate real life situations from laboratory results, even more so, if we bear in mind that those analyses are always carried out in closed systems that are influenced by one or two variables.]

This gap between scientific knowledge and the real world has important consequences in conservation science. The scientist often has to choose between working with samples from real conservation objects or with standardized samples. The former produce results that are seldom fully repeatable and that are unlikely to be of any use beyond the object they were extracted from. The latter

produce repeatable results, but their conclusions are hardly applicable to real, unrepeatable conservation objects. A typical example is the Whatman filter paper.

The Whatman filter paper is used in chemical laboratories for analytical purposes and is also frequently used in samples in conservation science tests: it is a kind of paper that has little to do with the kind of papers that conservators deal with, but it has analytical advantages: it is free from pollutants, it is new, it is as simple as paper can be and it is produced under very strict standards (not to mention the fact that it is easily available). One professional paper conservator wryly summarized this point complaining that, as a result of scientific conservation research, 'we have learned a lot about Whatman filter paper' (Hansen and Reedy, 1994).

A vindication of conservators' technical knowledge

Many scientists have become aware of these problems. The Portuguese conservation scientist, João Cruz, asked, 'Se cada obra de arte é única, porquê estudar materialmente conjuntos de obras?' (Cruz, 2001) ['If each artwork is unique, why do we study groups of artworks?'].

Since scientific research in conservation is essentially nomothetic, Cruz comes to the conclusion that studying groups of artworks in conservation science is useful for scientists because:

> Só os conjuntos premitem construir a escala que serve de medida ou referência às propriedades, químicas ou outras, que sao determinadas para cada uma das obras, propriedades estas em que se fundamenta a colaboraçao do laboratorio. (Cruz, 2001)

> [Only groups of artworks allow the production of a set of data against which the results of the chemical (and non-chemical) analyses of a given artwork can be compared, i.e. a set of properties on which cooperation with the scientific laboratory is based.]

However, in spite of the fact that the study of groups of artworks is the only way for successful co-operation with the scientific laboratory, and that it is a requisite for science to produce satisfactory results, it is actually extremely rare. The main reason for this is, very likely, the variety and complexity of these objects, which simply do not lend themselves to systemization. As Cruz states:

> De um modo geral, os problemas relacionados com a conservaçao e restauro podem ser abordados através da análise de uma só obra de arte – precisamente aquela que está na origem das dúvidas. (Cruz, 2001)

> [Generally speaking, conservation problems can be approached through the analysis of a single artwork – precisely the one that has posed the problems to be solved.]

This single-artwork approach is necessary because scientific *laws* are usually extremely general, and the objects are complex systems whose behaviour can deviate from the 'proper' path. This basic idea may not be obvious to outsiders and even to newcomers; it is certainly not obvious to many inexperienced conservators, that is, to conservators who have not yet conducted a significant number of hands-on, first-person experiments on actual objects under actual, real-life conditions. To cope with these problems, hands-on conservators apply what could be called real-time *adaptive intelligence* (the term has been freely taken from Beer (1990)): they are ready to deal with exceptional, unpredictable behaviours at every moment of the conservation process, and they can adapt to them in real time.

This real-time adaptation is crucial for a conservation process to be successful. Quite often, the projected treatment becomes inappropriate, and in nearly every case, it has to be adapted as new, unpredictable problems arise. The conservator-at-work is continuously gathering sensory data from the conservation object. Most, but not all, of these data come from what conservation scientist Ashok Roy has described as 'the most revealing form of

examination' of artworks, i.e. 'looking' (Roy, 1998). However, this is not the only source of information: other senses may well provide valuable information not only more efficiently, but also more accurately than many scientific analytical devices – Grissom, Charola and Wachowiak, for instance, scientifically compared to the accuracy of stylus profilometry, reflected-light computer-image analysis and microdrop water-absorption time measurement when measuring the roughness of stone surfaces, to conclude that 'touch evaluation was the most successful method (...) over a wide range of stone surfaces' (Grisson *et al.*, 2000). Data of this kind are then almost instantly analysed by conservators, and decisions are taken in real time. Shashoua has illustrated these decisions:

> A conservator may need to vary an established formulation in order to optimise the working properties of the material and thus meet the requirements of the object being treated. Such variations may involve adding matting agents to an acrylic paint to reduce gloss levels on an inpainted surface, reducing the volume of solvent to reduce the rate of flow of consolidant into a crack or altering the solvent blend to compensate for high seasonal temperatures. (Shashoua, 1997)

Quite interestingly, Shashoua acknowledges that these minor variations are *necessary*, but she regrets that they are not often properly recorded:

> Although such minor variations in formulation are fully justified, they are frequently undocumented in conservation records and, as a result, more difficult to reproduce at a future date. In addition, it is not always appreciated that changes in formulation are likely to alter the long-term stability of conservation materials. (Shashoua, 1997)

This approach is closer to actual conservation practice than classical hard-scientific approaches, because it stresses the relevance that small variations in formulation may have upon the future behaviour of a material. To achieve a better reproducibility of successful treatments, Shashoua suggests that those *fully justified*

'minor variations' in formulation should be recorded by the conservator.

Admittedly, minor variations of many types can certainly have an impact upon the long-term stability of the conservation materials employed in each case, but this stability is also likely to be similarly affected by many other *non-recordable* factors, which may render the recording of those 'minor variations in formulation' almost completely useless. Shashoua herself acknowledges the existence of 'minor batch-to-batch variations' in commercial conservation products, but the ever-changing materials that the conserved objects are made of, and the different conservation conditions that the objects have been exposed to should also be taken into account.

Then, a second set of factors must be considered: how can a conservator record those *minor variations in formulation*? Let us imagine a common example: a conservator is consolidating a small sculpture, made of some porous stone, which has some menacing cracks. The conservator can note down the formula of each pot of consolidant, registering any variation that is introduced into each one for any reason. However, the viscosity required for a consolidant to penetrate a crack in a sculpture is likely to vary from one given area of the sculpture to another, and in fact, from one part of the crack to another. To cope with these variations, the conservator usually dips the brush into the adhesive pot *and* into the solvent pot to achieve the adequate degree of viscosity for each point; and then he or she applies a varying number of careful brushstrokes at each point to achieve an adequate penetration of the consolidant. How can the adhesive/solvent ratio be recorded? To accurately record the concentration of adhesive applied at each point, the brush would have to be fully cleaned after each brushstroke to make sure that no adhesive remains on it, and perhaps apply it at a consistent angle and pressure. An appropriate tridimensional co-ordinate system would have to be developed

and applied upon the sculpture to allow for at least a minimally precise localization of each application, and all of these details would have to be noted down for every brushstroke. In all, this recording would constitute a huge, unreasonable effort.

Thus, only a part of the information that is received by a conservator during a conservation treatment can be effectively (or usefully) recorded. This results from the very nature of the adaptive attitude that practicing conservators usually take. Conservation ('conservator's conservation, to be precise) is a profession in which decisions are taken at very different levels. After the examination of the object by whatever means available (including scientific means), the conservator makes major overall decisions: in the case of a painting, this could include its lining, the technique to employ for the lining, the adhesive to be used, the type of inpaintings, the replacement of an old frame and so forth. These decisions are all recordable and these records are likely to be useful, as are other data that may be recorded in the process (the location of the lacunae, the existence of an inscription on the back of the painting, the nature of the fibres of the canvas, etc.). Afterwards, the conservator starts taking what might be called *microdecisions*.

Microdecisions are decisions that are taken in real time and that affect the way major ('bigger') decisions are implemented. For instance, when removing an old varnish from a painting the conservator continuously, and often unconsciously, evaluates the effect of a given solvent on a small portion of the painting's surface. The conservator applies a certain amount of a solvent to the tip of a swab; the amount is important: too much and the solvent will very likely run down the painting; too little and it might do nothing at all or, worse still, the swab might erode the painting. This amount of solvent simply cannot be measured using a *scientific* method (e.g. weighing the amount of solvent absorbed by the swab or applying it with a graduated pipette would make the whole process

extremely slow and, most likely, not better at all). Furthermore, to have any meaning, the measurement of the amount of solvent applied would require swabs with similar shape, weight, cotton-fibre size, density, etc., requirements which, at this point are difficult to achieve.

So, each time a swab is imbibed with a solvent, the conservator is judging whether or not the swab contains an adequate amount of solvent. After *deciding* that the amount of solvent is adequate (a microdecision based upon previous experiences in varnish removal), the swab is applied, usually with a rubbing motion. This rubbing motion can vary considerably: the swab can go back and forth following a short, straight stroke pattern, or can follow a circular stroke pattern. The pattern can be smaller or larger, or, then again, it may not exist at all. The swab can also be moved in just one direction or be moved and redirected according to the painting's surface. Of course, the movement of the swab is of paramount importance in achieving satisfactory results, as is the duration of the rubbing action, and the pressure exerted on the painting's surface. However, in practice, none of these factors can be scientifically measured. To evaluate the results and take real-time microdecisions, the conservator not only has to rely on that 'most revealing' examination tool, the eye, but also on other very valuable tools, such as the continuous tactile feedback provided from the swab's handle and, perhaps, the sound of the rubbing action, or even the smell of the dissolved varnish. The conservator analyses the information gathered through these tools and immediately reacts by changing the motion pattern, modifying the pressure, adding more solvent, disposing of the swab, etc. Occasionally, the information gathered leads the conservator to adapt to the problem by taking 'larger' decisions, such as reformulating the solvent, or even substituting it for an entirely new one, perhaps even stopping the cleaning altogether, or intensifying it only in some portions of the painting's surface, etc.

Microdecisions exist and lie at the core of the activity of most professional, hands-on conservators, even if the rationale behind them is beyond, or different to, classical rationalism:

> One important tenet of the Enlightenment's view on rationality is the identification of rationality with the consistent use of logic and probability. In the framework of psychology the main problem with the classic definition of rationality is its blindness to context. Another problem of the classical definition of rationality is that it makes excessive demands of the mind. (...) Expecting people's inferences to conform to classical rational norms in (...) complex environments requires believing that the human mind is a super-computer with an unbounded amount of time, knowledge and computational power. (Martignon, 2001)

Even if non-rational in the classical sense, microdecisions are still efficient; in fact, taking the right microdecisions on a regular basis is a requirement for many conservation processes to produce acceptable results. However, while 'larger' decisions (such as substituting a solvent, or even removing an aged varnish) are clearly noticeable even for laypeople, microdecisions are not. They cannot be easily evaluated, communicated or recorded. This is also the case with so many other activities, from cooking to surgery, from teaching to playing music. In all cases:

> ... hay serias limitaciones cuando se trata de envasar en los moldes verbales del conocimiento reflexivo las habilidades prácticas: cuando se intentan estos trasvases hay pérdidas importantes de líquido informativo, que tienen que ver con la dificultad de captar las circunstancias *concretas*, tanto verbales como extraverbales. (Rivera, 2003)

> [... there are important problems when it comes to packing practical skills into the verbal moulds of reflective knowledge: when these transfers are attempted, important amounts of informative liquid are lost, derived from the inherent difficulty of grasping *specific* circumstances which can be of both verbal and non-verbal nature.]

Many activities (from architecture to law making, from plumbing to teaching, from enterprise management to dentistry) heavily depend on a kind of knowledge that cannot be quantified or expressed in words or formulae, a kind of knowledge that is, to use Polanyi's expression, *tacit* (Polanyi, 1983). Indeed, most people waiting for surgery would prefer an experienced surgeon who has forgotten many of the things learnt while in college to an inexperienced one who remembers most of the contents of the textbooks; likewise, most people would rather choose an experienced airline pilot with just a working knowledge of aerodynamics to someone with a deep knowledge of aerodynamics, but with very little flying time.

From a scientific viewpoint, the tacit nature of some kinds of knowledge is an important disadvantage, since 'the characteristic of the scientific method is to isolate a particular band of truth ... namely a strip containing that which can be measured.' (Brooks, 2000). However, it is also disadvantageous from other, more pragmatical angles. For example, conservation teachers find it very difficult to transmit this kind of information and often have to resort to just putting the students in a situation where *they* can learn that kind of knowledge, and encourage them to actually acquire the knowledge. Scientists, on the other hand, disregard this kind of knowledge on the grounds that it is completely subjective and untransmittable: some even deny that it can be considered *knowledge* at all. For Reedy and Reedy, for instance, it is just *skill*:

> Art conservation practice combines philosophy, skill, and knowledge. Philosophy covers the goals and evaluation of conservation practice, including aesthetics, questions of restoration versus preservation, and questions of reversibility versus permanence. Skill comes from hands-on practice obtained in apprenticeship and training programs. Knowledge can be communicated (...). (Reedy and Reedy, 1992)

Since measurement and analytical isolation of factors is an extremely important requirement for most science to be performed, it is logical that only the band of knowledge that can be successfully registered and transmitted (i.e. the band of knowledge that can be successfully worded or formulated) is considered to be true knowledge. Indeed, most scientists share a deep belief in what Ryle has called 'the intellectualist legend': the belief that all decisions and knowledge are produced out of conscious, speakable thinking (Ryle, 1984).

The intellectualist legend, however, has been contended by many authors from many points of view, Ryle being one of the most prominent ones. To briefly illustrate:

> Acting intelligently is not doing two things, one mental and one bodily. It is instead doing just one thing, but doing it efficiently or shrewdly or successfully in the face of unexpected obstacles. So knowledge is primarily how to do things. (Chemero, 2002)

Juan A. Rivera has expressed this idea in a way that seems purposely made to contend Reedy and Reedy's distinction between knowledge and skill, and which is very helpful to describe the way most conservators develop a large part of their knowledge:

> Los conocimientos prácticos o habilidades se apoyan en más conocimiento tácito de lo que suponemos y en menos conocimiento explícito de lo que imaginamos. Se apoyan, dicho con algo más de detalle, no solo en modelos emulables, sino en una *historia* de ejercitación previa, a lo largo de la cual cada conducta no ha sido una simple repetición maquinal de lo anterior, sino que cualquiera de esas conductas ha quedado bajo el control de sus consecuencias, que han reobrado sobre la respuesta afinándola con cada nueva emisión, aumentando su idoneidad. Ese proceso de ajuste paulatino, aunque revela un aprovechamiento inteligente de la experiencia previa, no necesita en ningún momento de la participación de la conciencia alerta del sujeto. Tirar al blanco o jugar al ajedrez son ejemplos de habilidades prácticas, algo que ha mejorado en su ejecución a través de la experiencia acumulada. Las habilidades

prácticas son actividades inteligentes aun cuando no vayan precedidas de una atención teórica hacia las reglas ni de su recitado, ni sean el resultado de aplicar esas reglas. Incluso aquellas personas con habilidades prácticas – como la música o la cirugía – que requieren o suelen requerir buenas dosis de conocimientos teóricos no son juzgados como inteligentes por la posesión de esos conocimientos teóricos, ni siquiera por su aplicación, sino ante todo por su capacidad para haber aprendido a hacerlo mejor a partir de la práctica continuada.

Este conocimiento tácito no está verbalmente articulado, lo que dificulta que una mentalidad racionalista lo reconozca como tal conocimiento. Para alguien con esa mentalidad solo es conocimiento el que se puede meter entre las dos tapas de un libro. (Rivera, 2003)

[Practical knowledge and skills are based upon more tacit knowledge than we think, and less explicit knowledge than we imagine. More precisely, it is based not only on imitable models, but also on a *history* of previous performance; a history in which each behaviour is not a mechanical repetition of the preceding behaviour but rather is controlled by its own consequences; these consequences have refined the response each time it was repeated, thus optimizing it. That process of progressive adjustment reveals an intelligent use of previous experience, though it does not require the participation of the subject's consciousness. Target shooting or chess playing are examples of practical skills, the execution of which improves through accumulated experience. Practical skills are intelligent activities even if they are not preceded by a theoretical recall of their rules or by enunciation – even if they are not the result of the application of those rules. Even those people with practical skills – such as playing music or surgery – which require, or usually require, large amounts of theoretical knowledge, are not contemplated as intelligent individuals because they possess that theoretical knowledge, but, above all, because of their ability to improve their performance through accumulated practice.

This tacit knowledge is not verbal, which makes it difficult for rationalist thinking to acknowledge it. For someone who thinks this way, knowledge is only that fragment of knowledge that can be put between the covers of a book.]

Microdecisions cannot be stored between the covers of a book, yet they introduce those 'minor variations' that are so important

to the conservators' profession. For Ryle the notion of *microde-cision* would perhaps be an incorrect one if it were to be understood as the result of an – admittedly lightning fast – deliberate rational process, as he denied that such processes lie at the core of most actions. In fact, it is possible that paying special theoretical and analytical attention to a given action would end up hindering its efficient development; Einstein, the paradigm of twentieth-century science, described this phenomenon in a parable about a centipede that could not walk when it tried to find out the precise order in which it moved its many feet (Viereck, 1930); Polanyi did so recalling how the performance of a pianist might actually be slowed down if the pianist tried to concentrate on the precise sequence in which each finger has to be moved (Polanyi, 1983). That is not to say that no reflective act actually exists, but just that many non-reflective acts are required to effectively develop many important activities – and thus, these acts are a crucial sort of knowledge. Microdecisions, so to speak, have life-size relevance in real life, regardless of how we call them.

Failing to recognize the time-proven validity of the practicing conservator's wisdom or ability, be it knowledge or skill, and regardless of how it is called, is a potential source of conflicts. A good example of this is the cleaning of what is arguably the world's most famous sculpture, Michelangelo's David. The David was made by a young Michelangelo to stand in front of the Palazzo della Signoria of Florence, where it was admired for centuries. In 1873 it was decided that it would be safer to substitute a full-size copy while keeping the original safely indoors, and the David was moved to the Galleria della Accademia, where it has remained ever since. Since this move, the David was not restored until 2002, when it was decided that it should be cleaned on the occasion of its 500th anniversary.

There were some alarming precedents. In 1843, hydrochloric acid was applied all over the David to clean it, a technique which,

while conferring the work with a nice snow-white finish, surely damaged the delicate marble surface – in spite of the wax it had been covered with in 1810, intended to act as a protective layer against atmospheric deterioration agents. The acid cleaning had been criticized at that time for being too aggressive, and the mistake was not to be repeated. Agnese Parronchi, an experienced conservator, who is known for her favouring of mild treatments, was put in charge of the restoration. Parronchi made a preliminary examination of the work, photographed the David's surface in detail, and carried out a series of tests. After this, a simple dry cleaning technique, based upon the use of extremely soft materials, such as brushes, special erasers and chamois cloth, was chosen as the safest and most efficient cleaning procedure. As any conservator knows, this simple technique is slow and cumbersome, but has minimal effects upon the marble and allows for an extremely tight control of the process, drastically reducing the chances of unwanted effects.

However, a scientific committee was also created to assist in the restoration. The committee was composed by scientists from the Consiglio Nazionale delle Ricerche (the National Research Council) and the Opificio delle Pietre Dure (a government art-restoration department), and university professors. The committee performed their own tests and analyses and reached a conclusion that differed from Parronchi's: the committee considered that the statue should be cleaned by applying distilled water-soaked poultices. The poultices should be applied all over the sculpture's surface, remaining in contact with the marble for 15 min.

Parronchi, who had successfully restored other Michelangelo masterpieces, such as the Medici tombs or the bass-reliefs in the Casa Buonarotti, considered that the 'wet' method proposed by the committee was less controllable, and she refused to abide by the committee's directives. Finally, in April 2003, she resigned from what should have been the greatest opportunity in her

career. Later on, a new conservator who abided by the committee directives was hired, but regardless of the technical arguments over the adequacy of either technique, the story shows the tensions that can arise between conservators and conservation scientists (Beck, 2002; Colalucci, 2003; Riding, 2003).

Much of this tension arises when it is not acknowledged that there is knowledge beyond the covers of books; that 'know-how', idiotechnic, tacit knowledge does exist; and that conservators, like many other professionals, critically depend on it – often much more so than on the 'know-that', nomothetic, explicit, *scientific* kind of knowledge which indeed fits between the two covers of a book.

Lack of technological knowledge

Between 1989 and 1993, an AIC 'task force' studied the role of science in actual conservation. 'Early on it became apparent that a number of conservators felt that scientific research in conservation was often not relevant to their practice'. Many comments from different practicing conservators stressed this point:

> Annoyingly, most of the research seems to be either too general or too specific in terms of the material to which it applies. I feel I rarely see anything in my shop that I would classify as either. A lot of work is frustrating in this respect, even when it is addressing such interesting topics as light bleaching and deterioration of cellulose, colour reversion, etc. (Hansen and Reedy, 1994)

> Just as a general observation, there is a lack of correlation between scientific research and practical application. Empirically, the information presented as research conclusions is interesting but not easily applicable to treatment problems. (Hansen and Reedy, 1994)

> It seems rare that basic research is directly applicable to real-life treatment of art on paper, since often only paper samples are used in testing, and paper is only part of the story. (...) I find that many talks I hear have promising titles and abstracts but fail to deliver

information that I can use to improve my practice – there are too many qualifiers and inconclusive results that require yet more research. (Hansen and Reedy, 1994)

Scientific research should better reflect actual conservation use. For instance, some of the paper testing procedures reflect industry's concerns and not the conservator's or document user's needs (Hansen and Reedy, 1994).

Lack of communication and the basic insufficiency of science to cope with conservation problems are two main reasons why this happens, but they are not the only ones. De Guichen has also noted that scientists' duties and status contribute to this phenomenon as well: they have been educated to do research, and the fulfilment of this task is measured by the amount of articles published in science magazines, and not by the amount and relevance of problems actually solved. This is in direct contrast to professional conservators, who are judged by their efficiency in solving practical problems. This being the case, many conservation scientists end up as what he has boldly – but effectively – described as 'satellites which are launched into orbit with a specific task and which eventually escape the earth's pull and drift away towards other planets while continuing to send out messages which become increasingly indecipherable' (De Guichen, 1991). In the European Symposium 'Science, Technology and European Cultural Heritage', De Guichen pondered 'why do scientists make such a limited contribution to the protection of our heritage', and found nine different reasons, stressing both lack of communication between scientists and conservators, and the scientists' different status, needs and approaches to problems:

(a) Scientists move without any further training from university to conservation work. (…)

(b) Scientists often work in isolation. (…)

(c) Scientists have a very individual view of conservation. (…)

(d) Scientists are afraid of getting involved in discussions with restorers and for fear of having to answer questions – which are not

always well formulated – they retreat into their laboratories, their ivory towers, whence they emerge only to attend major conferences where they can at last talk in a common language with their equals. (…)

(e) Competition between scientists working in institutes responsible for the cultural heritage and those in universities and similar places. (…) We have to remember that a restorer's credibility depends on his having preserved and restored objects while a scientist has to publish in order to attain professional recognition. (…)

(f) There is little communication between scientists and, unlike the situation in other fields, articles are seldom criticized by others in the same field. (…) If a restorer ever expresses any doubts, he is often bluntly told: 'You are not a scientist, you cannot criticize my results'. (…)

(g) Lack of acknowledgement of mistakes which are made and published. What ought to be part of normal scientific behaviour becomes a matter of exception in the field of conservation. (…)

(h) Consultation and coordination are rare. In spite of the number of meetings and committees and working parties, it is seldom that there is any genuine consultation to identify the areas where research would be the most useful and the most needed. (…)

(i) Among the various specialists at work in the profession there is still no one who can bridge the gap between research and application. (…)

(j) Lastly, those involved in conservation and restoration work have often given scientists carte blanche and have not always been able or willing to ask questions and/or guide their research. (De Guichen, 1991)

Other authors have found other reasons for this striking lack of technological knowledge, blaming the conservator for their lack of education, time or will (Hansen and Reedy, 1994). Staniforth, on the other hand, suggests that there is indeed usable knowledge, but it is not applied for a number of motives:

Current knowledge is not applied to current practice for a variety of reasons: lack of time, unwillingness to give first priority to quality,

lack of money, and the shortage of well-trained specialists.
(Staniforth *et al.*, 1994)

Whatever the reasons, the fact is that most conservators, with
very different backgrounds, find it difficult to get actual help
from scientific research as it is commonly practised nowadays.
The obvious conclusion is that conservation science has not
proved itself to be all that advantageous for actual conservation.

However, there is no doubt that conservation science has import-
ant advantages, in both the technical and the social sense. For
conservators, there is little excuse for ignoring the part of science
that is actually helpful: it can help in understanding – and pre-
dicting – some phenomena; it can shorten the learning curve of
several conservation techniques, especially for non-practicing
conservators; it has provided conservators with techniques and
procedures that are considered safer and better than traditional
ones; and it can provide conservators with new complementary
information that is sometimes valuable in taking decisions. How-
ever, the bulk of the knowledge involved in actual conservation
still remains outside the realm of science. Conservation profes-
sionals do not require scientific knowledge, but rather technical
solutions: technoscience (as opposed to endoscience) or 'targeted
research', as defined by Tennent:

> I believe the term 'targeted research' is a useful one for conser-
> vation: the prime target must be ability to tackle any conservation
> project better, in a satisfactory timescale. (Tennent, 1997)

Technoscience

Criticizing the arguments for scientific conservation does not
mean criticizing science in conservation at large. It should be
emphasized once again that science in conservation, though not

perfect, is a good thing for many reasons. To use Kirby Talley's words, 'the issue is not what science and the scientific method can do for us, but rather what they cannot do for us.' (Kirby Talley Jr, 1997). The criticisms towards scientific conservation are not directed against the idea of science, but against the idea that science, and especially hard science, can be the guiding criterion behind conservation decisions at most levels.

These criticisms are not an excuse for ignorance either, but just a plea for open-mindedness. Science can help conservation in several ways: it has contributed to its improvement, and will do so in the future. What is in question here is the actual relevance and usefulness of science in conservation practice. Scientific knowledge – *some* scientific knowledge – does play a role in conservation practice, and it can help to produce better results, but, as actual practice demonstrates, the knowledge acquired by professional conservators plays a much more important role (De Guichen, 1991; Torraca, 1991; Hansen and Reedy, 1994). As some important conservation scientists have noted, 'a flawless execution with a low-performance material may produce a better overall result than the inept application of a scientifically tested procedure' (Torraca, 1996); actually, 'it would often be better to apply good sense before calling on a good scientist' (De Guichen, 1991). Conservation science can play a role in some areas of conservation, while other areas remain beyond its reach. It cannot help in making microdecisions nor can it replace the 'acts of taste' inherent to any conservation process; however, it can help in making some 'mid-size', technical decisions, such as choosing a wood consolidant or selecting a paper de-acidification technique. Sometimes, it can also play a minor role in establishing the target state of a restoration process, as it can help the decision-maker to know the history of a given object. The role that hard-sciences play in conservation is, thus, a rather minor one; it is hardly enough to actually turn the entire activity of conservation into something properly 'scientific'.

Trying to make conservation science even more scientific will not actually increase its influence. Instead, it should shift its general approach in order to become a 'technoscientific' discipline. As Organ has stressed, scientists are not what is most urgently needed in conservation, but 'engineers' (Organ, 1996), or 'technologists' (Torraca, 1996). Conservation needs experts who can convert pure knowledge into useful solutions and make them available to conservators – people who can bring the 'know-that' closer to the 'know-how'.

From objects to subjects _____

The communicative turn in conservation has important conse-quences upon the entire logic of conservation. Communication is not a physical or chemical phenomenon, nor is it an intrinsic fea-ture of the object; rather, it depends on the subject's ability to derive a message from the object. In contemporary conservation theory, the primary interest is therefore no longer on the objects, but rather on the subjects. Objectivism in conservation is thus replaced by certain forms of subjectivism, which are described and discussed in this chapter.

Radical subjectivism

Criticisms of objectivity in conservation have led to new, alternate ways of understanding conservation. If conservation deliberately *alters* both the objects and their meaning, instead of actually con-serving them; if it does not *restore* meanings or objects, but it rather adapts them to present-day expectations and needs; if *truth* is no longer the necessary ultimate goal of conservation, what can a conservator do? What *should* a conservator do?

A logical answer is to simply renounce any objectivist temptation. By letting it become a *creative* activity (not merely in a technical sense, but also in an artistic sense) conservation will better respond to the problems it is supposed to solve. This position,

which can be described as *radical subjectivism*, has been aptly defended by authors such as Cosgrove (1992), MacLean (1995) or Zevi (1974). In 'Should We Take It All So Seriously? Culture, Conservation, and Meaning in the Contemporary World' Cosgrove posed some brilliant questions:

> ... why, after all, should the original Mona Lisa not be given her moustache – it can be trimmed later if we choose – or the Haywain not circulate on loan like a library book to the ordinary individuals who so admire it. If such acts seem shocking in their subversion of the meaning conventionally ascribed to these objects, consider the subversion already practiced upon them. What might our reaction be to someone who responded to an earlier (original?) meaning of Giovanni Bellini's *Madonna of the Meadows* in London's National Gallery by kneeling with their rosary before it? (...) These acts become simply further interventions in the life process of artifacts. Any decision to deploy specific technical skills to restore an object to its 'original' state, to an intermediate state, or simply to keep it from further change is by definition arbitrary and should be recognized to be so. Conservation may thus be regarded as itself a creative intervention, subject to the same individual and social negotiations and struggles over meaning and representation as any other action (...). Rather that imprisoning the cultural heritage within the ideological straightjacket of 'authenticity', why should conservation and preservation not seek to liberate the fluidity of meaning inherent in the idea of art as utopia? (Cosgrove, 1994)

For Cosgrove, conservation does not allow the development of some of the objects' possibilities:

> The act of conservation turns the artefact into ideology rather than utopia, from art into culture. (...) conservation threatens the utopian possibilities inherent in the object as art.

He asserts that *creative* restoration, instead:

> ... allows both for the fluidity and flexibility demanded by contemporary formulations of culture and avoids tying culture to a single canon. It also opens the possibility of greater creative freedom on the part of the conservator; of escape from slavish subordination

to a distorting notion of the authentic, 'the real thing'. (Cosgrove, 1994)

Interestingly enough, Cosgrove relates preservation with conservatism and restoration with progressiveness, a view shared by MacLean:

> Restoration is about people. (...) It is a celebration of process and of interaction (...) rather than conservation's celebration of stasis. Conservation shares its linguistic roots with 'conservatism', and functions to sustain a status quo: it locks artefacts in amber in much the same way as good citizens today try to reassert traditional values.

> Restoration however, through its engagement with people and process, is intrinsically politically destabilizing: restoration is in dialogue with the present and asserts the untidy and anarchistic interconnectedness of life. Implicit in this is an acceptance of the reality of decay and destruction. Process implies momentum, and thus, a future – though presumably the preservation of historical artefacts for future historical analysis needs no defending. Like the Angel of History, conservation flings itself forward into the void – facing backwards. (MacLean, 1995)

MacLean suggests that scientific conservation works in a conservative manner, favouring preservation and restricting creative, 'destabilizing' restoration. In a somewhat different tone, Urbani has stressed the role of science within *creative* conservation:

> If it is possible to measure the speed with which galaxies diverge in millions of light years, and if, at the other end of the spectrum, it is possible to measure the time it takes for a material to halve its radioactivity, why should it not be possible to measure the deterioration rate of the Colosseum?

> Whoever succeeds in elaborating a theory for this kind of measurement will certainly solve the problem of conservation, no matter what the implication for restoration. This is so because the demonstrated scientific imagination would be no less impressive than the creativity stamped on the art of the past. Finally then, the work of art will be preserved in the only way that matters: as the matrix of a

> renewed experience of the creative art, and no longer as a mere object of study or of aesthetic contemplation. (Urbani, 1996)

More modest expressions of these ideas rely on historical arguments, recalling that in past times it was common practice to modify existing monuments with a great degree of freedom. The following example has the virtues of clarity and conciseness:

> ... hace muchos años un arzobispo, que tenía inquietudes artístico-arquitectónicas y poder sobre la Basílica de San Pedro, encargaba continuos trabajos y modificaciones en la zona de las grutas vaticanas, bajo la Basílica; aunque los resultados eran discutibles, por lo que, a aquellos que objetaban que no eran lícitas aquellas intervenciones, contestaba: Bernini lo hacía, ¿por qué no podría hacerlo yo? (Colalucci, 2004)

> [... many years ago, an archbishop, who had a liking for art and architecture, and had some power over Saint Peter's Basilica, commissioned several works and changes in the Vatican caverns, under the Basilica; as the results were dubious, however, when his right to do such works was questioned, he answered: 'Bernini did it; why couldn't I do the same?']

Of course, arguments of this kind are not very solid, as it is obvious that tastes and ideas evolve over time: no one would justify slavery because it existed in the United States at some point in its history, or the Inquisition because it existed in Imperial Spain. Regardless of their arguments, the archbishop, MacLean, Cosgrove or Zevi have all reached a similar basic conclusion: creativity in conservation is not just allowable, but desirable. True re-creations are not possible, but pure creations are, and there is no reason why conservation should deny itself that possibility.

Re-examining the problem: inter-subjectivism

Radical subjectivism, in any form, can be defended under the light of pure logic, but in some ways, it goes against common sense.

Adding a moustache to the Mona Lisa is an alarming possibility, even though, as Cosgrove suggested, it is not all that different from removing an altarpiece from a church and placing it in a new environment for which it was not devised. In the new place, the altarpiece is neither illuminated by candles nor contemplated by respectful, God-fearing churchgoers; instead, it is surrounded by a flood of people who may not have religious concerns, are often from other countries or cultures, and have no special devotion to the saints depicted in it. In its new location, the altarpiece is surrounded by other paintings depicting war victories, portraits and still lives, no-smoking signs and push-in-case-of-fire buttons.

When speaking of ancient buildings, Ruskin bluntly stated that 'we have no right whatever to touch them. They are not ours. They belong partly to those who built them, and partly to all the generations of mankind who are to follow us' (Ruskin, 1989). However, ancient buildings, as well as heritage at large, not only belong to our ancestors and our descendants, but also to us to a similar extent, as we are both ancestors and descendants of other people, and thus we have no more or fewer rights than others had or will have. So, why should we not use heritage as we see fit?

The main reason is hidden in the phrase itself: it belongs to *us* – not to *me*, not to *some of us*. We can use it as we see fit, but that 'we' is not just comprised of a minor group of empowered decision-makers and me; it refers to a much larger group of people. The fact is that moving altarpieces from the place they were created for, removing corpses from their burial site, or illuminating sculptures with brilliant electric lights that severely alter the way they may be perceived are socially accepted decisions. Painting a moustache on the Mona Lisa would be seen by most people as a blatant aggression. True, some people (Duchamp included) might think that it is an act of creative freedom. They might even honestly believe that it is a brilliant decision, one that is so startlingly intelligent that a certain amount of time is needed for regular

people to understand. However, the fact is that it would still be a decision imposed by an individual or a small group of individuals against the will of most people. Fortunately, there is a better answer to the need to integrate subjectivism within the theoretical framework of conservation, an answer that reconciles subjectivity and common sense: it could be called 'inter-subjectivism'.

Inter-subjectivism has been defended by many different authors in different fields. Given the predominant role of significance in modern conservation approaches, a very interesting example is Charles Morris' notion of language as a set of 'inter-subjective signs' that are used according to a number a rules (1938). Most semioticians agree that communication between subjects is often based upon a set of conventional rules that is known by every subject involved in the communication process. To mention a common example, most people know the meaning of a squarish red cross when it is displayed against a white background. The great significance of this symbol, i.e. its strong communicative value, is based upon the fact that it is meaningful for an extremely large number of people, and thanks to a number of factors (its simple design, its frequent appearance, the dramatic circumstances usually linked to it, etc.), it is very well known, indeed. However, what would happen if the people simply did not agree on the meaning of the symbol? What would happen if, for instance, the cross had other meanings for people? Then, it would be forgotten, or perhaps, if the meaning were to be maintained, another symbol would replace it (a red crescent, for instance). Collective meanings occur because there is a basic agreement on the part of the interpreters on what a symbol means. If there is no social agreement, meanings can still exist, though they will be more private. Meanings, it must be stressed, exist because subjects interpret them: meanings depend on subjects and are produced by subjects.

Objects become conservation objects because they convey messages in the senses described in Chapter 2. They are conservation

objects because a number of people agree that they have desirable social, private or scientific meanings, not because of their material features: for them to become social symbols, they must be socially accepted; for them to possess scientific meaning, they must be recognized by scientists; for them to be private objects of conservation, they must have some special meanings for a family, for a group of friends or even for an individual. And if the subjects no longer agree that the object has that meaning for them, the object would simply lose its meaning. Inter-subjectivism in conservation can be viewed as a consequence of agreements among the subjects for whom objects have meanings. Furthermore, the responsibilities for the conservation of an object fall on the affected people – or their representatives; it is their duty to preserve or restore those objects, and it is for them that conservation is performed.

It might also be worth noting that the notion of conservation objects as meaningful objects has an important side effect with regard to classical conservation theories: it substitutes the notion of communication for that of truth. When the relevance of meaning is acknowledged, truth simply ceases to be the guiding criterion of conservation operations, and communicative efficiency becomes the likely substitute. This is not to say that truth is no longer pursued, because, in many cases, the communicative efficiency of an object can require that some sort of truth be implemented (e.g. when conserving historical evidence). Instead, it means that truth *may or may not* be pursued.

The expert's zone: objectivism and authority

As scientific findings pertain to the physical world, no contamination is supposed to be possible from the observer: the data are the same regardless of the gender, nationality, preferences, cultural background or any other particular characteristic of the observer.

Since the observer is not relevant at all, scientific, objective truths are universally valid. Universal truths of this kind are supposed to be facts, not beliefs, which puts them beyond subjective discussion or, at least, beyond discussion by untrained people: employing Lyotard's terminology, scientific talk is isolated from the other social *language games* (1979); scientific truths can only be contended by scientists, that is, by people who most often share training and core beliefs with the scientists that produced the piece of knowledge under contention; in practice, this results in an important reduction of the actual arguability of conservation processes.

This *restricted arguability* can lead to science being used as a kind of 'umbrella' (the expression is taken from Colalucci, 2003a) against actual or potential criticisms from those many observers who are unable to discuss or even understand the analytical procedures or the interpretation of the experimental data. Because conservation decisions appear to be based upon scientific data, the results of the process seem to be arguable only by the limited group of people who have a thorough knowledge of science *and* who have a working knowledge of the analytical techniques employed in the treatment – that is, those who know not only the principles of those techniques, but also their practical limitations (the actual precision of the analyses, the reproducibility of results, the degree of statistical tweaking of raw data, the influence of impurities, the reliability of conclusions, etc.).

As the expertise required to discuss conservation decisions is restricted to scientists, the conservators' role in conservation may also be dramatically reduced. Given that science leaves little room for choices and is only discussable by scientists, and since most conservators are not scientists, conservators might be thought of as mere operators implementing the decisions that others have made over them. This is an unwelcome effect for many people working within the conservation field: it has been described as a 'terrible trend' (Colalucci, 2003b) or as an 'imperialist' process

of 'colonization' of the conservation world by science, as was mentioned in the preceding chapter (De Guichen, 1991; MacLean, 1995; McCrady, 1997; Clavir, 2002).

On the other hand, it is not infrequent to hear or read that the conservator has a responsibility not to the affected people, but to the object itself. By unconsciously taking the conservation-as-medicine metaphor to the point of personifying the treated object, the notion of objectivity is also moved a step further: an objective conservation is that in which the object is 'listened to' and its needs catered to. If the object 'requests' a treatment, if an object 'speaks', then a conservator who listens and follows those indications is not actually taking subjective choices, but just doing what the object requests. Those decisions cannot be questioned by other subjects, as the conservator actually had no choice but to follow the object's directives. This is a sort of *rhetorical objectivism* that is based on benevolent visions of animated objects. However, as Pye put it, the object is neither the 'client' of the conservator (Pye, 2001) nor is the conservator accountable to it.

However flawed, rhetorical objectivism is interesting indeed, as it constitutes an unexpected form of non-scientific objectivism. It is often used by non-scientific conservators, but it should be noted that, in fact, scientific conservators and conservation scientists do something similar: first, the object is examined or 'listened to', and then the data that is derived from the object dictates the choices.

Admittedly, differences between rhetorical and scientific objectivism exist, as both use different kinds of tools for collecting the data transmitted by the object: scientific conservation uses complex analytical tools, such as confocal microscopy, X-ray diffraction or Raman spectroscopy, while for rhetorical objectivism, the naked eye is the most common tool. Nevertheless, the basic attitude is strikingly similar: the underlying notion is that conservation is performed for the object itself, and therefore, decisions must

be grounded on the object's inherent features – its condition, its constituents and its actual evolution. As a conservator in the Prado Museum has stated:

> La restauración de una pintura no es una acción subjetiva y caprichosa del restaurador que modifica el cuadro a su gusto. Tampoco sirve la opinión estética y subjetiva de los que al ver el resultado dicen: 'Antes me gustaba más'.
>
> Las obras de arte son como son, como las concibió su autor en un momento preciso de la Historia. (Alonso, 1999)
>
> [The conservation of a painting is not a subjective, fanciful action by a conservator changing the painting at will. The aesthetic, subjective opinion of those contemplating the work and saying 'I liked it better before the conservation', is not useful either.
>
> Artworks are as they are, as their author conceived them at a given moment in History.]

There is an obvious contradiction in this statement. While it is hard not to agree that an object 'is as it is', it is hard to admit that it can simultaneously be 'as it is' and 'as its author conceived it' – the kind of contradiction that the tautological argument debunks. However, the statement brings along with it the idea of rhetorical subjectivism: the idea that conservators do not really make choices, but rather 'listen' and interpret the symptoms of the physical object in a non-fanciful, subjective manner. Thus, both scientific and rhetorical objectivism transfer the responsibilities of conservation choices to the object itself, as the task of the expert is more that of a mediator than that of a decision-maker. As conservator Mark Leonard put it:

> ... a lot of conservation in the past was done in the name of scientific objectivity, when in fact, what we were really doing was absolving ourselves of any responsibility. (Considine *et al.*, 2000)

Another immediate consequence of these assumptions is that conservation decisions are beyond the reach of most people, since only a reduced group of experts knows how to interpret the

symptoms (the 'language') of conservation objects. Conservation thus becomes an experts-only zone, the public being considered as a mere audience with no special authority. When German conservator Kurt Niclaus was asked '¿A quién corresponde la tarea de marcar las pautas en los criterios de intervención (...)?' ['Who is responsible for deciding the guidelines for conservation criteria (...)?'], he summarized this view as follows:

> Los profanos en el tema (la sociedad) pueden no entender una ciencia o un ámbito de trabajo tal y como lo entendemos los profesionales.
>
> Naturalmente sólo los restauradores pueden marcar las pautas para los criterios de intervención. (Gironés Sarrió, 2003)
>
> [Laypeople (society in general) may not be able to grasp a science or a field of work as we professionals can.
>
> Of course, only conservators can set the guidelines of [conservation] criteria.]

By transforming conservation objects into metaphorically 'ailing' subjects, they may even be thought of as possessing inherent 'rights' – Beck's *Declaration of the Rights of the Works of Art* is a clear example of this view (Beck, 1994; 1996). However, though well intended, this is just another instance of this same rhetoric. Objects are produced, maintained and cared for just because they are useful to us; we use them, and discard them when they cease to be useful. There is neither cruelty in it, nor can a moral judgement be made on the grounds that an object has suffered damage. Objects have no rights; subjects do have them.

However, damaging an object can actually be harmful to people. If someone burns another person's house, ethical judgements about this action will not be made on the grounds that the house suffered while being burnt, but on the grounds that it was someone's property. Even if only the house is physically affected, the owner will still be an affected party. Moreover, from any moral or ethical point of view, the owner would be the most affected party

in this situation. The house should not have been burnt (this a moral judgement) not because the house has a right to exist (*objects have no rights*), but because the owner has a right to own and use it (*subjects do*). It is the subjects who are served through conservation: the realization of this simple idea is one of the underlying principles behind the increasing relevance that subjects have in most manifestations of contemporary theory of conservation.

From the experts' zone to the trading zone: the emergence of the subject

Affected people

Conservation processes affect many people in many ways. They certainly affect the owner, who will likely have the object changed in evident or subtle ways. In the case of monuments, they can also affect visitors and people living nearby during and after the works (accesses may be restricted, electrical or water supplies may be disrupted, etc.), and the works can also have economic effects on certain jobs related to tourism. In some exceptional cases, these effects can be very great: owners of small shops within a ruined urban neighbourhood will greatly benefit if it is restored and transformed into a fashionable, picturesque area attracting an important number of visitors. However, the access to shops might also be severely restricted, or shops might be in a building about to be demolished.

Apart from these tangible effects, conservation processes also have intangible, communicative effects. These effects, however, are not the same for everybody. People with a greater degree of involvement with the object (those for whom the object is especially significant) will be more affected than those for whom the object has little significance. For instance, a handwritten letter by a person who died some years ago can be very meaningful to the person's

relatives; however, it can also have a different meaning for other people. In time, it could acquire historical value; for example, should Stanislaw Lem's funny vision of a future where all paper is destroyed by bacteria become real, any remaining paper sample would, in turn, become extraordinarily meaningful to historians of technology, as it would be valuable evidence of a distant past (Lem, 1986); if the text in the letter contained some valuable, historical information, such as data proving that a conspiracy existed against Kennedy, such a letter would also take on a special meaning for historians; if the person who wrote the paper was an important historical figure, it could easily become a symbol of the values that the person represents – Beethoven's 'Heiligensstadt testament', which symbolizes the victory of the human will and genius against all odds, is a clear example of this. Similarly, a building can have different meanings for different people. An old factory, for instance, can be a symbol for the inhabitants of the neighbourhood, a work of art can be a symbol for art historians, and historical evidence can be a symbol for industrial archaeologists.

The number of people affected when a symbol of this kind is altered can vary from a single family or even an individual (the *patrimonio modesto* [modest heritage] described by Waisman (1994)) to all humanity (objects on the World Heritage list are supposed to have universal value). Meaning is a totally subjective phenomenon, and, in most cases, it is an *inter-subjective* phenomenon. As such, it is neither based upon objective criteria nor is it objectively measurable, even though it is real and can be judged under moral and ethical criteria. Provisions are made in most legal systems to prevent the production of meanings when they are thought to have damaging effects for individuals or societies (false testimonies or documents, defamation, burning of flags, exhibition of nazi symbols, etc. are often forbidden and punishable). Heritage objects of social value are also protected for this same reason. Even if a heritage object, which has been officially recognized as such, is the property of an individual, that

object cannot be freely sold, disposed of or otherwise altered at the will of that individual.

Once again, it must be emphasized that societies protect these objects not because of the objects themselves, but because of the intangible, symbolic effects an unwarranted alteration might have upon the subjects that make up that society. The widespread legal protection of heritage objects is based upon (and is a proof of) the significance those objects have for an important number of people within the society: this protection has been developed in order to prevent the unwanted meanings that their free modification might produce.

The stakeholders

The symbolic value of an object is not inherent to it, but is rather generated by the people themselves. If Van Gogh were not regarded as a genius, his works would not be appreciated in so many ways by so many people (as indeed was the case when he was alive). The widespread recognition of the value of artworks by most people (i.e. the sharing of their artistic and historic meaning by a large number of subjects) is what makes them the all-important pieces of heritage they are now. Of course, not all subjects contribute in the same degree to their value: power (in the media, in the hi-cult world, in the art market, etc.) plays an important role when it comes to assigning value to an object (Dickie, 1974; Taylor, 1978; Ramírez, 1994; Thompson, 1994; Bueno, 1996); however, even in these cases, the meaning of the objects is determined through subjective mechanisms. Power can enforce these mechanisms among powerless people, but even in these cases, the result is agreement. An increase in the number of people that agree upon the conservation meanings of an object can result in an increase in the significance of a given object.

The authority that people have on heritage objects therefore derives from, and is proportional to, two closely related factors:

(a) their contribution to the overall significance of the object,
(b) their being affected by the object's alteration.

The people for whom a heritage object is meaningful, have been called *stakeholders* by several authors (Avrami *et al.*, 2000; Cameron *et al.*, 2001), a term which is especially appropriate: stakeholders own a tiny part of something larger; as such, they are affected by the decisions that are taken regarding it, and they have the right to have a say in relation to it. People's right to impose their views is proportional to their involvement with the object.

Discrepancies in meanings underlie many of the judgements and debates related to restoration processes. Most of these debates, in fact, might be summarized as a discussion on the relative merits that a given meaning of an object has for certain people. In the above-mentioned 'cleaning controversy' or in the debate over the restoration of the Sistine Chapel, for example, the historical meanings of the objects clash with the artistic meanings of those same objects. However, the private or social values of the objects are seldom taken into account. A probable reason for this is that meanings of this kind are beyond the expert's realm, and most of the debates about conservation processes are held in that domain. Architects, conservators, art historians, archaeologists, scientists and a few other educated professionals are the ones who can discuss conservation treatments because conservation is supposed to be an experts-only zone, and they are supposed to be 'the experts'. Admitting that a larger number of people are *authorized* to voice opinions on a conservation treatment would likely result in a loss of the authority which has traditionally been given to conservators and other experts.

However, the work of the experts usually affects many other people, and these people have the moral right to be heard. Admittedly, there are decisions that should be taken on technical grounds and require technical expertise; no layperson is authorized to decide what is the best formulation of an adhesive for a canvas lining, nor what thickness a reinforcing wall should have. However, they are authorized to voice an opinion about different aspects of the conservation processes, such the observable results of the lining ('It looks like a poster, I liked it better when it was not that tense') or of the reinforcing wall ('The entrance to the sanctuary is blocked by those ugly reinforcement walls'), and other aspects of the conservation process.

Taking into account the opinions of non-experts implies that the experts-only zone becomes an affected-people zone. This zone can be very populated, indeed, and some people in the zone will have a more substantial stake in an object than others, as the object may be more meaningful to them than to the rest of the people.

These two factors can make it difficult to reach a decision as these stakes cannot be objectively quantified: it is not possible to precisely know the exact number of people for whom the Parthenon is actually meaningful, nor is it possible to know how much more meaningful the Parthenon is for Athenians than it is for the people of Heraklion, Milan or Calcutta; it is also impossible to measure how much these people would be affected by a given alteration on such objects.

The impossibility of measuring these effects should not lead to the belief that they do not exist or that they are negligible. They do exist and are of great importance. Their sheer complexity can make conservation decision-making extremely challenging, and trying to escape the challenge through objectivism is just

that: escapism. Instead, conservation should leave the experts-only zone to enter what Sörlin has called *the trading zone* (Sörlin, 2001).

The trading zone

Pondering whether non-experts should criticize a scientific conservation work, De Guichen asked 'Do you need to be a murderer to judge a murderer?' (De Guichen, 1991). The answer, needless to say, is 'no': the conservator's work has, of course, experts-only aspects, but it also has many aspects in which no technical knowledge is involved: feelings, sentiments, memories, biases, preferences and interests (rather than acidity, refraction indexes, stability, relative humidity variations, oxidation or adhesive strength) are the key factors to be considered. Decisions are ultimately taken by experts or by individuals with power – with technical, political, economical and media power – but it would be a mistake to think that they should not take into account the other stakeholders' views. This does not simply mean determining which conflicting view is the most popular or which group of stakeholders deserves to be satisfied. It should attempt to integrate the conflicting views as much as is reasonably possible. It thus opposes the 'agonistic' way of decision-making in conservation, in which several conflicting views are considered and the strongest one is adopted. The notion of trading tends to diminish power struggles within conservation to reach an agreement between affected people. The contemporary theory of conservation is based on *negotiation* (Avrami *et al.*, 2000; Staniforth, 2000), on *equilibrium* (Jaeschke, 1996; Bergeon, 1997), on *discussion* (Molina and Pincemin, 1994), and on *consensus* (Jiménez, 1998; Cameron *et al.*, 2001).

Experts may exert some authority on the laypeople with regard to their field of expertise. But then again, this authority resides in the public recognition of the experts' ability and good will, and it thus critically depends upon the public perception of the experts'

ability – on the trust that the public is willing to concede to the experts:

> Los técnicos, los 'expertos' en los que la gente confía, podemos con-
> tribuir a alterar la opinión de los usuarios más directos, tanto más
> cuanto mayor sea el prestigio que nosotros tenemos sobre los usuar-
> ios, o por decirlo de otra forma, cuanto mayor sea la autoridad que los
> usuarios nos conceden. Pero ésta no es una autoridad que nosotros
> poseamos de forma natural o indiscutible, sino que es una autoridad
> concedida; es decir, que en última instancia el origen de esa autori-
> dad siempre está en los usuarios. (Muñoz Viñas, 2000)

> [We technicians and experts whom the public trusts can contribute
> to changing the opinion of the most direct users [of a conservation
> object], even more so when our prestige among users is great or, in
> other words, when the authority that is granted by users is great.
> However, we do not intrinsically possess this authority, but it is
> rather an authority that is granted; that is, the source of this
> authority ultimately lies in the users themselves.]

Since conservation decision-making is done not only in the soli-
tude of the laboratory but is also done in the 'trading zone', more
and more conservators are becoming aware of the great import-
ance of communication skills. In a survey conducted by Joyce H.
Stoner, conservators were asked 'What was missing from your
original training that you've had to teach yourself?'; the majority
of the responses fell into the area of management, interpersonal
communications and politics (Stoner, 2001). In the final round
table of the 1996 Meeting of the International Institute for
Conservation, held in Copenhagen, Colin Pearson spoke about
the need to 'persuade the public', Rise Taylor stressed the need to
develop 'a new language that others understand', Diane Dollery
stated that conservators should learn 'skills of tact and diplo-
macy' and Jørgen Nordqvist concluded that:

> A good conservator is a communicating conservator and he or she
> will be listened to. I think this is the skill we have to concentrate
> on. (Nordqvist *et al.*, 1997)

Clashes in meanings: inter- and intra-cultural issues in conservation

Some of the clearest examples of the need to take into account the different meanings that the same object can have for different people occur whenever a conservator has to deal with objects from different, *living* cultures. Miriam Clavir has vividly described and analysed these problems. As a conservator in an anthropology museum, she found that the objects displayed or conserved in the museum can possess a meaning for their original makers and users that is entirely different from the meaning they have for people who have displayed them in the museum and for their visitors, who most often have been raised and educated in the cultural environment that we call 'Western culture'. For most Westerners, these objects are symbols of an extraneous culture: they inform us of different ways of being, of different sets of beliefs and of different matrices of attitudes. By doing so, they become anthropological documents, and supposedly, they help us to better understand our culture, and to realize that we have our own way of being, set of beliefs and matrices of attitudes, which are not the only possible ones. Enclosed in glass cases, lit by electric lamps and surrounded by explanatory signs, they allow us to take a safe walk on the wild side, to get a glimpse of 'the others', and to perhaps prove that we are not 'the others', reminding us of our own identity. However, what if the visitors belong to the group of people that produced those objects? For them, these objects are lost symbols of their culture that other people are using for their own purposes and also a painful 'reminder of cultural loss and deprivation' (Tamarapa, 1996). This view might perhaps be better described through a poem:

> Buffalo Bill opens a pawn shop on the reservation
> right across the border from the liquor store
> and he stays open 24 hours a day, 7 days a week
>
> and the Indians come running in with jewelry
> television sets, a VCR, a full-length beaded buckskin outfit
> it took Inez Muse 12 years to finish. Buffalo Bill

takes everything the Indians have to offer, keeps it
all catalogued and filed in a storage room. The Indians
pawn their hands, saving the thumb for the last, then pawn

their skeletons, falling endlessly from the skin
and when the last Indian has pawned everything
but his heart, Buffalo Bill takes that for twenty bucks

closes up the pawn shop, paints a new sign over the old
calls his venture THE MUSEUM OF NATIVE AMERICAN CULTURES
charges the Indians five bucks a head to enter. (Alexie, 1992).

The author of this poem, wryly called 'Evolution', is a Native American, which perhaps confers it with some added value. Those objects, 'all catalogued and filed in a storage room' are certainly preserved in as good an environment as possible. They will not be physically damaged, and, according to Western thinking, they will be used in a scientific way – to increase our knowledge, and will be displayed in a 'democratic' manner, guaranteeing that they are accessible to every citizen. Conservation contributes towards this scheme of things by guaranteeing that the objects will last as long as possible, and even by restoring them to a *truer* condition.

However, the assertion that the objects will not be damaged is only partially true, as it is made from an objectivist, scientific point of view: a point of view which, in its attempt to be purely scientific and objective, only takes into account some of the features of the object – the 'tangible' or the *measurable* features. In the name of democratic access to knowledge, this point of view considers it appropriate to place the objects in a situation that reinforces certain meanings while restricting those that the originators had intended.

Conservation brings about this same effect. By ignoring the intangible, by devoting its best efforts towards the maintenance

and recovery of only the material features of the objects, it can deprive them of what makes those objects important for some people. Objects with a religious or a ritual significance are the most representative example: some objects at the New Zealand *Te Papa Tongarewa* Museum are thought to lose their spiritual life when food is placed nearby. What if there is a food-vending machine located next to the conservation lab? The objects, with the meaning that they have for Westerners, would be treated in a laboratory as the material objects they are supposed to be, effectively depriving them of what actually made them special for other people. Similarly, in the southwest of the United States of America, some masks are regularly 'fed' with corn pollen and meal, and the Museum of New Mexico houses some objects that the Indians consider as living entities, and which should thus be stored in open places in contact with fresh air – while others need to be ritually exposed to smoke (Clavir, 2002).

Of course, all of these actual practices would be disregarded by conservators who strictly abide by classical principles. Fresh air is likely to bring along with it strong variations in relative humidity, which are thought to be detrimental to the stability of most objects; corn meal and pollen open the possibility of insect eggs entering the museum; smoke, at the very least, will make the object dirty (Welsh *et al.*, 1992). The conservator has to make choices, and there are, indeed, some ethical considerations involved in them because these choices will not only affect an object, but will also affect the people for whom that object has some significance.

Clavir's depiction of these issues is both intellectually and emotionally appealing to the Western reader, who is introduced to the views and feelings of First Nations people regarding these issues. Part of the strength of this work lies in the fact that it deals with problems of people from other cultures, whose points of view are clearly different from ours: this renders the many examples especially striking when it comes to showing the problems arising

from these 'clashes in meaning' in conservation practice. Furthermore, the large cultural gap makes these views so clearly distinct as to make it obvious that it is unfair to contemplate them from regular Western standards.

This is not the case in most debates on conservation ethics, as they are intra-cultural affairs. While First Nations people might see conservation as a practice coming from a different, imperialist culture, James Beck, John Ruskin, Sarah Walden, and other critics of conservation, do belong to the same Western culture as the conservators they criticize. Clavir is describing inter-cultural problems (that is, problems between members of different cultures), while debates on conservation ethics are usually intra-cultural problems (that is, disagreements between people who belong to the same society and culture).

This makes a difference, and, in fact, many people might think that these problems only affect a minority of people beyond the boundaries of their own culture. This assumption can lead to regarding these problems as something remote. However, they are not that remote after all, as in fact inter- and intra-cultural issues in conservation decision-making can well be viewed as just a variation of the same theme: an object that has different meanings for different people – and a decision-maker who holds the power to decide which one should prevail.

In conservation, these choices are made on a regular basis. Whenever a paper conservator decides to clean the crayon marks that a collector has made on a nineteenth-century print, the conservator is deciding that its meaning as an artwork is greater than its meaning as evidence of its own history (or that of the collection, for that matter). Whenever a conservator decides to remove a layer of varnish to make the painting look brighter, newer or more beautiful, the conservator is deciding that the painting should function as an artwork more than as an antique. Whenever an

architect decides to brightly light the ceiling of a Gothic church, the architect is deciding that its meanings as evidence of how mediaeval churches were actually experienced by their users should be subjugated to its meaning as evidence of the ribbed building techniques that the lightning now makes so clearly visible.

The panel of Saint Lucy in the Williams College Museum of Art is a good example of choices of this kind. It was painted by three, or perhaps four, different painters. The first and most important one was Gonçal Peris, who painted a typical fifteenth-century tempera painting: measuring nearly 1.5 m in height, it depicted a standing Saint Lucy against a gilt background holding a palm leaf, the sign of martyrdom, in one hand, and a plate with the two eyes she was supposed to have lost in her martyrdom in the other. However, at some point in its history, a book was painted over the plate with the eyes, thus turning Saint Lucy into Saint Cecilia. Post suggests that this change could have been made as early as the first half of the sixteenth century by the Artés Master. The work was slightly modified again in the eighteenth century by an anonymous author who changed some minor details. And finally, in the nineteenth century, it was extensively overpainted by an artist whose name also remains unknown to us: the book, the robes and the face of the martyr were extensively modified in order to be more appealing to the tastes of their contemporaries. In 1953, when it became part of the Williams College Museum of Art, the painting was interesting evidence of both nineteenth-century aesthetic tastes and painting techniques and of the prevailing attitudes towards heritage. However, when the painting was restored in 1983, the work of all the painters except Peris was eliminated in an irreversible way (Watson, 1994). For the observer, the work is now a nice International Gothic panel painting. Since many people actually prefer a fifteenth-century painting to a nineteenth-century one, this treatment was considered perfectly acceptable by most people. However, the fact is that the object now has an entirely different meaning from the one it had

before the treatment. Conservation has changed the meaning of the object: it has made *one* of all the possible meanings prevail, at the expense of the other possible ones.

Intercultural issues in conservation decision-making are similar in nature to these intra-cultural cases: some objects which have ethnographical meanings for some people may have entirely different meanings – religious, sentimental, group identification, etc. for other people. Regardless of whether the issue is inter- or intra-cultural, the first questions behind the conservators' decisions should not only be whether or not the object 'requests' something, or whether or not it has some rights. They should not be about how discernible the restored parts should be from the 'original' parts, nor how to better control the ultraviolet radiation within the display rooms. Instead, prior to any other consideration, it should be asked why, and for whom, the conservation process is done.

The answers to these questions are closely linked to the communicative turn described in Chapter 2: objects of conservation are so because of what they mean for some people. These meanings are neither fixed, nor are they universal: the same object can have a strong significance for some people, while being irrelevant to others. Conservation is performed for those people for whom the object is meaningful, and it is because of them that so many delicate operations are performed, so many efforts are taken, or so many resources are employed in that complex set of operations we call conservation. Their interests (their needs, their preferences and their priorities) should thus be considered as the most important factor when it comes to decision-making, regardless of their training. Their authority derives not from their level of education, but rather from their being directly affected by the actions that others perform upon objects that are meaningful to them.

The reasons for conservation _____

Understanding why an activity is performed comes very close to understanding the activity itself. It may reveal its goals and, by doing so, how to better fulfil them, which rules to abide by, and why they should be followed. Acknowledging that conservation objects have communicative effects is useful to this end. In the following chapter, the reasons behind conservation are examined and discussed, and two important manifestations of the contemporary theory of conservation (functional and value-led conservation) are described.

Reasons for conservation

Conservation is an intriguing activity: sophisticated and costly actions are performed in order to solve or delay the otherwise unavoidable decay of certain objects; most countries devote a large part of their economic resources to the conservation of their heritage, and individuals often devote a part of their income to the conservation of objects that have only a private meaning. Many different reasons of many different kinds have been proposed to explain the existence of this activity. It has been suggested, for instance, that conservation is done for 'piety' (Yourcenar, 1989); genetic reasons have also been proffered (Carlston, 1998), as well as psychological ones. For Watkins (1989), conservation mirrors

171

the ever-present contemporary desire to live a long life, and to look young throughout it. Baudrillard (1985), faithful to his own style, stated that objects are conserved and restored because they evoke both the figure of the father and the involution into the mother's womb. Walden, however, thinks that conservation is done so that masterworks are adapted to our own mediocrity:

> The relevance for restoration could be that, in some strange sub-conscious way, we may be compensating for the shortcomings of the present by over-interference with the artistic excellence of previous eras, through the one means of undoubted modern supremacy – science and technology.
>
> It is even possible to suspect that we somehow resent the very superiority of past schools of painting, and are quietly cutting them to size, emptying them of some of their mysteries, and avenging ourselves in the process for obscure dissatisfactions with our current condition. (Walden, 1985)

Likewise, Pierre Ryckmans has stressed that conservation is done to cope with our 'own inability to invent the present' (Nys, 2000), while Mark Jones has mentioned anxiety and lack of confidence:

> The twentieth century is more uncertain and anxious about its relationship with history than any previous age. With declining confidence in the present, the urge to conserve and revive the past has become even more frantic. (Jones, 1992)

In a less pessimistic vein, Hockney has said that conservation is done for 'love' (Constantine, 1998), although he does not explain what that love is for. Beck (2000) could well argue that conservation is done for love of money:

> Underlying much of the [conservation] activity is, of course, a factor which I had understood from the very start of my own involvement in the issues 15 years ago. People need to pay the rent, to eat. (Beck, 2000)

Rodríguez Ruíz, on the other hand would argue that it is done for love of power:

> ... la conservación del patrimonio (...) se ha convertido en uno de los pocos argumentos que quedan a historiadores, arquitectos o artistas para poder mantener activa su presencia, su lugar, en el espacio privilegiado de la cultura. (Rodríguez Ruíz, 1995)

> [... heritage conservation (...) has become one of the few remaining arguments for historians, architects or artists to maintain their presence, their niche within the privileged area of culture.]

These opinions, however curious or provocative, are not fully devoid of reason, but they do not explain conservation in full, nor in-depth (or perhaps, some of them explain conservation too in-depth to be of any use). Fortunately, there are more useful views on why conservation is performed, which are analysed in this chapter.

From the conservation of truths to the conservation of meanings

To cope with the ethical issues posed by most conservation treatments when contemplated from a classical perspective, Caple has developed what he called the 'RIP' (revelation, investigation and preservation) model (Figure 7.1), where conservation is understood to be driven by three principal opposing goals:

> Before worrying about whether the conservation treatment being undertaken is 'reversible' or 'minimally interventive' it is essential to have established what one is seeking to achieve through treatment. The aims and principles of conservation (...) can be expressed in the form of three almost opposing aims: revelation, investigation and preservation.

> *Revelation*: Cleaning and exposing the object, to reveal its original form at some point in its past. The visual form can be restored to give the observer, typically a museum visitor, a clear visual impression of the original form or function of the object (...)

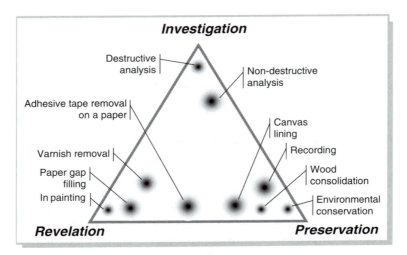

Figure 7.1 A graphic representation of Caple's 'RIP' model

Investigation: All the forms of analysis which uncover information about the object, from visual information and X-radiography to complete destructive analysis (...)

Preservation: The act of seeking to maintain the object in its present form, without any further deterioration. This will typically involve a full range of preventive conservation practices and the stabilization processes of interventive conservation (...)

Any conservation process can be seen as a balance of these three activities. (Caple, 2000)

Caple still defends classical positions, as truth remains the core objective of any treatment. However, the RIP model represents an intelligent step towards fully contemporary views, as it also stresses that truth can be served in different ways, a logical step after the recognition that there may be several 'truths' within the same object:

Every object has evolved through its creation and use; any, and every point within an object's working life could be described as its 'true nature'. Every sword eventually becomes a piece of scrap iron and both states represent the true nature of the object. Thus, every object

> contains numerous truths, making it impossible to define one point as
> the true nature of the object as opposed to any other. (Caple, 2000)

Deciding which truth – and which goal – should prevail in each
case is a fundamental, preliminary step in conservation decision-
making. Furthermore, ethical principles (reversibility, minimum
intervention) are not recognized as actually being principal, but
rather as added values relative to the goal of the treatment, as
'forces' within the triangular space where any conservation
process can be located:

> Ethical concepts such as minimum 'intervention' and 'reversibility'
> can be described as forces moving towards the extreme of preser-
> vation, whilst concepts such as 'true nature' can be seen as mov-
> ing towards investigation and revelation. (Caple, 2000)

Contemporary theory of conservation does not relate conserva-
tion to truth but rather to meanings. Conservation contributes to
preserving and improving the three kinds of meanings represented
in Michalski's three-dimensional space; thus, from a theoretical
point of view, there are three main reasons for conservation:

1. to preserve or improve the scientific meanings of an object,
 that is, to make sure that it can be used as scientific evi-
 dence now and in the future;
2. to preserve or improve the social, hi-cult symbolic mean-
 ings that an object has for large groups;
3. to preserve or improve the sentimental symbolic meanings
 that an object has for small groups or even for individuals.

These reasons are not mutually exclusive, as both of them can con-
cur in the conservation of a given object, just as many other reasons
may concur as well. Admittedly, greed, vanity, political issues, or
even psychological problems can play a role in deciding whether a
given object is conserved or restored, but these reasons are neither
exclusive nor inherent to conservation. It would be a mistake to

assume that conservation is mostly performed due to greed, vanity or even to alleviate individual or collective psychological problems. The reason for the existence of conservation is not the greed of the conservators, just as the reason for the existence of surgery is not the greed of the surgeons, nor is vanity the reason for the existence of architecture, art, history, or carpentry – although, it could actually be a relevant factor for certain decision-makers in these as well as in most other human activities.

Expressive conservation

Caring for something expresses appreciation for that object and, very often, for what it symbolizes. Conservation, therefore, unavoidably fulfils an expressive function. The cleaning of a painting, or the flattening of a photograph, for example, may have only a very slight impact on the object's actual preservation. In fact, in these cases, its conservation also fulfils a different role, that of expressing the group's values and beliefs, the appreciation for a given culture, for knowledge, for the arts, for one's own identity, for one's own history, etc. For Cosgrove, for example, 'it is the act of conservation itself that makes an object part of the cultural heritage, not the cultural heritage that demands conservation' (Cosgrove, 1994); and, as Watkins has noted, 'the impression of clear coatings and vividly painted surfaces, all in flat plane within their frames, clearly expresses to the public an image not only of great beauty, but also of an organization exercising proper stewardship over its objects' (Watkins, 1989). In fact, this expressive function can well lead to the *revaluation* of the object, as we actually 'give monetary and societal values to an artifact through the act of preservation' (Vestheim *et al.*, 2001).

Classical theories of conservation, which are based around the pursuit of truth, cannot cope well with these communicative phenomena, which are outside of their conceptual frames. Objectivist views cannot acknowledge the inherent expressive

effect of conservation either, as conservation is thought to be developed solely because the object needs it. Nevertheless, this expressive function of conservation is inherent to the activity. Even if it is considered as a by-product, it is an ever-present and often desirable by-product, and thus it might well constitute another reason for conservation to exist.

Functional and value-led conservation

Meaning is a pivotal notion in contemporary theory of conservation. From a logical point of view, it has two important virtues: first, it provides a good criterion for understanding why some objects are considered conservation objects; second, the notion of inter-subjectivity, and those of trading and negotiation, are derived from it in a natural and fluid manner. However, it is not free from problems. First of all, meanings are often difficult to elucidate: they form a complex tangle, a 'web of meanings', in which boundaries become quite blurred. On the other hand, meanings – the conservation meanings described above – are not the only factors that must be considered in real-life conservation decision-making. For trading, consensus and negotiation to be truly so, they must take into account factors of different nature. In this regard, the notions of 'value' and 'function', which have been put forward by several contemporary authors, are worth noting.

Functional views stress that conservation should not just consider the artistic and historic functions of a heritage object, but also its other, more mundane functions: Is it a tourist attraction? Does it have economic value for the owners? Do people work inside? Does it function as a social icon in any sense? Does it work as a *personal* icon? In conservation, these functions can be contemplated from several points of view:

> At the systems level, preservation is connected with three kinds of interests, which are interrelated (...). One is political interest (...)

> Next are the economic interests and aspects, which are partly private and partly public. Economic interests include private markets as well as public budgets and are intertwined with political interests to varying degrees, depending on political tradition and ideology.
>
> The third interest is cultural, which we define to be the interests of the 'sector' that deals with cultural activities. (...) Preservation work is primarily associated with cultural interests, but it continually must make contact with political and economic interests as well. (Vestheim *et al.*, 2001)

This classification does not contemplate other interests, such as private, sentimental or religious interests, but it is still useful to show how 'cultural heritage' is not just 'cultural', since it can function in many ways. If – and how – a conservation process is to be performed should be decided after considering all the possible functions performed by an object, as even the damage that conservation is thought to repair or prevent can be considered as directly related to functionality. As Urbani has suggested:

> ... we can precisely evaluate the state of conservation of an item or artifact only in terms of the specific function that the item or artifact is meant to have. (Urbani, 1996)

'Value-led conservation' is another incarnation of contemporary theory of conservation that is closely related to the functional views of conservation. In this case, the guiding criterion is neither meaning nor function, but the set of values people place upon a given object. Value-led conservation has been emphasized by several authors associated with the Getty Conservation Institute (GCI), and the reflections are not just interesting – they also have an important degree of internal coherence. In 2000, the GCI published *Values and Heritage Conservation* (Avrami *et al.*, 2000), which is a volume where contemporary points of view are very solidly expressed. In 2002, this was followed by *Assessing the Values of Cultural Heritage* (De La Torre, 2002), where some approaches to value in heritage objects are described in a more

technical tone. The core notion behind value-led conservation is that conservation decision-making should be based on the analysis of the values an object possesses for different people in order to reach an equilibrium among all the parties involved:

> In earlier times, conservation was a relatively autonomous, closed field composed of specialists and experts. These experts, together with art historians and archaeologists, decided what was significant (...) the right of these specialists to make decisions was tacitly recognized by those who funded the work (...) but new groups have become involved in the creation and care of heritage. These groups of citizens (some are professionals from such fields as tourism and economics, others are advocating the interests of their communities) arrive with their own criteria and opinions (...).

> All the same, democratization is a desirable development, and it has changed the heritage field: (...) the opinions of the specialists are not taken as articles of faith; and heritage decisions are recognized as complex negotiations to which diverse stakeholders bring their own values. (Avrami *et al.*, 2000)

This is no easy task, as the notion of value is extremely broad; attempts have been made at its quantification from very different points of view, including statistical, economic, and scientific approaches, as well as some interesting taxonomic attempts. However, as these approaches are based upon objective, scientific methods, they seem condemned to some of the problems described in Chapters 4 and 5; in fact, value-led conservation is interesting not because it allows for a precise, numerical estimation of values, but because the idea of value is applicable to a wide range of conservation ethical issues.

Both *functional* and *value-led* conservation are fully contemporary, as they substitute the classical notion of truth for those of usefulness and value – both of which are dependant on the subjects who *use* and *evaluate* the object in different ways. Classical theories formally disregard these notions, for they are not truth

based; one of the clearest expressions of this disregard may be found in Brandi's *Teoría del restauro*:

> ... allorché si tratti di opere d'arte, anche se fra le opere d'arte se ne trovano che posseggono strutturalmente uno scopo funzionlae, come le architecture e in genere gli oggetti della cosiddetta arte applicata, risulterà chiaramente che il ristablimento della funzionalità, se pure rientra nell'intervento di restauro, non ne rappresenta in definitiva che un lato o secondario o concomitante. (Brandi, 1977)

> [... yet for works of arts, even if there are some that structurally possess a functional purpose (such as architecture, and in general, objects of the so-called applied arts), the re-establishment of the functional properties will ultimately represent only a secondary or accompanying aspect of the restoration.]

Function and value are, in fact, closely related notions, for, as Ashworth *et al.* have put it, 'it is the service [the objects] deliver that ascribes value to them' (Ashworth *et al.*, 2001). A value would thus be directly related to an object's ability to perform a given function, and indeed, in the conservation theoretical discourse, value-led and functional conservation are very similar in their grounds and principles. The difference between them is mostly a matter of terms: an object with symbolic value fulfils a symbolic function; an object with economic value fulfils an economic function; and if we say that an object has historic or artistic value, it is because it can fulfil historic or artistic functions. In most cases, both notions are interchangeable. In fact, the notion of 'meaning' can also be substituted quite easily: an object with artistic value has an artistic meaning; an object that fulfils an economic function has an economic meaning, etc. (e.g. Clark, 2000).

Henceforth, it comes as no surprise that the theories developed around the notions of meaning, value and function are very similar in their conclusions: conservation increases some of an object's

possible functionalities or values, very often at the cost of decreasing others. A historical building can house people more conveniently if a modern air-conditioning system is installed during its restoration, but this can require the alteration of some of the original parts of the building – or the installation of insulated pipes might be visible in some places. Under these circumstances, the building's usefulness as historical evidence (its ability to function as historical evidence, its historical value, its historical meaning) is decreased, although its usefulness as convenient housing (its ability to function as convenient housing, its functional meaning, its functional value) are improved. Likewise, a painting that has suffered flaking and loss of some parts of its surface due to the fires produced during a social revolt in the late nineteenth century might be restored to an earlier condition, thereby increasing its artistic value or significance – thus performing its artistic function better than it did before the restoration. However, the meaning it had before as evidence of the social revolts that caused the damage, its historic value, its ability to function as a historical document, will be substantially decreased. In all cases, the final decisions regarding these topics must be the result of a compromise, of a negotiation, of a dialogue, regardless of whether we are using the notion of value, meaning or function.

Sustainable conservation _____

Once it is known why conservation is performed, the question of how it should be performed arises: How can the main goals of conservation be achieved in the most beneficial manner? As contemporary theory emphasizes the relevance of the subject throughout the entire process, an intuitive answer might simply be to do what most affected subjects decide. However, things are not that easy, as there are other users who also have to be taken into account: our heirs. To cope with their interests, the principle of sustainability has been advanced, and it is, indeed, a crucial notion underlying contemporary conservation theory. It is due to the notion of sustainability that contemporary conservation ethics requires the conservator to avoid the excesses that are described in Chapter 9.

The criticism of reversibility

Conservators are no more perfect than physicians, computer-program designers, or taxi drivers: conservation processes can be poorly designed and developed, actually damaging the material components of the object in ways that may or may not become evident shortly after the process is finished. In addition, a conservation process can be offensive to the people for whom it is supposedly performed: it can be contrary to their tastes or their beliefs, or it may be beyond their *horizon of expectations*, to use

the concept that Martínez Justicia (2000) borrowed from Mikhail Bakhtin. The tastes of many people, for example, were offended by the restoration of the Roman theatre of Sagunto, Spain, just as the cleaning of the Ilaria del Carreto tomb offended James Beck's taste. Likewise, the personal preferences of many people would be offended if the Islamic symbols that were added to Hagia Sophia after Mehmet the Conqueror entered Constantinople in 1453 were removed – even if in this case it is certain that they are an addition to the original building.

Science has little to do with decisions regarding tastes, beliefs, preferences and expectations, except for the authority it may exert upon offended users, making it easier for them to accept the 'offense' as being scientifically based. However, science has an important role to play in technical decisions, as it can collaborate in developing more efficient conservation techniques. However, relying on science is not a perfect solution, as science, just like conservation and many other activities, is far from perfect. Reality can be far too complex to fully comprehend; instruments may lack the precision required to measure quantities which might be relevant; and hypotheses can fail when confronted with reality.

A very relevant example of a mistaken hypothesis is the idea that actual objects actually abide by Arrhenius laws. This is unfortunate, as this hypothesis lies at the theoretical core of all accelerated-aging tests – and accelerated-aging tests lie at the core of the scientific prediction of material behaviour. As Torraca put it:

> … when a scientist proposes a conservation treatment and guarantees its reliability and durability, he is either consciously bluffing – in the best cases – or suffering from delusions because of lack of experience. (Torraca, 1999; see also Shanani, 1995; Porck, 1996; 2000)

Henceforth, unless a material has passed the test of real-time aging, it is not possible for scientists to guarantee that it will age in a certain way. The result is that scientists 'suffer delusions', 'bluff',

or simply interpret accelerated-aging tests in a tentative way. Conservators, however, consciously or unconsciously, do take risks when using materials which have not been age tested in real time. In fact, just like many other activities, most conservation actions involve some sort of risk: the materials of the objects can be damaged, and their acquired meanings can be damaging. The awareness of their fallibility is a good reason for many conservators to stress the need for *reversible* treatments.

Reversibility is a fuzzy concept. It is frequently present in conservation texts, and indeed, in the minds of many conservators, but it is not easy to define. In a very basic way, it could be described as an *ethical* principle that mandates that it should be possible to take the object back to the state it was in before the treatment took place. For instance, if a varnish that a conservator added as a protective layer happens to be unstable and damaging to the binding media in a canvas painting, it should be possible to safely remove it; or, if a finger that is missing is added to a classical sculpture, it should be possible to separate it from the original should this be preferred for any reason.

Reversibility has many advantages for both the conservation professionals and the users of the objects. For professionals, it reduces risks and responsibilities; for the users of the object, it implies that it is theoretically possible to shape the object according to their wildest preferences.

However, reversibility might also have some adverse consequences. The greater the reversibility, the lower the responsibility: conservators may feel authorized to do whatever they like as long as it is reversible, just as the users of the objects may feel authorized to demand anything they happen to prefer. The conservator and the empowered users (those users with power to take decisions that affect others) have little responsibility to the other users, and all of them have little responsibility to their descendants, because, if anything should go wrong, the process can safely be

undone. Conservation might become a sort of 'cultural entertainment' profession, thus radically changing the way it is performed and understood today.

Nevertheless, there is little chance for this to happen, as reversibility has proven to be a difficult goal. As has been argued from both a scientific perspective and a conservation perspective, it is not possible to achieve full reversibility in conservation. The laws of physics demonstrate that it is absolutely impossible for an object to ever be taken back to a preceding state (Seeley, 1999), and from a conservator's perspective, several down-to-earth observations can be made with regard to this principle:

1. All forms of cleaning are irreversible. Dusting a marble sculpture with a suede cloth is an irreversible process, as is removing a darkened varnish from a wooden bellboy. Even if every bit of the material cleaned-off were retained for scientific purposes, its original disposition would be forever lost (Oddy, 1995; Jaeschke, 1996).

2. In most porous materials, the capillary action and adsorption phenomena would make its complete removal impossible (Appelbaum, 1987).

3. As any conservator knows from first-hand experience, and as science confirms, the physical features and the behaviour of many materials vary with time. This is especially true with solubility, a feature upon which the reversibility of many conservation products heavily relies. Solubility usually decreases over time, and many particular circumstances can affect the rate at which a given material becomes progressively insoluble. Thus, it is not possible to know whether a material will remain soluble enough for it to actually be removable in the future.

4. Even if a material remained fully soluble forever, its mere presence would still have an irreversible chemical effect on

the materials of the treated object. For example, a varnished sheet of paper can be protected from potential surface abrasion by varnishing it with a reversible protective product. However, over time, the cellulose molecules in contact with it can be altered in other ways by the chemicals present in the varnish. The varnish layer is also likely to prevent the sheet from moving freely, making it curl when the relative humidity in the environment oscillates. This curling can, in turn, affect the strength of the sheet; some parts of it can touch adjacent materials, such as a protective glass, thus increasing the chances for condensed water to concentrate in those areas and accelerating the sheet's localized alteration. What should be stressed here is that all these alterations would be irreversible, even if the varnish could be fully and safely removed at a later date: an ideally reversible conservation treatment can still produce irreversible effects on the object even if the treatment is 'reversed' later on.

For these practical reasons, the status of reversibility within conservation theory has substantially changed: from being considered as a 'basic principle' (Cordaro, 1994; Bergeon, 1997), a 'basic tenet' (Oddy, 1995; Appelbaum, 1987), or even a 'sacred tenet' (Smith, 1999) of any conservation treatment, to becoming a 'chimera' (Child, 1994), a 'ghost' (Palazzi, 1999) or a 'myth' (Melucco Vaccaro, 1996) – a sort of 'Holy Grail' (Charteris, 1999). The awareness that true reversibility may not be achieved led to the development of alternative, less stringent notions, such as *removability* (Charteris, 1999) or *retreatability* (Appelbaum, 1987), which are sort of scaled-down versions of the principle of reversibility. 'Removability' acknowledges that a material may have an effect upon the object it is in contact with, which is not likely to disappear even after the material is removed. 'Retreatability' is an even more relaxed notion, as it only requires that a given treatment not make future treatments impossible.

In spite of these criticisms, reversibility is still a valid notion, as long as it is not understood to be a requisite or an absolute notion. Rather, it is more useful when used as an adjective modified by an adverb: there is no such thing as a 'reversible' treatment, but rather treatments that are 'quite reversible', or 'slightly reversible', or 'very reversible', etc., when compared with common contemporary treatments. Reversibility is not (cannot be) a requisite, but it is indeed a bonus, a value added to any conservation treatment, which increases its overall quality: it should be pursued, but not at all costs. As Smith suggested, 'the time has come for professional judgement to be substituted for the philosophy of reversibility' (Smith, 1988; 1999).

Minimum intervention

In a sense, the notions of removability and retreatability are a subtle acknowledgement that reversibility is an unattainable goal. The idea of 'minimum intervention' (the principle that any conservation treatment should be kept to a minimum) can initially be seen as one more step in this same general direction. However, this last step has finally taken the notion to a point that is somehow diametrically opposed to the starting notion of reversibility: if conservation were actually reversible there would be little need to keep it to a minimum. Likewise, whenever a truly *minimal* intervention is possible – that is, when no intervention is developed at all – no concern about reversibility exists. It can thus be said that the notion of minimum intervention thrives on the failure of the notion of reversibility.

The principle of minimum intervention is interesting for many reasons, perhaps the most important of which is that it introduces a sense of relativity. Strictly speaking, the 'minimum' conservation intervention that the principle calls for would consist of leaving the object as it is, renouncing to modify its evolution in any way.

This would therefore mean the end of any sort of conservation. It is clear that the principle of minimum intervention is to be understood as being relative to the goals of the process itself. As Caple has put it, 'the problem with minimum intervention is that it is not a complete statement. The minimum intervention to achieve what?' (Caple, 2000). The fact is that 'minimum intervention' cannot be truly minimal if the entire process is to have any consequential effect. The principle could thus be summarized by saying that a conservation process should consist of the minimum intervention required to achieve its goals. This brings about a fundamental question: why is something conserved and/or restored? Only when this question is answered, can this notion become useful. For example, the minimum intervention required to restore a small marble sculpture can vary substantially: if the sculpture is a decorative piece in a private household, its restoration might be done to repair any damage it may have suffered, or simply to make it 'look good'. The minimum intervention to achieve this can consist of a thorough surface cleaning, the completion of missing parts, or perhaps the varnishing and polishing of the surface. If the piece is, instead, an archaeological find about to be studied in a university laboratory, the main purpose of the intervention will be to enhance its meaning as historical evidence. The minimum intervention necessary to achieve this goal will, thus, be very different from that of the previous case: its cleaning will be very gentle, and no varnish will be applied to it; very likely, no new parts will be added before its material analysis. Thus, there may be many different 'minimum interventions' for the same object, the purpose of these interventions being the crucial notion here.

The principles of reversibility and minimum intervention are opposite in a sense, but they seem to aim at common goals: they are different approaches to the same problem and have been created for similar reasons. Among these reasons is, of course, preservation efficiency. A conservation treatment must be durable and actually contribute to the preservation of the object. This was

surely a foremost concern when the notion of reversibility was created, but what about minimum intervention? An intervention that is not minimum, such as the addition of a missing part, can have a negligible effect upon the actual preservation of the original object; therefore, the principle of minimum intervention may or may not be useful for the sake of the material preservation of the object. However, it is always useful in a different sense: it helps to keep the work as it is, ruling out *unnecessary* modifications of the object. By restraining the intervention of the conservator as much as possible, this principle implies that the conservator's intervention is a 'necessary evil', to use the words of Friedländer (1996).

This idea, which underlies the whole notion of minimum intervention, is very interesting in many ways. First, it stresses the notion that conservation treatments are not 'all-positive' operations. Conservation does pose risks and has negative effects on the object's materials; it is generally performed because the positive effects are considered to be much more important than the negative ones. Using the conservation-as-medicine metaphor once again, doctors or surgeons can also be considered to be 'necessary evils', since most medical treatments have negative, unwanted side effects upon the human body. Surgery is an even clearer example, as it usually requires the patient to be inoculated with some chemicals to induce artificial sleep so that he or she does not feel the immediate pain produced by incisions that may take weeks to heal. Why do most people freely accept these damaging operations? For the same reason that conservation is usually accepted: because the benefits are greater, and usually far greater, than the damage. In fact, the principle of minimum intervention is mandatory in surgery much to the same degree as it is in conservation.

However, the decay of conservation objects can have a positive value which illness lacks: the value of historical truth. Damage, in any form, is the consequence of an object's historical evolution,

be it a broken arm on a sculpture, a bombed building or a curled parchment in an archive. Repairing the damage means that the historical evidence that the damage itself conveys will not be available for future users of the object. Restoration always has this deleterious effect: it hides or transforms the true nature of an object – it works against historical truth by destroying its evidence.

Classical theories hold that restoration is done for the sake of truth in many different forms; their discourse is that truth is recovered or rescued from oblivion. However, in some subtle sense, from the perspective of classical theories, the principle of minimum inter-vention could be contemplated as an acknowledgement that this is not the case. Actually, were it not for the tautological argument, the opposite would be truer: restoration actually destroys or hides historical evidence, just as preservation attempts to freeze the authentic, natural evolution of the object. In this sense, historical truth (the imprints of history upon the object) is a victim of restoration, and very often of preservation as well: it is the price to pay for converting the object into something more functional, more valuable, more meaningful. The notion of minimum inter-vention is just a reminder that the conservator should keep the concealment or destruction of this evidence to a minimum, just as the surgeon should not cut more flesh than necessary. In this way, the benefits of the operation are maximized.

From minimum intervention to maximum benefit

Both the notion of reversibility and the notion of minimum inter-vention are very useful ones if they are properly understood. If they are applied in a strict way, reversibility is too inflexible a notion, while the principle of minimum intervention might be too flexible, as it is dependent on the purpose of the conservation treatment. Reversibility is not a requirement, but an ideal to be

pursued whenever possible. The principle of minimum intervention is a reminder that conservation is done for specific reasons, and that there is no need to overdo it. It is also a quiet reminder that conservation has an inherently negative effect.

A major flaw in classical, truth-based theories is that conservation is always considered a truth-enforcement operation. However, conserving or restoring a part of an object's truth means that other features may be sacrificed, even when the operation is done for science's sake. Digging a burial site, for instance, and treating the findings through conservation operations substantially modifies the true history of a corpse (a corpse which, *for the sake of truth and knowledge*, may end up being exhibited in a glass case for scientists to analyze – or for visitors to see).

Contemporary theory of conservation does not suffer from this flaw. It overcomes this theoretical problem by acknowledging that truth is not the final goal of conservation. Conservation is done to satisfy certain needs of individuals: objects are adapted to better convey certain meanings (social, sentimental, scientific meanings), to better fulfil certain symbolical functions, to enhance their value. Of course, in some cases, the idea of 'truth' (in any preferred sense) may be valuable to some users, but it is not the only value to be considered, or even the most important one. Instead, truth is one of many factors in an equation where the satisfaction of present and future stakeholders is the final goal. There is not an 'accountability' to truth (Leigh *et al.*, 1994). Truth is only desirable when and because stakeholders desire it, not necessarily because it is an abstract moral imperative.

Conservation can be contemplated from a cost-benefit perspective. Conservation has some costs that are both tangible and intangible. The restoration of an object may mean that some resources will not be devoted to other purposes (the installation of a traffic light, the purchase of a new machine for a hospital, etc.). The object will likely be inaccessible to some people for some time, and that may,

in turn, have some indirect economic consequences; for example, when that object is a tourist attraction. These costs are fairly easy to evaluate, as they can be expressed in precise figures, but there are other intangible, communicative costs.

As has been mentioned previously, whenever an object is conserved and/or restored, some evidence of its history will likely be damaged or destroyed. The range of possible readings (that is, of possible meanings) of the object will thus be reduced. These symbolic or evidential costs are harder to evaluate, but they are still real and have to be taken into account. Of course, meaning is a subjective phenomenon, and each person or group of people can interpret an object in very different ways. Western collectors might appreciate the acquisition of a statue of Ceacescu, as it might be a fashionable object to possess or to sell; but for many Romanians a statue of Ceacescu conveys different meanings (most of these statues were therefore destroyed or removed from their original sites, for the sake of meaning, when the Ceacescu regime collapsed). Similarly, many people prefer old paintings to look 'moderately old'; they prefer antique objects to have a subtle look of antiqueness, while others (such as historians or archaeologists) prefer to see them in their current damaged condition. Through restoration, these aged objects can be transformed to convey a meaning of ageless aesthetic splendour; through preservation, they can be made to convey a message of antiqueness or even of destruction. In real-life conservation, a combination of preservation and restoration is usually applied. In all cases, some meanings are made to prevail, and many times this means that the possibility for the object to convey other meanings is hindered or even made fully impossible. This is especially true in restoration operations, but many preservation operations also have this effect. Thus, conservation operations can have important communicative costs.

To continue with the cost-benefit analysis comparison, it should be pointed out that the best conservation operation is the one that provides the most satisfaction to the most people. The conservator

or the decision-maker cannot just work as if *their* point of view were the only relevant one. Their point of view is relevant because they have been educated in the appreciation of conservation objects to a greater degree than other people, but there is no reason for their point of view to be considered representative – in fact, that is one reason why it is not. The effort to acknowledge the likely plurality of meanings, functions and values that the same object may have for different people must be further extended to include other people's points of view. Kantian categorical imperatives might not be useful in conservation: good will might not be enough, since what is good for the decision-maker might not be good for other *users* of the object. Conservation should not be regretted, suffered or merely 'tolerated' by the affected people, but instead admired, enjoyed and respected by as many people as possible. Conservation should not be imposed, but agreed upon.

The principle of sustainability

Contemporary theory of conservation is developed around current democratic narratives – otherwise, it would not be acceptable at all – but it also resorts to another contemporary conceptual tool: sustainability. In common usage, 'sustainability' has economic and ecological resonance, but its usefulness in conservation has also been recognized. The economical sustainability of the conservation process has been called for by many authors (Bluestone *et al.*, 1999; ICC Kraków, 2000; Knowles, 2000; Staniforth, 2000; Vantaa Meeting, 2000), though this kind of sustainability is only possible in the case of objects with strong public appeal and cannot be applied to most conservation objects. A more interesting approach, however, is the application of the notion of sustainability to those features of the object that convert it into something valuable – to the object's significance. This notion has been adopted, used and defended by different authors (Baer, 1998; ICC Kraków, 2000; Staniforth, 2000; Burnam, 2001; Muñoz Viñas,

2003). Staniforth has summarized its principles and relevance as follows:

> One of the keys to the future, and not just for conservation, is sustainability. The Brundtland definition of sustainable development, which is 'development that meets the needs of the present without compromising the ability of future generations to meet their own needs', is reflected in the aim of the conservation of cultural heritage, which is to pass on maximum significance to future generations. (Staniforth, 2000)

This form of sustainability is very interesting, as it brings into contemporary theory of conservation a factor which might otherwise be overlooked and which is of primary relevance: future users. Each time an object is modified, some of its possible meanings are strengthened, while others are restricted forever. The principle of sustainability in conservation mandates that future users should be taken into account when decisions are made. The object is seen as a 'source of meanings' that can be exploited at different levels. If only present users were considered in conservation, it would only be natural to transform objects in as free a way as desired, just as radical subjectivism proposes: without the notion of sustainability, contemporary theory of conservation would be a sort of 'democratic radical inter-subjectivism', where 'anything goes' as long as it is democratically agreed upon. The object could, thus, end up being patched and remade over and over again until just a tiny kernel of the original object remained.

If such a radical change in the way conservation is presently understood took place, non-sustainable 'conservation' operations would become the norm, dramatically reducing the objects' usefulness for future users who happened to prefer different meanings. This is not at all an impossible scenario. Non-sustainable conservation was actually the norm until the nineteenth century: changing tastes and needs were naturally accepted; for example, churches could be transformed into mosques – and mosques into

churches – just as naturally as a late-Gothic Saint Lucy could be transformed into a late-Gothic Saint Cecilia, and then into a nineteenth-century-style Saint Cecilia. And, whether we realize it or not, we are not that far removed from that same path; this same nineteenth-century Saint Cecilia was transformed back into a fifteenth-century Gothic Saint Lucy in the second part of the twentieth century, just as the half-Roman, half-neoclassical Lansdowne *Herakles* was converted back to an extensively damaged Roman *Herakles*. The principle of sustainability is a *caveat* for conservators, decision-makers and users alike: it asks them not to abuse the object so that future users are not deprived of its ability to function in a symbolic, meaningful way. It asks them:

> ... to be historians aware of the changing historical context that artifacts are part of. (...) they must also understand that future generations may have other attitudes. (Vestheim *et al.*, 2001)

Sustainability in conservation is similar to reversibility or minimum intervention, although it is a more complete notion as it more explicitly acknowledges the need to take future uses and users into account. It confers contemporary theory of conservation with long-term purposefulness, precluding the abuse of the notion of negotiation – the kind of abuse that could derive from the fact that future users cannot complain or express their opinions.

This issue is crucial to conservation professionals, as it will be the experts who will likely have to speak for these yet-to-be users. This great important responsibility is one of the reasons why conservation is such an interesting and attractive activity – an activity deserving social recognition and requiring the best available education from its practitioners:

> ... symbolic, intangible sustainability can only lead to prudence and moderation. The dialogical relationship between these key notions is central here. In the 'negotiation' that modern conservation theory calls for, future users have to play a role, and, most likely, it will be

the experts who will have to speak for them. Sure, this is not an easy task – but it certainly is a fascinating one. (Muñoz Viñas, 2002)

Admittedly, people may become accustomed to almost any symbol given the time to assimilate it. The Venus de Milo or the Winged Victory of Samothrace are very good examples of this, as their extensive damage has come to be perceived as artistry-bearer features; the Tower of Pisa is another clear example: even if it was technically possible, no one would want it to be restored to is original (that is, vertical) condition. Similarly, any damaged symbolic object may well continue to be symbolic in its new state; this fact can give rise to doubts about the reasons for conservation itself to exist: it might be asked, along with Cosgrove, whether we should take conservation 'so seriously'.

The answer, however, is quite simple if we consider what conservation ultimately attempts to achieve: the satisfaction of the users of the object. We should take conservation so seriously because there are people who will be seriously affected if we do not.

Simple as it may seem, this idea summarizes the entire body of contemporary conservation ethics, as well as the complexity of an activity that requires a large assortment of knowledge and skills from the conservator. The conservator should possess sound technical knowledge, which is both tacit and explicit; solid scientific, artistic and historical training; and good communication skills. All of these should be complemented by the ability to keep in touch with the current needs and feelings of society at large and to envision what our descendants might expect from the objects that we are now taking care of. Even more difficult, conservators should be wise enough to know when not to make their opinions prevail.

From theory to practice: a revolution of common sense _____

The ethical principles described in the preceding chapters can have important consequences when it comes to making conservation decisions. In this chapter, some of these principles are briefly discussed, such as the need to make discernible restorations and the so-called 'single standard of care'. Contemporary theory of conservation applies flexible criteria, adapting itself to cater to the subjects' needs. However, as these are not measurable factors, the theory can be somewhat abused when making crucial decisions. This spectrum of ethical abuses includes genial (having to do with genius), evidential or demagogic conservation. To prevent these abuses, authority should be used with caution and intelligence, and factors should be honestly and correctly evaluated. To do this appropriately, no theory, no book, no catechism can substitute good old common sense. Contemporary theory of conservation, in any form, is perhaps nothing less than a revolution of common sense.

Discernible restoration

Contemporary ethics does not intend to change everything. It only proposes to deviate the spotlight from the object itself

199

towards the people for whom the object is (and will be) useful. This category of people most often includes the conservator and other experts who have been trained to appreciate the object in unconventional ways. The notion of truth in its traditional sense, for example, is not expected to prevail at all costs.

This does not mean that the conservator is authorized to lie. 'Thou shall not lie' is a principle that goes far beyond the scope of this book. It is assumed, for instance, that the estimate of the cost of a treatment will not be more expensive than necessary, that reports will be true to the facts, and that the interpretation of the analyses will be honest. These matters, and other similar ones, are not part of conservation ethics, but of general ethics, and should be taken for granted.

Nevertheless, the way this principle is implemented in other aspects of conservation practice is a matter of debate, as the reading of classical conservation theorists makes clear. Did Viollet-le-Duc lie in Notre Dame? He would probably be offended if someone suggested so, but many people, then and today, do believe he did. Does a conservator lie when he or she thoroughly cleans a painting that has been covered with smoke during a fire? Does a conservator lie if he or she repaints a few square centimetres of fallen paint in the corner of a large painting in an unnoticeable way – though duly recording it in an extremely detailed report? Or to give a more extreme example, why is permanently deleting a nineteenth-century inpainting considered to reveal truth, even if the nineteenth-century paint layer is as authentic as the older, underlying one? The conservator is not authorized to lie, not in classical nor in contemporary theories of conservation; intentional faking is not allowed in any case, and indeed, any addition should be precisely recorded. But aside from these general principles, the notion of how truth should be implemented in a conservation process can vary substantially without compromising the honesty of the process or of the conservator.

Truth is not the core issue in conservation ethics, but it is said to be. Many people would feel deceived if they learnt that only one-third of a seventeenth-century painting is actually seventeenth century, the other two-thirds being the work of a skilled conservator: intuitively, they might be tempted to blame the conservator for this. But then again, the responsibility for this 'lie' is not attributable to the conservator, but to the salesman, the auctioneer or perhaps the museum curator, who has carefully hidden or ignored that information in spite of knowing that it might be relevant to most people. For that matter, the 'lie' might even be attributable to the observer, who has not read the small print on the sign, or the catalogue sold at the entrance (where it should be clearly stated that the painting suffered extensive damage and was extensively restored to its present, showcase condition). Thus, for twentieth-century classical theories of conservation, every compensation for loss is necessarily done in a visible way: through *rigattino*, *tratteggio*, pointillism, a single background tone, or even leaving the zone recessed; in the name of truth, the conservator's additions to the object always have to be distinguishable from the original in all cases through a simple, naked-eye examination of the work.

In contrast, contemporary theory stresses that artistic merit, style, colour, shape, material, etc. are the meaning-bearing features; they are valued for what they 'mean' to the people, not for their relation to 'truth'. Contemporary ethics calls for an adaptive application of this principle, realizing that there are many cases in which it can be out of place either for technical reasons or because the object plays a role in which truth or material fetishism is not important. From these perspectives, it is ethically correct to reintegrate the missing parts of a religious sculpture in an undiscernible way if other perceivable techniques are not accepted by the devotees, just as it is ethically correct to invisibly reintegrate an old family photograph which is important to very few people, if those people really prefer it that way. It is the affected people who best know what meanings the object possesses, and how it

will best convey those meanings; it would not be ethically correct to impose a different point of view just because someone has some expertise in art history, in organic chemistry, or in stone conservation techniques.

Adaptive ethics

In scientific conservation, decisions are made on objective grounds and following objective criteria; meanings, or subjective feelings or preferences should have no role in its development. As a consequence, no preferred objects should exist, and therefore, none should be treated in any special manner. Since scientific conservation revolves around materials and physical features, and not around values, value-based judgements are disregarded as unscientific. Thus, every conserved object should be given the same importance, and a 'single standard' should be applied to its conservation. When applying this 'single standard of care' (Clavir, 2002) a masterpiece by a great artist should be treated according to similar criteria, and with similar attention to that given to a minor, anonymous painting, or to a tin toy dating from the 1940s.

In contrast, contemporary ethics is far more flexible, calling for what could be called 'adaptive ethics'. Adaptive ethics acknowledges that a conservation process might be performed for very different reasons and under very different circumstances. Material circumstances (such as the object's material components or the object's environment) do indeed play a role. However, subjective factors are usually more relevant, as they lie at the core of the activity. These factors are varied, and involve at least two crucial aspects:

(a) The meanings (or 'functions' or 'values') the object has for the affected people.

(b) The decision-maker's willingness to allocate resources to the conservation process. (Caple (2000) has coined the expression 'money ethic' to describe this crucial factor.)

These factors are not the only variables that can have an influence on a conservation work, but they are the most important ones, as they are both ever-present and fundamental in ethical and technical decision-making. Their recognition renders the 'single standard of care' useless, as there are no single standards of functionality or of resource allocation. Each conservation process is done to fulfil a number of expectations and needs of a given, unrepeatable kind, and there is no reason to impose a single standard – except for, perhaps, convenience, as it will free the conservator from a good share of responsibility. Just as there are different environmental variables that the conservator has to adapt to when making technical decisions, there are human variables that also have to be considered. Even from semi-contemporary positions, Caple concluded:

> The extent to which any single ethical idea should be followed is difficult to judge when used in isolation. For example, the desire to preserve all the evidence following Oddy's stricture that 'nothing should be done to an object which compromises any original part of it' (...) can leave the inexperienced conservator too worried about evidence preserved in corrosion products to attempt any cleaning of a corroded iron object. A more constructive method of approaching the ethical considerations of conserving an object is for the conservator to identify the balance desired to be achieved between revelation, investigation and preservation (...), and then explore the most ethical way of achieving it. (Caple, 2000)

Contemporary ethics does not call for hi-tech conservation, but for hi-efficiency conservation. There are hard decisions to be made here since devoting a large amount of resources to the conservation of an object means that some others will unavoidably be condemned to oblivion. Hi-tech is not a value in itself. It is only valuable if it is useful for conservation, and, in the end, for the people for whom conservation is performed. Spending a lot of resources on the hi-tech preservation of the U.S. Constitution may be reasonable, as it is a symbol of great relevance for most Americans, but requiring that all official documents be taken care

of in this same way would not be sensible, even though there is no scientific reason to sustain this belief. The reasons are subjective, and while classical theories may casually refer to these notions, contemporary conservation ethics explicitly acknowledges their great importance.

This same flexibility is applicable to other ethical issues in conservation. For example, it could justify the use of copies in some instances, as well as the implementation of irreversible processes if no better options exist: reversibility – or removability, or retreatability, or minimum intervention – are to be considered as added values, but in no case as imperatives. They could even be ignored in other cases, as the meaning of the object might be so strong that its value as historic evidence might be over-come by the need for the object to fulfil its symbolic function. Contemporary ethics could be defined as being essentially negotiatory and subject-oriented, and as a consequence, as highly adaptive.

As a rule of thumb, the principles put forward by classical theories become more strict the more 'social' the symbol is. At the other extreme, private symbols (not private objects, as an object can be privately owned while being a social symbol) may not require strict regulations. Scientifically valuable objects usually require preservation, although sometimes they may require restoration to show how the object actually was at some point in its history. The meanings, the functions and the values of these objects may vary to a substantial degree; the ethical approach cannot be a single, preconceived one. The conservator has the moral duty to find out the reasons why an object is to be conserved and to learn about its tangible and intangible uses before making decisions that can compromise its usability. When the conflict arises, negotiation is the path to follow, the aim being to maximize the benefits of the operation while keeping detrimental effects to a minimum.

This can be a difficult task, and the temptation to use sheer authority as a shortcut is always present. Nevertheless, the need for authority on the side of the conservator is indeed crucial if a conservation process is to abide by the principle of sustainability, as it is the conservator who will likely have to represent the interests of future users, something which many times will be unpopular.

Once this authority is recognized, it should be exerted with caution: too much, and the entire process will be imposed upon the users against their will, resulting in 'genial' or 'evidential' conservation; too little, and the object's future usability will be compromised as a result of 'demagogic' conservation.

The risks of negotiatory conservation

Evidential conservation

Sustainability can be taken to radical extremes if it is acknowledged that the significance of the object lies in 'our ability to decipher the object's scientific message and thereby contribute new knowledge' (ICOM, 1984). The preservation of *actual* or *potential* scientific evidence would mean that only environmental preservation would be acceptable: varnishes should always remain in place, discoloured dyes should be kept discoloured, torn paper manuscripts should not be repaired, etc. Even the mildest forms of cleaning would be ruled out, as they could actually alter the historical evidence contained in the object. An example of this position is the argument that Michelangelo's David should not be cleaned at all because even the most gentle cleaning could remove historic evidence, such as 'a follicle or a bit of skin' from Michelangelo himself that could remain on the sculpture, which, 'with the study of DNA (…) could in the future give unexpected information' (Beck, 2002).

This extreme, neo-Ruskinian position could also be argued to be a truly sustainable form of conservation. In this case, however, present users' needs would not be catered to at all, perhaps generating disaffection for the conservation process or for the object itself. Rather than serving the general public, this kind of conservation serves historians, archaeologists or scientific researchers, as it helps to preserve the kind of information only they can interpret and value: pollen, fingerprints, corrosion products, etc. Through 'evidential' conservation, scientific meanings of the object are stressed, and their ability to function as scientific evidence is made to prevail.

Genial conservation

Feeling that one's own views are more solid and well grounded than those of other people (laypeople or experts with no vision) – however honest and sincere these views may be – can lead to a well-intended imposition, to a sort of illustrated conservation despotism based on expertise and knowledge. When the appropriateness of a conservation work is discussed, the conservator or decision-maker may well argue that it has been done for the sake of the affected people, present and future. Even though the observers do not yet know it, the conservation work will eventually earn the appreciation it truly deserves as has happened time and again. Some genial, gifted individuals have views that are not the common, standardized ones. It is therefore unfair to judge their works by the standards of common people, but, by allowing time do its work, the present rejection can be transformed into admiration and respect. This kind of conservation could be called 'genial conservation', as it is considered to be the result of a stroke of creative genius.

Genial conservation occurs almost exclusively in restoration processes, and especially in architectural restoration, a field

where 'devotion to architectural heritage is particularly felt to inhibit creativity' (Lowenthal, 1985). There are different reasons for this: architecture is usually considered – and taught – as a creative, artistic discipline, and not simply a technical one. It is only logical that, when dealing with a conservation problem, architects feel authorized to *create* in the artistic sense expected from any prestigious architect – just as earlier craftsmen restorers thought it opportune to *create* in order to improve the old paintings they were entrusted with for conservation before the discipline reached the levels of specialization it has today.

Genial conservation is often praised for its artistic qualities – a rather candid acknowledgement that the conservation process has not been limited to just conservation. Defending a conservation process because of its artistic merit is a 'poisoned candy', as there are many other ways to prove a person's artistic abilities without affecting an object that is meaningful to many other people. In these cases, it may be opportune to remember Walden's blunt statement that many conservators thrive on the genius of the authors of the works they work upon (Walden, 1985).

In a sense, genial conservation is akin to the *grue* objects in Nelson Goodman's well-known *grue* paradox, which he employed to prove some problems in scientific acquisition of knowledge. It can be summarized as follows: a *grue* object is an object that looks green, and will continue to look green until the year 2100; after that year, grue objects will look blue. This is a strange property, indeed, and it may be hard to believe that grue objects exist at all; however, is it possible to refute that emeralds are grue objects? It is obviously not possible, as all available observations to date confirm that every single emerald actually looks green before the year 2100 (Goodman, 1965). This paradox can be very useful regarding genial conservation: it is for similar reasons that it is not possible either to demonstrate or to refute that the work of a given individual will, or will not, be acceptable to future users.

Classical theories criticize 'genial conservation' because it works against truth: adding a glass pane and a concrete tower to a Renaissance building, for instance, might be criticized as being against the true nature or history of the building. This criticism is quite frequently (and conveniently) rejected by twisting the tautological argument to prove that the conservation process during which the tower was added is simply another step in the life of the monument, just as any conservation intervention is.

For contemporary conservation ethics, however, genial conservation is to be rejected not because it goes against truth, but for two other reasons that are harder to debunk. First, because it may be disturbing to many people; to put it simply, the fact that a conservation process is a step in the life of a given object does not prove that the process is sensible or pertinent. Second, because it may be an unsustainable process; because it may compromise, to an unacceptable extent, the symbolic power that the object might have for future users. For honest, genial conservators, that is, for those who sincerely believe that their creations will eventually be beneficial to people, sustainability in conservation can be summarized in two common-sense principles: the principles of humility and prudence; humility to acknowledge that, after all, he or she might not be a creative genius; and prudence to acknowledge the possibility that even if he or she were a genius, history might still be unfair and not recognize it – after all, even the towers that Bernini added to the Pantheon were removed, much to the relief of many people.

Demagogic conservation

The other side of genial conservation is what could be called 'demagogic conservation'. In demagogic conservation, the conservator simply renounces any responsibility by delegating it to the people. Decisions are taken according to the preferences of the people with little or no regard for other considerations, producing what has been called 'the Theme Park effect' (Solà-Morales, 1998).

Curiously enough, demagogic conservation somewhat resembles the rationale behind scientific conservation, since, in both cases, the conservator willingly chooses to abide by the directives dictated by external factors; the difference is that, in the first case, the deciding factors are the people's preferences, while in the second case, the deciding factors are some material or historical features of the object. In both cases, however, there is a delegation of responsibilities, which can be very convenient in the short run, though it is likely to be damaging to the profession in the long run, as it converts the conservator into a mere operator with a few technical responsibilities – not to mention the deleterious effects that it might have on the future usability of the objects.

Exerting authority: the role of the experts in contemporary conservation

Contemporary ethics does not call for demagogic conservation, but for *negotiatory* conservation. Just as the will of empowered decision-makers should not be made to prevail at all costs, the will of an admittedly large group of users should not prevail at all costs, either. In particular, there are two special groups of *stakeholders* whose needs must be catered to: academic or cultivated users of the object, and future users of the object.

Academic users are, indeed, a minority group. They have preferences and needs, which are not those of the rest of the people. Appreciation of hi-cult-related objects and scientific evidence is a trademark of this group, and thus, most of these users would encourage the conservation of objects that would not usually be considered by other individuals. When in *the trading zone*, academic users might be considered special stakeholders for two reasons. First, they are very special users of many conservation objects, namely, those with ethno-historic and artistic meanings or values. Generally speaking, cultivated people, while not being the only users, are indeed special users of these objects. They

have been trained to use and appreciate the objects, and in fact, in many cases, they are the mediators between the objects and the rest of society: they interpret the meanings in the objects for the rest of society, which, in turn, learns to appreciate them thanks to that mediation. Similarly, cultivated experts interpret archaeological findings for the rest of the people who, in turn, learn to appreciate them; for example, cultivated experts tell why the Agamenon mask or the Portland vase is so special, and the rest of society consequently develops a special appreciation for it.

This ability to transfer meaning confers cultivated experts with power and converts them into special stakeholders. They have been trained to know and use – and many times to enjoy – these objects, and thus, these objects have some special, more intense meanings for them than they have for the rest of society. Just as the Manekken Piss has a stronger meaning for Belgians than it has for Finnish people, late Renaissance miniature paintings are usually more appreciated by an art historian than by a genetic biologist – and even more so by a Renaissance expert than by an expert in North American post-modern sculpture.

When conservation decision-making is done, it is not simply a matter of 'vote counting', because some stakeholders have more to say than others. Experts have much to say, as they are privileged users of certain objects. When dealing with museum paintings, the waterlogged remnants of a ship, or a set of handwritten documents in a historical archive, the voice of the experts will have a strong resonance at the negotiation table; when dealing with social symbols, even if it is a work of art or if it might be used as historical evidence – such as the Statue of Liberty, the Big Ben, or Lenin's corpse – the voice of the general public will grow stronger, and may even be louder than that of the experts. Also, the restored object may be strongly meaningful to a family or a small group, as is the case with personal souvenirs or extremely local symbols (a cross in a small town's square with little historical or artistic

relevance, or a posthumous letter by a relative). In this case, the experts will have little voice when negotiating the future of the object compared to the people within the family or the group for whom those objects constitute extremely powerful symbols.

The sustainability of an object's ability to convey messages is an argument against demagogic conservation, but it is also another reason why the experts deserve to have a special voice in conservation decision-making. As argued in Chapter 4, the idea that an object has a single reading is wrong. Contemporary conservation ethics consider this polysemic ability to be a value in itself. Sustainability mandates that this ability should be considered a value when taking decisions; for example, removing the aged varnish of a baroque painting is an action that eliminates one of its possible interpretations forever (that of a baroque painting which has been treated with typical nineteenth-century varnishes that give that golden look so characteristic of really old paintings). It can be said that a symbolic resource has been depleted forever.

When taking decisions of this kind, this depletion must be taken into account since it will compromise the future use of the object. To continue with the example of the painting, it could well happen that in the near future, paintings with old, yellowed varnishes become preferred for their being considered more authentic or for any other reason. In this case, our decisions, our adaptation of the objects to our particular needs may well deprive our descendants of some possible readings of those same objects. To use J. Jacobs' words, the conservation object is like a cake:

> We can't eat and have our cultural cake. It's just a question of whether we can eat it now or later. (Baer, 1998)

This metaphor is quite helpful, as it strongly conveys the view of conservation objects as finite resources. Consequently, it is very close to the ecological or economic notions of sustainability. However, this metaphor can be stretched even further, as it

somehow suggests that, just like our descendants, we too like cake. There is no reason why we should deserve it any more or less than our descendants, so there is no reason why *all* depleting actions should be accepted or rejected. Fortunately, we can eat a little and still leave enough cake for later eaters, so that there really cannot be an absolute rule concerning this matter. Instead, any conservation decision that depletes an object of any likely or strong source of meaning should be carefully weighed. Again, costs and benefits should be studied and balanced against each other, and should also be approached with vision, prudence and humility, so that these decisions can be acceptable to a vast majority of people.

These virtues (vision, prudence and humility) will most likely be defended by experts – it is certainly the kind of wisdom that is expected of them. This role, the role of a wise person looking beyond the obvious, is a very important one in conservation decision-making; it is also an extremely challenging one, as it may sometimes be unpopular. As Vestheim *et al.* have stated, 'conservators must accept the role of being "hindrances"' when shortsighted decisions are made (Vestheim *et al.*, 2001). When playing this unpleasant role, the experts should keep in mind that conservation is a trading zone, and not a laboratory or a classroom. They should accept the fact that their authority derives from their ability to convince other people: it is for this reason that the need for conservators to improve their communication skills has been highlighted (Leigh *et al.*, 1994; Nordqvist *et al.*, 1997; Frey, 2001; Stoner, 2001).

Conclusion: a revolution of common sense

Contemporary theory of conservation calls for 'common sense', for gentle decisions, for sensible actions. What determines this? Not truth or science, but rather the uses, values and meanings that an object has for people. This is determined by the people. Predicting the chemical alterations in an artwork, for instance, is

perfectly valid, but in conservation, it is far more important to predict how people will be affected by a conservation process. Allocating resources to determine how a cellulose monomer ages is socially acceptable because it affects people; for instance, the substitution of the oxhydril groups in a cellobiose unit is supposed to have an effect upon the tensile strength and the folding endurance of a sheet of paper, which may compromise its integrity, and which, in turn, might affect the user of that sheet for intangible, symbolic reasons. The ultimate goal of conservation as a whole is not to conserve the paper, but to retain or improve the meaning it has for people. Sure, this might mean keeping the paper in its current state, but then again, it may mean modifying it: cleaning stains, repairing tears, removing adhesive tapes, reinforcing and flattening it, etc. Researching the oxidation of the OH groups is just a means to an end, not an end in itself. From a conservator's point of view, the results of these efforts should be primarily judged not by their contribution to increasing the human body of knowledge, but by their contribution to increasing the satisfaction of the people for whom an object has meaning – or for whom it fulfils a symbolic function or has symbolic value.

In fact, conservation is a means, and not an end in itself. It is a way of maintaining and reinforcing the meanings in an object; it is even a means through which the appreciation for what an object symbolizes is expressed.

However, contemporary conservation ethics is not conservation *à la carte*: neither the conservator nor the public are given *carte blanche* to act as they choose. Conservators (or empowered decision-makers) cannot just do what they think honest or what they would do if the object were theirs.

Contemporary ethics offers better answers than classical theories, but this does not mean that these are easy answers – quite the contrary. Contemporary theory says to anyone involved in conservation decision-making that things are not as easy as classical

theories suggest: decision-making does not consist of deciding how to implement a number of well-known directives. Decision-makers are not just limited to studying how to enforce truth within the object. Contemporary ethics asks them to consider the different meanings that an object has for different groups of people, and to decide not just which meanings should prevail, but also how to combine them to satisfy as many views as possible.

Even though this is a difficult task, the intent of contemporary conservation ethics is not to eliminate discussion, but to encourage it. It also intends for this discussion to take place *before* the actual conservation process begins. Contemporary conservation ethics provides more efficient, down-to-earth, reflection tools for the understanding of ethical problems in conservation, and thus for their actual solution. Since it is based upon people's needs and feelings, it does not imply a radical change in current conservation practice. Science, material fetishism, *rigattini* or neutral reintegrations and other features common to current conservation practice will still be valid in many cases; as long as the affected people view these features as valuable and pertinent, they will be valuable and pertinent.

This is another advantage of contemporary conservation ethics: it is adaptive. It adapts to the needs of the users, revealing that these needs are ethically much more relevant than any scientific principle, revealing that objective or scientific principles are relevant only as long as they are accepted as such by the users of the object.

Therefore, there is no reason why contemporary conservation ethics should substantially modify the practice of conservation, except in those cases in which the affected people might feel offended by its practice. This is hardly a revolution, but if it were, it would be the revolution of common sense: the revolution of understanding why, and for whom, things are conserved.

Bibliographical references _____

Adorno, T. (1967). Valéry-Proust museum. In *Prisms*, (T. Adorno, ed.) pp. 175–185. London: Garden City Press.

AIC (American Institute for Conservation) (1996). AIC definitions of conservation terminology. *Newsletter of the Western Association for Art Conservation*, **18(2)**, 1996. Available at http://palimpsest.stanford. edu/waac/wn/wn18/wn18-2/wn18-202.html, accessed on 7 February 2002. Also available at http://aic.stanford.edu/about/coredocs/defin. html, accessed on 3 May 2004.

AIC (American Institute for Conservation) (1996). Definitions of conservation. *Abbey Newsletter*, **20(4–5)**. Available at http://aic.stanford. edu/about/coredocs/defin.html, accessed on 3 May 2004.

Alexie, S. (1991). Evolution. In *The Business of Faydancing* (Brooklyn, ed.) NY: Hanging Loose Press.

Alonso Fernández, L. (1999). *Introducción a la nueva museología.* Madrid: Alianza.

Alonso, R. (1999). En defensa de una restauración. *El Mundo*, **8 June**, 60.

Appelbaum, B. (1987). Criteria for treatment: reversibility. *Journal of the American Institute for Conservation*, **26**, 65–73.

Ashley-Smith, J. (1995). *Definitions of Damage.* Available at http:// palimpsest.stanford.edu/byauth/ashley-smith/damage.html, accessed on 8 November 2002.

Ashworth, G., Andersson, Å.E., Baer, N.S., *et al.* (2001). Group Report: Paradigms for Rational Decision-making in the Preservation of Cultural Property. In *Rational Decision-making in the Preservation of Cultural Property* (N.S. Baer and F. Snickars, eds.) pp. 277–293. Berlin: Dahlem University Press.

Australia ICOMOS (International Council on Monuments and Sites) (1999). *The Burra Charter: the Australia ICOMOS Charter for the*

215

Conservation of Places of Cultural Significance. Available at http://www.icomos.org/australia/burra.html, accessed on 3 May 2004.

Avrami, E., Mason, R., and De La Torre, M., eds. (2000). *Values and Heritage Conservation. Research Report.* Los Angeles: The Getty Conservation Institute. Available at http://www.getty.edu/conservation/publications/pdf_publications/assessing.pdf, accessed on 7 February 2002.

Azúa, F. de (1995). *Diccionario de las artes*, Barcelona: Planeta.

Baer, N. (1998). Does conservation have value? In *25 Years School of Conservation: the Jubilee Symposium Preprints* (K. Borchersen, ed.). pp. 15–19. Kobenhavn: Konservatorskolin Det Kongelige Danske Kunstakademi.

Baldini, U. (1978). *Teoria del restauro e unità di metodologia* **(2 vols)**. Florence: Nardini.

Ballart, J. (1997). *El patrimonio histórico y arqueológico: valor y uso.* Barcelona: Ariel.

Barthes, R. (1971). *Elementos de semiología.* Madrid: Alberto Corazón.

Baudrillard, J. (1985). *El sistema de los objetos.* Mexico, DF: Siglo XXI Editores.

Beard, M. (2003). *The Parthenon.* Cambridge, MA: Harvard University Press.

Beck, J.H. (1994). *Art Restoration: the Culture, the Business and the Scandal.* London: J. Murray.

Beck, J.H. (1996). A Bill of Rights for Works of Art. In *'Remove Not the Ancient Landmark': Public Monuments and Moral Values* (M. Reynolds, ed.) pp. 65–72. Amsterdam: Gordon and Breach Publishers.

Beck, J.H. (2000). The "Have you seen it?" myth, or how restorers disarm their critics. *Art Review*, **May 2000**, 26.

Beck, J.H. (2002). What does 'Clean' mean? *Newsday*, **6 October**, A26.

Beer, R.D. (1990). *Intelligence as Adaptive Behavior: An Experiment in Computational Neuroethology.* Boston: Academic Press.

Bergeon, S. (1997). Éthique et conservation-restauration: la valeur d'usage d'un bien culturel. In *La conservation: une science in évolution. Bilan et perspectives. Actes des troisièmes journées internationales d'études de l'ARSAG*, Paris, 21–25 avril 1997, pp. 16–22. Paris: ARSAG.

Bluestone, D., Klamer, A., Throsby, D., and Mason, R. (1999). The economics of heritage conservation. *The Getty Conservation Institute Newsletter*, **14(1)**, 9–11.

Bomford, D. (1994). Changing taste in the restoration of paintings. In *Restoration: Is It Acceptable?* (A. Oddy, ed.) pp. 33–40. London: British Museum.

Bonelli, R. (1995). *Scritti sul restauro e sulla critica architettonica.* Rome: Bonsignori.

Bonsanti, G. (1997). Riparare l'arte. *OPD Restauro*, **9**, 109–112.

Brandi, C. (1977). *Teoria del restauro.* Turin: Einaudi.

Brooks, H.B. (2000). The measurement of art in the essays of F.I.G. Rawlins. *IIC Bulletin*, **2002(2)**, 1–3.

Bueno, G. (1996). *El mito de la cultura.* Barcelona: Editorial Prensa Ibérica.

Burke, J. and Ornstein, R. (1995). *The Axemaker's Gift.* New York: Penguin Putnam.

Burnam, P.A.T.I. (2001). What is cultural heritage? In *Rational Decision-Making in the Preservation of Cultural Property* (N.S. Baer and F. Snickars, eds.) pp. 11–22. Berlin: Dahlem University Press.

Cameron, C., Castellanos, C., Demas, M., Descamps, F., and Levin, J. (2001). Building consensus, creating a vision. A discussion about site management. *Conservation. The Getty Conservation Institute Newsletter*, **16(3)**, 13–19.

Caple, C. (2000). *Conservation Skills. Judgement, Method and Decision Making.* London: Routledge.

Carbonara, G. (1976). *La reintegrazione dell'immagine. Problemi di restauro di monumenti.* Rome: Bulzoni.

Carlston, D. (1998). *Storing Knowledge.* Available at http://www.longnow. com/10klibrary/TimeBitsDisc/snpaper.html, accessed on 3 May 2004.

Charteris, L. (1999). Reversibility – myth and mis-use. In *Reversibility – Does it Exist?* (A. Oddy, ed.) pp. 141–145. London: British Museum.

Chemero, A. (2002). Reconsidering Ryle. *Electronic Journal of Analytic Philosophy. Special Issue on the Philosophy of Gilbert Ryle.* Available at http://ejap.louisiana.edu/EJAP/2002/Chemero.pdf, accessed on 3 May 2004.

Child, R. (1994). Putting things in context: the ethics of working collections. In *Reversibility – Does it Exist?* (A. Oddy, ed.) pp. 139–143. London: British Museum.

Chomsky, N. (1989). *Necessary Illusions. Thought Control in Democratic Societies.* Boston: South End Press. Also available at http://www. zmag.org/chomsky/ni/ni-overview.html, accessed on 4 April 2004.

Clark, K. (2000). From regulation to participation: cultural heritage, sustainable development and citizenship. In *Forward Planning: The Functions of Cultural Heritage in a changing Europe*, pp. 103–110. Available at http://www.coe.int/T/E/Cultural_Co-operation/Heritage/ Resources/ECC-PAT(2001)161.pdf, accessed on 3 May 2004.

Clavir, M. (2002). *Preserving What is Valued. Museums, Conservation, and First Nations*. Vancouver: UBC Press.

Colalucci, G. (2003a). Los comités científicos. *Restauración& Rehabilitación*, **78**, 18.

Colalucci, G. (2003b). Ciencia y sabiduría. *Restauración& Rehabilitación*, **80**, 20.

Colalucci, G. (2004). Aún más sobre el tema de la restauración. *Restauración&Rehabilitación*, **84**, 12.

Considine, B., Leonard, M., Podany, J., Tagle, A., Khandekar, N., and Levin, J. (2000). Finding a certain balance. A discussion about surface cleaning. *Conservation. The Getty Conservation Institute Newsletter*, **15(3)**, 10–15.

Constantine, M. (1998). Preserving the legacy of 20th century art. *Conservation. The Getty Conservation Institute Newsletter*, **13(2)**, 4–9.

Conti, A., ed. (1988). *Sul restauro*. Milan: Einaudi.

Cordaro, M. (1994). *"Il concetto di originale nella cultura del restauro storico e artistico", en Il cinema ritrovato: Teoria e metodologia del restauro cinematografico*. Bolonia: Grafis Edizioni.

Coremans, P. (1969). The training of restorers. In *Problems of Conservation in Museums. Joint Meeting of the ICOM Committee for Museum Laboratories and the ICOM Committee for the Care of Paintings*, Washington-New York, September 17–25, 1965, pp. 7–31. London: Allen and Unwin.

Cosgrove, D.E. (1994). Should we take it all so seriously? Culture, conservation, and meaning in the contemporary world. In *Durability and Change. The Science, Responsibility, and Cost of Sustaining Cultural Heritage* (W.E. Krumbein, P. Brimblecombe, D.E. Cosgrove, and S. Staniforth, eds.) pp. 259–266. Chichester: John Wiley and Sons.

Cruz, A.J. (2001). Se cada obra de arte é única, porquê estudar materialmente conjuntos de obras? *Boletim da Associação para o Desenvolvimento da Conservação e Restauro*, **10/11**, pp. 28–31.

Daley, M. (1994) Oil, tempera and the National Gallery. In *Art Restoration: The Culture, the Business and the Scandal* (J.H. Beck, ed.) pp. 123–151. London: J. Murray.

Danto, A.C. (1998). *After the End of Art: Contemporary Art and the Pale of History*. Princeton: Princeton University Press.

Davallon, J., ed. (1986). *Claquemurer, pour ainsi dire, tout l'univers: la mise en exposition*. Paris: Centre Georges Pompidou.

De Guichen, G. (1991). Scientists and the preservation of cultural heritage. In *Science, Technology and European Cultural Heritage.*

Proceedings of the European Symposium, Bolgona, Italy, 13–16 June 1989 (N.S. Baer, C. Sabbioni, and A.I. Sors, eds.) pp. 17–26. Oxford: Butterworth-Heinemann.

De la Torre, M., ed. (2002). *Assessing the Values of Cultural Heritage.* Los Angeles: The Getty Conservation Institute. Available at http://www.getty.edu/conservation/publications/pdf_publications/assessing.pdf, accessed on 3 may 2004.

Deloche, B. (1985). *Museologica. Contradictions et logique du musée.* 2nd edn. Paris: J. Vrin.

Desvallées, A., Bary, M.-O., and Wasserman, F., eds. (1994). *Vagues: Une Anthologie de la Nouvelle Muséologie.* Lyon: Diffusion, Presses universitaires de Lyon.

Dezzi Bardeschi, M. (1991). *Restauro: punto e da capo. Frammenti per una (impossibile) teoria.* Milan: Franco Angelli.

Dickie, G. (1974). *Art and the Aesthetic: An Institutional Analysis.* Ithaca, NY: Cornell University Press.

Donahue, M.J. (s.d.). *Chaos Theory: The Mergence of Science and Philosophy.* Available at http://www.duke.edu/~mjd/chaos/Ch3.htm, accessed on 5 May 2004.

Donato, E. (1986). The museum's furnace: notes toward a contextual reading of *Bouvard et Pecuchet.* In *Critical Essays on Gustave Flaubert* (L.M. Porter, ed.) pp. 207–222. Boston: G.K. Hall.

Duncan, C. (1994). Art museums and the ritual of citizenship. In *Interpreting Objects and Collections* (S.M. Pearce, ed.) pp. 279–286. Londres: Routledge.

Eastop, D. and Brooks, M. (1996). To clean or not to clean: the value of soils and creases. In *Preprints. ICOM Committee for Conservation. 11th Triennial Meeting*, Edinburgh, Scotland, 1–6 September 1996, (J. Bridgland, ed.) pp. 687–691. London: James & James Science Publishers.

Eco, U. (1965). *Apocalittici e integrati. Communicazioni di massa e teorie della cultura di massa.* Milan: Bompiani.

Eco, U. (1990). *I limiti dell'interpretazione.* Milan: Bompiani.

Eco, U. (1997). Function and sign: the semiotics of architecture. In *Rethinking Architecture. A Reader in Cultural Theory* (N. Leach, ed.) pp. 182–202. London: Routledge.

Feilden, B.M. (1982). *Conservation of Historic Buildings.* London: Butterworth Scientific.

Fernández-Bolaños Borrero, M.P. (1988). Normas de actuación en arqueología. In *V Congreso de Conservación y Restauración de Bienes Culturales*, pp. 369–373. Barcelona: Generalitat de Catalunya.

Feyerabend, P. (1975). *Against Method: Outline of an Anarchistic Theory of Knowledge*. London: NLB.

Feyerabend, P. (1979). *Science in a Free Society*. London: Routledge.

Frey, B.S. (2001). What is the economic approach to aesthetics? In *Rational Decision-Making in the Preservation of Cultural Property* (N.S. Baer and F. Snickars, eds.) pp. 225–234. Berlin: Dahlem University Press.

Friedländer, M. (1996). On restorations. In *Historical and Philosophical Issues in the Conservation of Cultural Heritage* (N. Stanley Price, M. Kirby Talley, and A. Melucco Vaccaro, eds.) pp. 332–334. Los Angeles: The Getty Conservation Institute.

Gironés Sarrió, I. (2003). *Knut Nicolaus. Entrevista. Restauración & Rehabilitación*. **74**, 66–68.

Goodman, N. (1965). *Fact, Fiction and Forecast*. Indianapolis: Bobbs-Merrill.

Gordon, G.N. (1998). Communication. In *Britannica CD 98® Multimedia Edition* © 1994–1997.

Grisson, C.A., Charola, A.E., and Wachowiak, M.J. (2000). Measuring surface roughness on stone. *Studies in Conservation*, **45(2)**, 73–84.

Guerola, V. (2003). La visión privilegiada. Documentación de archivo y tomografía computerizada aplicada en el análisis de la imagen de Ntra. Sra. de Aguas Vivas. *Restauración & Rehabilitación*, **80**, 70–75.

Guillemard, D. (1992). Éditorial. In *3ᵉ Colloque International de l'ARAAFU*, pp. 13–18. Paris: ARAAFU.

Hachet, P. (1999). *Le mensonge indispensable. Du trauma social au mythe*. Paris: Armand Colin Éditeur.

Hansen, E. and Reedy, Ch.L. (1994). *Research Priorities in Art and Architectural Conservation*. A report of an AIC membership survey. Washington DC: American Institute for Conservation.

ICC Kraków (International Conference on Conservation 'Kraków 2000') (2000). *Charter of Cracow 2000*. Available at http://home.fa.utl. pt/~camarinhas/3_leituras19.htm, accessed on 3 May 2004.

ICOM (International Council of Museums) (1984). *The Code of Ethics. The Conservator-Restorer: A Definition of the Profession*. Available at http://www.encore-edu.org/encore/documents/ICOM1984.html, accessed on 3 May, 2004.

ICOMOS (International Council on Monuments and Sites) (1964). *The Venice Charter: International Charter for the Conservation and Restoration of Monuments and Sites*. Available at http://www.getty. edu/conservation/research_resources/charters/charter12.html, accessed on 3 May 2004.

Jaeschke, R.L. (1996). When does history end? In *Preprints of the contributions to the Copenhagen Congress: Archaeological Conservation and its Consequences* (A. Roy and P. Smith, eds.) pp. 86–88. London: International Institute for Conservation of Historic and Artistic Works.

Jiménez, A. (1998). Enmiendas parciales a la teoría del *restauro* (II). Valor y valores. *Loggia. Arquitectura & Rehabilitación*, **2(5)**, 12–29.

Jones, M., ed. (1992). Introduction: Do fakes matter? In *Why Fakes Matter: Essays on Problems of Authenticity* (M. Jones, ed.) pp. 7–10. London: British Museum.

Keck, C. (1995). Conservation and controversy (letter to the editor). *IIC Bulletin*, **1995(6)**, 2.

Keene, S. (1996). *Managing Conservation in Museums*. Oxford: Butterworth-Heinemann.

Kirby Talley Jr., M. (1997). Conservation, science and art: plum, puddings, towels and some steam. *Museum Management and Curatorship*, **15(3)**, 271–283.

Knowles, A. (2000). After Athens and Venice, Cracow. *Trieste Contemporanea. La Rivista*, **6/7**. Available at http://www.tscont.ts.it/pag4-e.htm, accessed on 3 May 2004.

Kosek, J.M. (1994). Restoration of art on paper in the west: a consideration of changing attitudes and values. In *Restoration: Is It Acceptable?* (A. Oddy, ed.) pp. 41–50. London: British Museum.

Leech, M. (1999). *Assisi after the Earthquake (restoration of Assisi church) (brief article)*. Available at http://www.findarticles.com/cf_dls/m1373/1_49/53588890/print.jhtml, accessed on 2 March 2004.

Leigh, D., Altman, J.S., Black, E., *et al.* (1994). Group Report: What are the responsibilities for cultural heritage and where do they lie? In *Durability and Change. The Science, Responsibility, and Cost of Sustaining Cultural Heritage* (W.E. Krumbein, P. Brimblecombe, D.E. Cosgrove, and S. Staniforth, eds.) pp. 269–286, Chichester: John Wiley and Sons.

Leitner, H. and Paine, S. (1994). Is wall-painting restoration a representation of the original or a reflection of contemporary fashion: an Australian perspective? In *Restoration: Is It Acceptable?* (A. Oddy, ed.) pp. 51–66. London: British Museum.

Lem, S. (1986). *Memoirs Found in a Bathtub*. San Diego: Harvest Books.

Longstreth, R. (1995). I can't see it; I don't understand it; and it doesn't look old to me. *Historic Preservation Forum*, **10(1)**, 6–15.

Lowenthal, D. (1985). *The Past is a Foreign Country*. Cambridge: Cambridge University Press.

Lowenthal, D. (1994). The value of age and decay. In *Durability and Change. The Science, Responsibility, and Cost of Sustaining Cultural Heritage* (W.E. Krumbein, P. Brimblecombe, D.E. Cosgrove, and S. Staniforth, eds.) pp. 39–49. Chichester: John Wiley and Sons.

Lowenthal, D. (1996). *Possessed by the Past. The Heritage Crusade and the Spoils of History*. New York: The Free Press.

Lowenthal, D. (1998). Fabricating Heritage. *History & Memory*, **10(1)**. Available at http://iupjournals.org/history/ham10-1.html, accessed on 3 may 2004.

Lyotard, F. (1979). *La condition postmoderne*. Paris: Minuit.

Manieri Elia, M. (2001). La restauración como recuperación del sentido. *Loggia. Arquitectura & Rehabilitación*, **12**, 20–25.

Mansfield, H. (2000). *The Same Ax, Twice. Restoration and Renewal in a Throwaway Age*. Hanover: University Press of New England.

Martignon, L.F. (2001). Principles of adaptive decision-making. In *Rational Decision-Making in the Preservation of Cultural Property* (N.S. Baer and F. Snickars, eds.) pp. 263–275. Berlin: Dahlem University Press.

Martínez Justicia, M.J. (2000). *Historia y teoría de la conservación y restauración artística*. Madrid: Tecnos.

Matsuda, Y. (1997). Some problems at the interface between art restorers and conservation scientists in Japan. In *The Interface Between Science and Conservation* (S. Bradley, ed.) pp. 227–230. London: British Museum.

McCrady, E. (1997). Can scientists and conservators work together? In *The Interface Between Science and Conservation* (S. Bradley, ed.) pp. 243–247. London: British Museum.

McGilvray, D. (1988). Raisins versus vintage wine. Calvert and Galveston, texas. In *Adaptive Reuse: Issues and Case Studies in Building Preservation* (D.G. Woodcock, W.C. Steward, and R.A. Forrester, eds.) pp. 3–17.

MacLean, J. (1995). The ethics and language of restoration. *SSCR Journal*, **6(1)**, 11–14.

Melucco Vaccaro, A. (1996). The emergence of conservation theory. In *Historical and Philosophical Issues in the Conservation of Cultural Heritage* (N. Stanley Price, M. Kirby Talley, and A. Melucco Vaccaro, eds.) pp. 202–211. Los Angeles: The Getty Conservation Institute.

Michalski, S. (1994). Sharing responsibility for conservation decisions. In *Durability and Change. The Science, Responsibility, and Cost of Sustaining Cultural Heritage* (W.E. Krumbein, P. Brimblecombe,

D.E. Cosgrove, and S. Staniforth, eds.) pp. 241–258. Chichester: John Wiley and Sons.

Minissi, F. (1988). *Conservazione Vitalizzazione Musealizzazione*. Roma: Multigrafica Editrice.

Molina, T. and Pincemin, M. (1994). Restoration: acceptable to whom? In *Restoration – Is It Acceptable?* (A. Oddy, ed.) pp. 77–83. London: British Museum.

Morris, Ch. (1938). *Foundations of the Theory of Signs*. Chicago: University of Chicago Press.

MPI (Ministero della Pubblica Istruzione) (1972). *Carta di Restauro 1972*. Available at http://www.unesco.org/whc/world_he.htm, accessed on 5 May 2004.

Müller, M.M. (1998). Cultural heritage protection: legitimacy, property and functionalism. *International Journal of Cultural Property*, **7(2)**, 395–409.

Muñoz Viñas, S. (2002). Contemporary theory of conservation. *Reviews in Conservation*, **3**, 25–34.

Muñoz Viñas, S. (2003). *Teoría Contemporánea de la Restauración*. Madrid: Síntesis.

Myklebust, D. (1987). Preservation philosophy: the basis for legitimating the preservation of the remains of old cultures in a modern world with new value systems. In *Old Cultures in New Worlds (ICOMOS 8th General Assembly and International Symposium)*, **Vol. 2**. pp. 723–730. Washington: ICOMOS United States Committee.

Noble, D.F. (1997). *The Religion of Technology*. New York: Alfred A. Knopf.

Nordqvist, J. *et al.* (1997). Archaeological conservation and its consequences. *IIC Bulletin*, **5**, 1–8.

Nys, P. (2000). Landscape and heritage – Challenges of an environmental symbol. In *Forward Planning: the Functions of Cultural Heritage in a changing Europe*, pp. 65–82. Available at http://www.coe.int/T/E/Cultural_Co-operation/Heritage/Resources/ECC-PAT(2001)161.pdf, accessed on 3 May 2004.

Oddy, A. (1995). Does reversibility exist in conservation? In *Conservation, Preservation and Restoration: Traditions, Trends and Techniques* (G. Kamlakar and V.P. Rao, eds.) pp. 299–306. Hyderabad: Birla Archaeological and Cultural Research Institute.

Organ, R.M. (1996). Bridging the conservator/scientist divide. *AIC News*, **6**.

Orvell, M. (1989). *The real thing. Imitation and Authenticity in American Culture 1880–1940*. North Carolina: North Carolina University Press.

Palazzi, S. (1999). Reversibility: dealing with a ghost. In *Reversibility: Does It Exist?* (A. Oddy and S. Carroll, eds.) pp. 175–188. London: British Museum.

Pearce, S., ed. (1989). *Museum Studies in Material Culture*. London: Leicester University Press.

Pearce, S.M. (1990). Objects as meaning; or narrating the past. In *New Research in Museum Studies: Objects of Knowledge* (S. Pearce, ed.) pp. 125–140. London: Athlone.

Philippot, A. and Philippot, P. (1959). Le problème de l'intégration des lacunes dans la restauration des peintures. *Bulletin (Institut Royal du Patrimoine Artistique)*, **2**, 5–19.

Philippot, P. (1996). Restoration from the perspective of the humanities. In *Historical and Philosophical Issues in the Conservation of Cultural Heritage* (N.S. Price, M. Kirby Talley, and A.M. Vaccaro, eds.) pp. 216–229. Los Angeles: Getty Conservation Institute.

Philippot, P. (1998). *Saggi sul restauro e dintorni*. Rome: Bonsignori.

Pizza, A. (2000). *La construcción del pasado*. Madrid: Celeste Ediciones.

Podany, J. (1994). Restoring what wasn't there: reconsideration of the eighteenth-century restorations of the Lansdowne *Herakles* in the collection of the J. Paul Getty Museum. In *Reversibility – Does it Exist?* (A. Oddy, ed.) pp. 9–18. London: British Museum.

Polanyi, M. (1983). *The Tacit Dimension*. Gloucester: Peter Smith.

Popper, K. (1992). *The Logic of Scientific Discovery*. London: Routledge, 1992.

Porck, H.J. (1996). *Mass Deacidification. An Update of Possibilities and Limitations*. Amsterdam: European Commission on Preservation and Access. Also available at http://www.knaw.nl/ecpa/PUBL/PORCK. HTM, accessed on 3 May 2004.

Porck, H.J. (2000). *Rate of Paper Degradation. The Predictive Value of Artificial Aging Tests*. Amsterdam: European Commission on Preservation and Access. Also available at http://www.knaw.nl/ecpa/publ/pdf/2112.pdf, accessed on 3 May 2004.

Pye, E. (2001). *Caring for the Past. Issues in Conservation for Archaeology and Museums*. London: James and James.

Ramírez, J.A. (1994). *Ecosistema y explosión de las artes*. Barcelona: Anagrama.

Reedy, T. and Reedy, Ch. (1992). *Principles of Experimental Design for Art Conservation Research*. Los Angeles: Getty Conservation Institute.

Riding, A. (2003). Question for 'David' at 500: is he ready for makeover? *The New York Times*, 15 July 2003. Available at

http://www.floria-publications.com/italy/news_from_italy/
question_for.htm, accessed on 24 July 2004.

Riegl, A. (1982) The modern cult of monuments: its character and its
origin [1903]. *Oppositions* 25, **Fall 1982**, 21–51.

Rivera, J.A. (2003). *Lo que Sócrates diría a Woody Allen*. Madrid:
Espasa Calpe.

Rodríguez Ruíz, D. (1995). Presentación. In *Mecenazgo y conservación
del patrimonio artístico: reflexiones sobre el caso español*, S.l.:
Fundación Argentaria-Visor Distribuciones, pp. 9–15.

Roy, A. (1998). Forbes prize lecture. *IIC Bulletin*, **1998(6)**, 1–5.

Ruhemann, H. (1982). *The Cleaning of Paintings. Problems and Poten-
tialities*. New York: Haecker Art Books.

Ruskin, J. (1989). *The Seven Lamps of Architecture*. New York: Dover
Publications.

Ryle, G. (1984). *The Concept of Mind*. Chicago: University of Chicago
Press.

Sánchez Hernampérez, A. (s.d.). *Paradigmas conceptuales en conser-
vación*. Available at http://palimpsest.stanford.edu/byauth/hernampez/
canarias.html, accessed on 3 May 2004.

Seeley, N. (1999). Reversibility – achievable goal or illusion? In
Reversibility – Does it Exist? (A. Oddy, ed.) pp. 161–168. London:
British Museum.

Shanani, Ch. J. (1995). Accelerated aging of paper: can it really fore-
tell the permanence of paper? *Preservation Research and Testing
Series* **No. 9503**. Washington: Library of Congress. Available
at http://lcweb.loc.gov/preserv/rt/age/age_12.html, accessed on 20
December 2000.

Shashoua, Y. (1997). Leave it to the experts? In *The Interface Between
Science and Conservation* (S. Bradley, ed.) pp. 231–236. London:
British Museum.

Smith, R.D. (1988). Reversibility: a questionable philosophy. *Restaurator*,
9, 199–207.

Smith, R.D. (1999). Reversibility: a questionable philosophy. In
Reversibility, Does it Exist? (A. Oddy and S. Carroll, eds.) pp.
99–103. London: British Museum.

Šola, T. (1986). Identity. Reflections on a crucial problem for museums.
ICOFOM Study Series, **3**, pp. 15–22. Vevey: M.R. Schärer.

Solà-Morales, I. de (1998). Patrimonio arquitectónico o parque
temático? *Loggia. Arquitectura & Rehabilitación*, **5**, 30–35.

Sörlin, S. (2001). The trading zone between articulation and preser-
vation: production of meaning in landscape history and the problems

of heritage decision-making. In *Durability and Change. The Science, Responsibility, and Cost of Sustaining Cultural Heritage* (W.E. Krumbein, P. Brimblecombe, D.E. Cosgrove, and S. Staniforth, eds.) pp. 47–59. Chichester: John Wiley and Sons.

Staniforth, S. (2000). Conservation: significance, relevance and sustainability. *IIC Bulletin*, **2000(6)**, 3–8.

Staniforth, S., Ballard, E.N., Caner-Saltik, R., *et al.* (1994). Group Report: What are Appropriate Strategies to Evaluate and to Sustain Cultural Heritage? In *Durability and Change. The Science, Responsibility, and Cost of Sustaining Cultural Heritage* (Krumbein, W.E., Brimblecombe, P., Cosgrove, D. and Staniforth, S., eds.) pp. 217–224. Chichester: John Wiley and Sons.

Stoner, J.H. (2001). Conservation of our careers. *IIC Bulletin*, **2001(4)**, 2–7.

Stopp, M. (1994). Cultural bias in heritage reconstruction. In *Archaeological remains, in situ Preservation: Proceedings of the Second ICAHM International Conference, Montreal, Quebec, Canada*, October 11–15, 1994, pp. 255–262. Montreal: ICAHM Publications.

Stovel, H. (1996). Authenticity in Canadian conservation practice. Talk presented at the *Interamerican Symposium on Authenticity in the Conservation and Management of the Cultural Heritage* (San Antonio, March 1996).

Tamarapa, A. (1996). Museum Kaitiaki; Maori perspectives on the presentation and management of Maori treasures and relationships with museums. In *Curatorship: Indigenous Perspectives in Post-Colonial Societies: Proceedings*, 160–169. Ottawa: Canadian Museum of Civilization.

Taylor, R. (1978). *Art, an Enemy of the People*. Hassocks: The Harvester Press.

Tennent, N.H. (1994). The role of the conservation scientist in enhancing the practice of preventive conservation and the conservation treatment of artifacts. In *Durability and Change. The Science, Responsibility, and Cost of Sustaining Cultural Heritage* (W.E. Krumbein, P. Brimblecombe, D.E. Cosgrove, and S. Staniforth, eds.) pp. 166–172. Chichester: John Wiley and Sons.

Tennent, N.H. (1997). Conservation science: a view from four perspectives. In *The Interface Between Science and Conservation*, (S. Bradley, ed.) pp. 15–23. London: British Museum.

Thompson, M. (1994). The filth in the way. In *Interpreting Objects and Collections* (S.M. Pearce, ed.) pp. 269–278. London: Routledge.

Torraca, G. (1991). The application of science and technology to conservation practice. In *Science, Technology and European Cultural*

Heritage. Proceedings of the European Symposium, Bologna, Italy, 13–16 June 1989 (N.S. Baer, C. Sabbioni, and A.I. Sors, eds.) pp. 221–232. Oxford: Butterworth-Heinemann.

Torraca, G. (1996). The Scientist's Role in Historic Preservation with Particular Reference to Stone Preservation. In *Historical and Philosophical Issues in the Conservation of Cultural Heritage* (N. Stanley Price, M.K. Talley, and A. Melucco Vaccaro, eds.) pp. 439–443. Los Angeles. The Getty Conservation Institute.

Torraca, G. (1999). The scientist in conservation. *Conservation. The GCI Newsletter*, **14(3)**, 8–11.

Tusquets, O. (1998). *Todo es comparable*. Barcelona: Anagrama.

UKIC (United Kingdom Conservation Institute) (1983). *Guidance for Conservation Practice*. London: UKIC.

Urbani, G. (1996). The science and art of conservation of cultural property. In *Historical and Philosophical Issues in the Conservation of Cultural Heritage* (N.S. Price, M. Kirby Talley, and A.M. Vaccaro, eds.) pp. 445–450. Los Angeles: The Getty Conservation Institute.

Vantaa Meeting (2000). *Towards a European Preventive Conservation Strategy*. Available at http://www.pc-strat.com/final.htm, accessed on 3 May 2004.

Vargas, G.M., García, C., and Jaimes, E. (1993). Restaurar es comunicar. *ALA*, **13**, 10–18.

Vestheim, G., Fitz, S., Foot, M.-J., *et al.* (2001). Group report: values and the artifact. In *Rational Decision-Making in the Preservation of Cultural Property* (N.S. Baer, and F. Snickars, eds.) pp. 211–222.

Viereck, G.S. (1930). *Glimpses of the Great*. London: Duckworth.

Viollet-le-Duc, E. (1866). Restauration. In *Dictionnaire Raissoné de l'Architecture Française du XIe au le XVIe Siècle*, **VIII**, pp. 14–34. Paris: Bance et Morel.

Wagensberg, J. (1985). *Ideas sobre la complejidad del mundo*. Barcelona: Tusquets.

Wagensberg, J. (1998). *Ideas para la imaginación impura. 53 reflexiones en su propia sustancia*. Barcelona: Tusquets.

Waisman, M. (1994). El Patrimonio en el tiempo. *Boletín del Instituto Andaluz de Patrimonio Histórico*, **6**, 10–14.

Walden, S. (1985). *The Ravished Image or How to Ruin Masterpieces by Restoration*. London: Weinfeld and Nicolson.

WCG (Washington Conservation Guild) (s.d.). Exactly what is conservation? Available at http://palimpsest.stanford.edu/wcg/what_is.html, accessed on 13 September 1999.

Watkins, C. (1989). Conservation: a cultural challenge. *Museum News*, **68(1)**, 36–43.

Watson, W.M. (1994). 1. Gonçal Peris: Saint Lucy, probably first third of the 15th century. In *Altered States. Conservation, Analysis and the Interpretation of Works of Art* (W. Wendy, ed.) pp. 36–39.

Welsh, E., Sease, C., Rhodes, B., Brown, S., and Clavir, M. (1992). Multicultural participation in conservation decision-making. *Newsletter of the Western Association for Art Conservation*, **14(1)**, 13–22.

Windelband, W. (1894). *Geschichte und Naturwissenschaft*. Available at http://www.psych.ucalgary.ca/thpsyc/windelband.html, accessed on 3 May, 2004.

Wolfe, T. (1975). *The Painted Word*. New York: Farrar, Straus and Giroux.

Yourcenar, M. (1989). *El tiempo, gran escultor*. Madrid: Alfagurara.

Zevi, B. (1974). *Architettura e storiografia. Le matrici antiche del linguaggio moderno*. Turin: Einaudi.

Subject index

Proper names index

Author index